TIME

History's Greatest Images

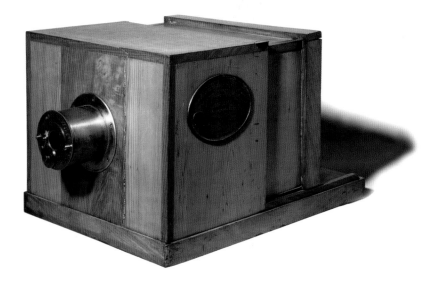

Box of light *The world's first cameras went on sale in 1839. Utilizing the daguerreotype process, they created a single, positive image on a copper plate that could not be reproduced*

TIME

MANAGING EDITOR Richard Stengel
ART DIRECTOR D.W. Pine
DIRECTOR OF PHOTOGRAPHY Kira Pollack

History's Greatest Images
The World's 100 Most Influential Photographs

EDITOR/WRITER Kelly Knauer
DESIGNER Ellen Fanning
PICTURE EDITOR Patricia Cadley
RESEARCH Tresa McBee
COPY EDITOR Bruce Christopher Carr

TIME HOME ENTERTAINMENT
PUBLISHER Richard Fraiman
VICE PRESIDENT, BUSINESS DEVELOPMENT AND STRATEGY Steven Sandonato
EXECUTIVE DIRECTOR, MARKETING SERVICES Carol Pittard
EXECUTIVE DIRECTOR, RETAIL AND SPECIAL SALES Tom Mifsud
EXECUTIVE PUBLISHING DIRECTOR Joy Butts
DIRECTOR, BOOKAZINE DEVELOPMENT AND MARKETING Laura Adam
FINANCE DIRECTOR Glenn Buonocore
ASSISTANT GENERAL COUNSEL Helen Wan
ASSOCIATE PUBLISHING DIRECTOR Megan Pearlman
ASSISTANT DIRECTOR, SPECIAL SALES Ilene Schreider
BOOK PRODUCTION MANAGER Suzanne Janso
DESIGN AND PREPRESS MANAGER Anne-Michelle Gallero
BRAND MANAGER Michela Wilde
ASSOCIATE BRAND MANAGER Isata Yansaneh
ASSOCIATE PREPRESS MANAGER Alex Voznesenskiy

EDITORIAL DIRECTOR Stephen Koepp

SPECIAL THANKS
Christine Austin, Katherine Barnet, Jeremy Biloon, Stephanie Braga, Jim Childs, Susan Chodakiewicz, Rose Cirrincione, Lauren Hall Clark, Brian Fellows, Jacqueline Fitzgerald, Christine Font, Jenna Goldberg, Hillary Hirsch, Amy Mangus, Robert Marasco, Kimberly Marshall, Amy Migliaccio, Nina Mistry, Dave Rozzelle, Adriana Tierno, Vanessa Wu, TIME Imaging

ISBN 10: 1-60320-197-1
ISBN 13: 978-1-60320-197-1
Library of Congress Control Number: 2011940343

We welcome your comments and suggestions about TIME Books. Please write to us at:
TIME Books, Attention: Book Editors, P.O. Box 11016, Des Moines, IA 50336-1016

To order any of our hardcover Collector's Edition books, please call us at 1-800-327-6388.
Hours: Monday through Friday, 7 a.m.–8 p.m., or Saturday, 7 a.m.–6 p.m., Central Time

Film strip *At right, photographer Alfred Eisenstaedt works on a light table with the original negatives of his famed image of a sailor kissing a nurse after World War II ended*

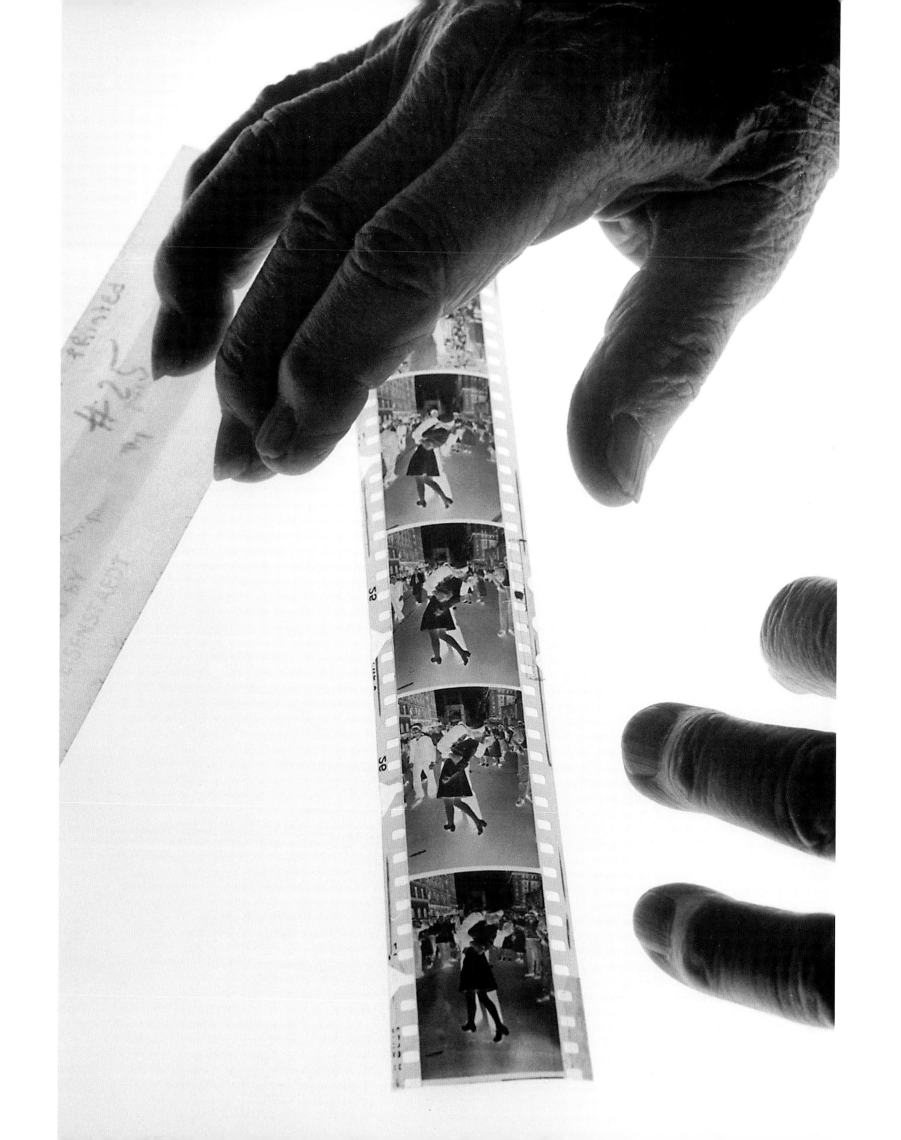

Index of Photographers

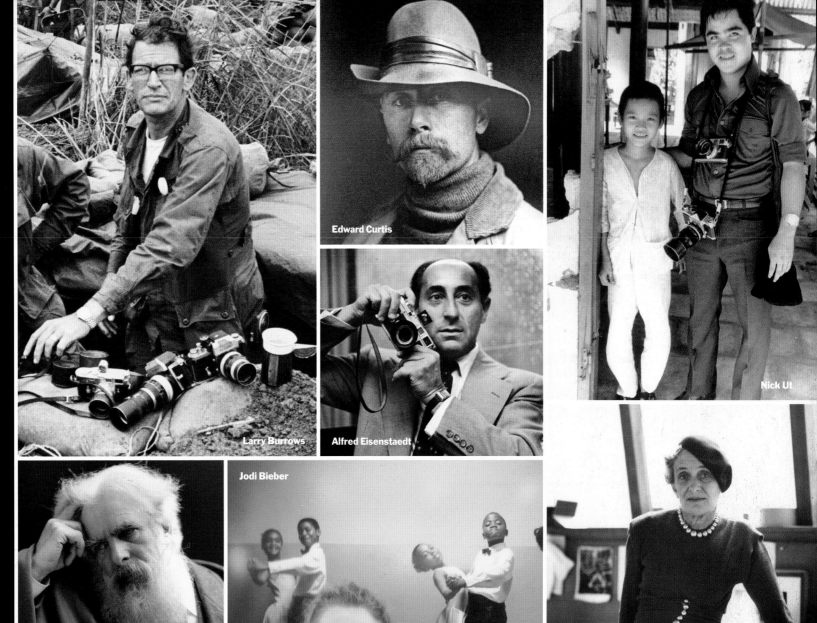
Edward Curtis

Larry Burrows

Alfred Eisenstaedt

Nick Ut

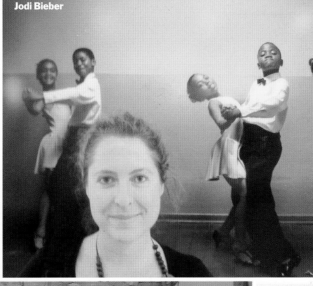
Jodi Bieber

Eadweard Muybridge

Dorothea Lange

Chris Hondros

Joe Rosenthal

The Power of the Image

By Kira Pollack

WRITING IN *TIME,* ASSOCIATED Press photographer Eddie Adams once declared, "Still photographs are the most powerful weapon in the world." Adams came by that opinion the hard way: he will always be associated with a single photo he took during the Tet Offensive in Vietnam in 1968. It shows South Vietnamese national police chief General Nyugen Ngoc Loan shooting a captured Viet Cong soldier in cold blood at close range, without legal proceedings. The photo is on page 102 of this book; it won awards for Adams, but he came to regret taking it, for he respected Loan, and the image haunted the general even after he immigrated to the U.S. in 1975. "The general killed the Viet Cong. I killed the general with my camera," Adams wrote in TIME after Loan died in 1998.

As the director of photography for TIME, I appreciate the power of photographs to evoke powerful emotions. Like Adams, I understand that photographs can be as powerful as a gun; but I also know they can be as incisive as a scalpel, as illuminating as a searchlight, as truthful as a mirror.

Yet even after spending most of my professional life as a photo editor at the New York *Times* Magazine and at TIME, I never experienced the full power of a single image to move hearts and minds around the world until the summer of 2010, when TIME published a photo of an 18-year-old Afghan woman on its cover. Let me tell you the story from my perspective.

In that summer, some nine months after President Barack Obama dispatched 30,000 troops to Afghanistan in an attempt to regain the offensive for the U.S. and its allies in the conflict there, many Americans were questioning the need for the U.S. commitment to Afghanistan and to the government of controversial President Hamid Karzai.

Seeking to highlight the stakes involved in the U.S.-led intervention, TIME's editors sent correspondent Aryn Baker to Afghanistan to prepare a cover story on the plight of the women of that nation. Under a government allied to the West, many Afghan women had emerged from the repressive years of Taliban rule to take leading roles in society. Yet many others remained imprisoned in the ways of the past.

Baker's story was designed to portray the full spectrum of women's lives in today's Afghanistan. To illustrate the article, I enlisted South African photographer Jodi Bieber, who had recently visited my office in New York City, where she showed me a series of portraits she had taken of South African women called "Real Beauty." This remarkable gallery showed middle-age and older women stripped to their undergarments, revealing the effects of age on their bodies. The photos not only illuminated the character of Bieber's subjects, but they also functioned as journalism, delivering important information about them.

Some weeks later, we received the portraits Bieber had taken in Afghanistan. The compelling shots captured many women who were playing important roles in their nation's media, its professions, its legislature. But one image stopped me in my tracks. It was a picture of a young woman, Bibi Aisha, whose nose and ears had been cut off by her own in-laws, as punishment after she ran away from her abusive husband. The photo shocked me: I wanted to look away from

Pollack is Director of Photography at TIME

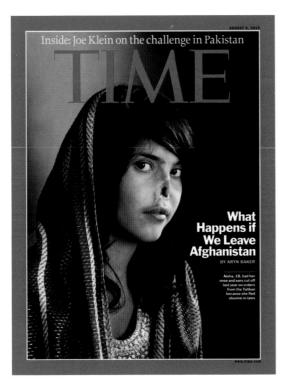

it, yet at the same I time I couldn't stop looking at it. The image conveyed, in the most disturbing visual language, the stakes involved in the ongoing debate over the future of the U.S. mission in Afghanistan.

As soon as I saw it, I knew that I wanted to publish the photo on the cover of TIME, where it would command enormous attention. But I was also aware that the gruesome nature of the image would disturb some readers. The days that followed were among the most compelling of my career, as we at TIME debated the use of the photo. The argument for publishing it on the cover was clear: we believed it would illuminate, memorably, how Afghanistan's political future might play out in the personal lives of its citizens.

But the arguments for not featuring the photo in such a prominent position were also powerful. Putting the image on the magazine's cover would amount to placing it on the kitchen counters and office desks of millions of Americans. We were very concerned about the young children who would see the image. And we worried especially about the impact of the photo's usage on Aisha herself.

To underline the thrust of TIME's cover story, the editors wrote a powerful headline to run with the picture: "What Happens if We Leave Afghanistan." The words generated almost as much debate as the photo, but after long consideration inside TIME and its parent company, Time Inc., the editors decided to run the photo and the provocative headline on the cover. As TIME managing editor Richard Stengel wrote, "Bad things do happen to people, and it is part of our job to confront and explain them."

When TIME's Aug. 9, 2010, issue hit the newsstands, it created just as powerful a response in the wider world as it had within our building. One thing I have learned about TIME: placing any image within its familiar red border lends it an iconic status. The cover photo quickly went viral on the Internet, generating a debate about our decision to publish it, as well as raising the more important debate we had sought in the first place: over the future of the U.S. intervention in Afghanistan. Newspapers, blogs and other magazines covered the decision to publish the photo itself as news. For me, it was an incredible moment, as I realized that people everywhere in the world, from Hong Kong to Kansas to Karachi, were seeing this powerful image and reacting to it in the strongest terms.

Never have I felt more forcefully the power of a single photo to move the world. And never have I felt more forcefully the power of TIME to analyze and articulate the news and to set the agenda for international debate. The photo received a number of awards, including the coveted World Press Photo Award as the year's most powerful picture. As for Aisha, she consented to the use of her photo, welcoming it as an opportunity to create a new future for the women of Afghanistan. After the photo was taken, she was brought to the U.S., where she was fitted with a prosthetic nose (see p. 149).

As Eddie Adams noted, still photographs can act as very powerful weapons indeed. This book features Bieber's photo of Aisha, as well as 99 other photographs that are among history's most influential images. Some are beautiful; some are inspiring; some will make you want to turn away, even as you can't stop looking at them. But all of them are instruments of knowledge, tools in our battle to confront, understand and change the world we live in. ∎

Trap for Facts, Tool for Progress

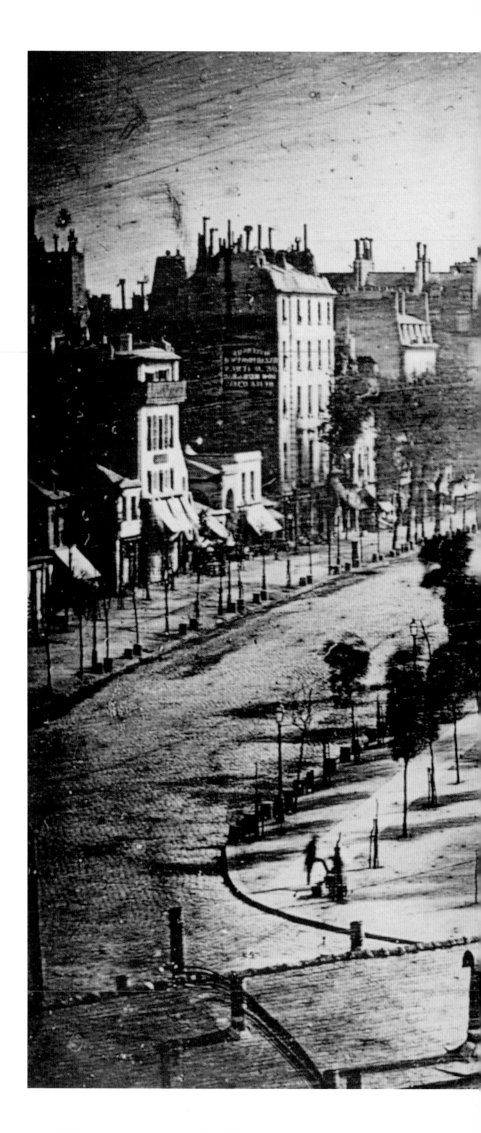

THIS BOOK PRESENTS A GALLERY OF 100 OF the most influential photographs in history: those that have moved people and nations, recorded achievements and tragedies, opened our eyes to previously unseen aspects of nature. The volume is arranged in roughly chronological order, so along the way, it documents the medium's evolution, as the novelty of a few 19th century amateur tinkerers evolved into photography, and the camera became a potent new force for observing and changing the world.

Three names dominate the early era of photography: France's Joseph Nicéphore Niépce and Louis-Jacques-Mandé Daguerre and Britain's William Henry Fox Talbot. Niépce, a retired army officer and amateur inventor, made a permanent record of a visual scene by using the camera obscura, a pinhole device long known to students of optics, to focus and then preserve an image on a pewter plate coated with a light-sensitive chemical solution. Niépce's partner in optical exploration was Daguerre, a Paris stage designer and entrepreneur. He turned their first, halting experiments with recorded images into the earliest form of photography to achieve wide recognition by the public, the daguerreotype. These photos were small, affordable portraits created on silver-plated copper sheets, and they caused a sensation in Europe and the U.S. after their introduction in 1839.

Daguerreotypes required long exposure times, forcing subjects to maintain a stiff pose for several minutes, neither blinking nor smiling. And they could not be duplicated: each of them was unique, one-of-a-kind. It was Fox Talbot who solved this problem with the photographs he called calotypes, Greek for "beautiful pictures." His calotypes recorded reality as a negative image on paper, from which multiple positive copies could be printed. This technique, increasingly refined, would help photography become a mass medium.

Landmark image *Daguerre's photograph of the Boulevard du Temple in Paris, taken in 1838, is the first to show human beings. A pedestrian at lower left is getting his shoes shined, thus remaining stationary long enough for his image to register on a plate covered with light-sensitive chemicals*

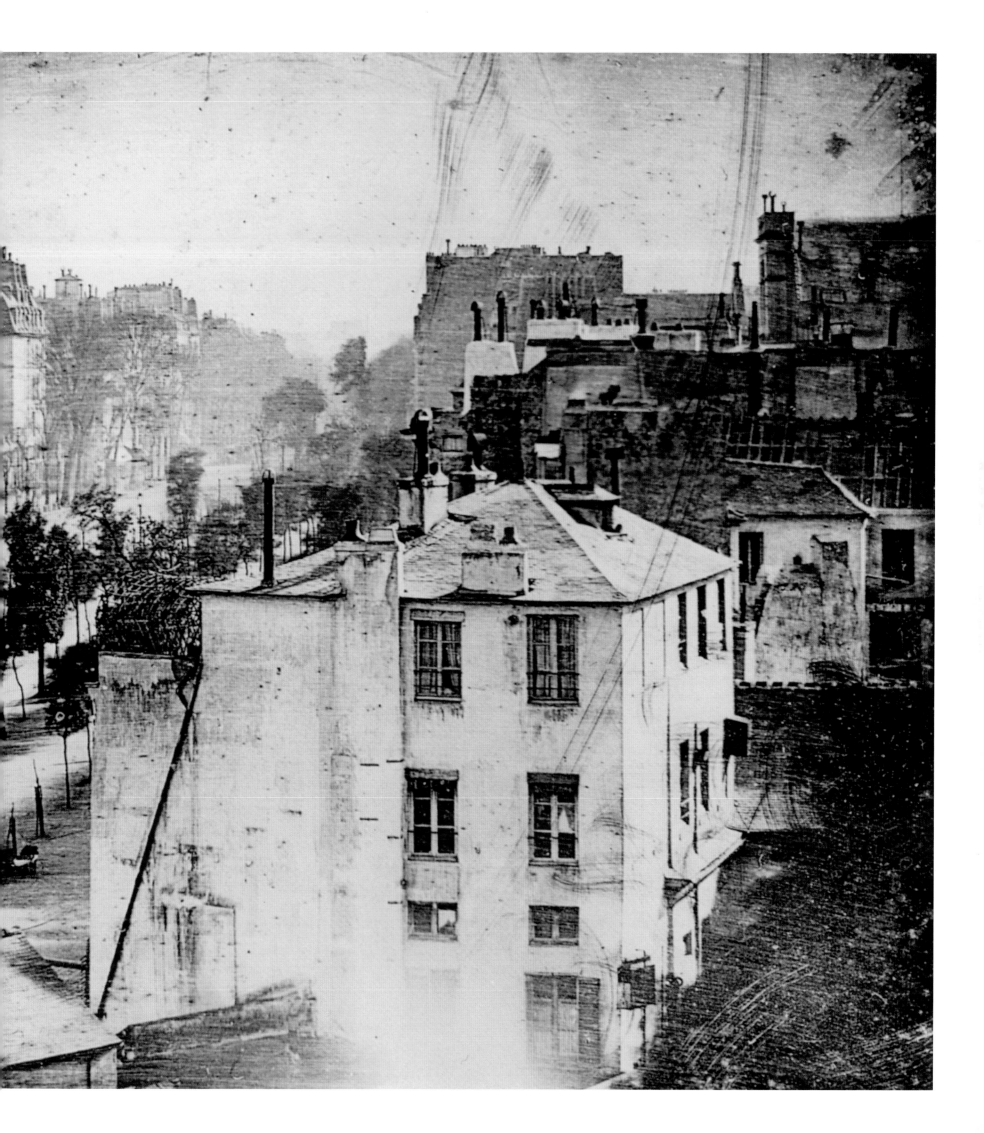

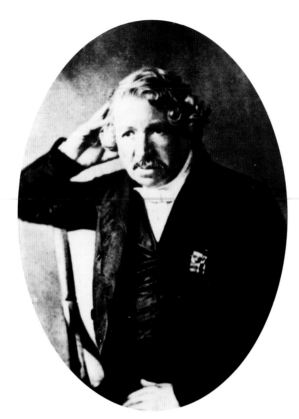

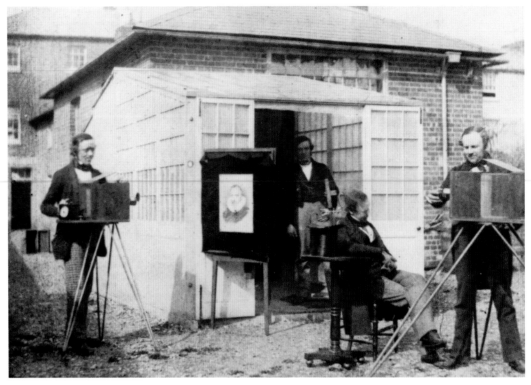

Calotypes and daguerreotypes, with their long exposure times, were tame, domesticated creatures of the parlor and the studio. But in the 1850s Fox Talbot's paper negatives were replaced by a glass plate coated with emulsion and inserted into a heavy box camera. The process was cumbersome, for the images on the glass had to be developed immediately, but it made photography more mobile.

British photographer Roger Fenton took his box cameras to the Crimean Peninsula to record Britain's war with Russia in the 1850s. While long exposure times kept him from recording action scenes, he documented the war's camp life and battlefields, creating for posterity an invaluable visual record of the conflict.

In the next decade, American photographer Mathew Brady commissioned a corps of photographers to record images of the Civil War, fitting them out with traveling, horse-drawn darkrooms in which the photographs were developed; Union soldiers called the conveyances "whatizzit wagons." Yet printing press technology lagged behind the surging advances in photography: newspapers and magazines could not yet render the gray

areas in black-and-white photos, so publishers employed artists to make line drawings based on the pictures.

The halftone process, perfected by U.S. and German inventors in the 1880s, at last allowed black-and-white photos to be printed, leading to an explosive growth in news pictures and the publications that featured them. In the 1890s, the advent of flash-lighted photography allowed the recording of scenes indoors and at night, overcoming yet another barrier to the camera's eye.

As the 19th century came to an end, technical advancements made cameras smaller and more affordable. With the introduction of his iconic $1 Brownie device in 1900, photography pioneer George Eastman put cameras in the hands of the masses, although the development process was still cumbersome: amateur "shutterbugs" mailed their film to Eastman's factory, where it was developed and mailed back to the photographer.

In the 1890s, the development of flexible film that could be ratcheted past a lens at high speed, breaking down actions into a sequence of images, helped create a powerful new kind of photography, motion pictures. In the U.S., Thomas Edison and his employee William Dickson were pioneers in this area, but their Kineto-

Developing photography *At far left is an image of the inventor of the first widely used form of photography, Daguerre; yes, he is seen in a daguerreotype.*

Above, Fox Talbot, shown on the right operating a box camera, works with his assistants to create calotypes at Lacock Abbey, his estate in England

War correspondent *Above, Brady, seated on left, and an assistant make camp outside their horse-drawn darkroom during the American Civil War. Brady employed a cadre of traveling photographers to cover the war's various theaters of combat, creating a visual record of its people, events and locations*

scope process thought small: viewers watched compact filmstrip images privately, in a one-person viewing kiosk that was essentially an arcade novelty. It was France's Lumière brothers who took motion pictures out of the box, using a bright electric bulb to project moving images on a blank wall, creating a larger-than-life experience that was also communal and charging the "movies" with the emotional power previously reserved to live theater.

The social uses of photography advanced in tandem with the technical developments inside the camera, as progressive reformers began employing photos to document society's ailments. American activists Jacob Riis and Lewis W. Hine created compelling pictures of poverty and discrimination that raised awareness and led to progressive new laws. In the fine phrase of TIME critic Richard Lacayo, the camera had first been conceived as a mere "trap for facts." Now it became a tool to drive social protest and progress.

Photojournalism blossomed in the first decades of the 20th century. Picture-driven magazines were first created in Germany; in the U.S., publisher Henry Luce unveiled a magazine devoted to photojournalism, LIFE, in 1936.

At the same time, the introduction of small, light 35-mm cameras allowed photographers to record events more nimbly and capture more intimate situations. Color film was introduced, recording reality more truthfully, if less dramatically, for the austerity and unreality of black-and-white images lent them a heroic grandeur.

At the turn of the 21st century, the technology of photography took another large step forward, with the development of digital cameras: farewell, film and darkroom. At the same time, advances in Internet communications allowed photos to be seen around the world only seconds after they were taken. Yet however quickly the mechanics of photography advance, the best photojournalism still works its magic in the slow lane, as the memorable photos in this book prove: it is the time we spend scrutinizing these still images, absorbing their messages, that matters.

The Greek scientist Archimedes once declared that with a lever long enough and a purchase strong enough, he could move the world. He had the right idea but the wrong tool: it is a lens, not a lever, that created the pictures in this book, 100 images that changed the world. ∎

—*The Editors*

History's Greatest Images

1826-2011

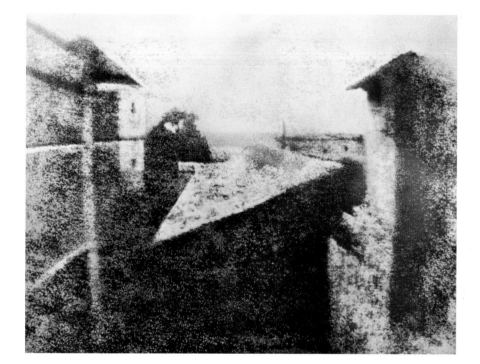

1

Written by Light
View from a Window • Joseph Nicéphore Niépce • 1826

Behold the first true photograph ever taken. The man who created it was a well-to-do retired French army officer and government bureaucrat with time on his hands and dreams of photography—literally, writing with light—in his head. Joseph Nicéphore Niépce, an accomplished inventor, suspected that images of reality could be captured on a flat surface spread with chemicals that reacted to light; he succeeded in making this impression of the view outside his window with a pinhole camera, or camera obscura, on a pewter plate covered with a solution of bitumen. It took some eight hours for the image to register.

In 1839 Niépce's former partner, Louis-Jacques-Mandé Daguerre, perfected the daguerreotype process, which produced a single positive image on a copper plate covered with a silver solution. The new technology swept the world much as the radio, television and computer would later do; the urge to have one's portrait captured for posterity created a frenzy the French christened *Daguerreotypemanie.*

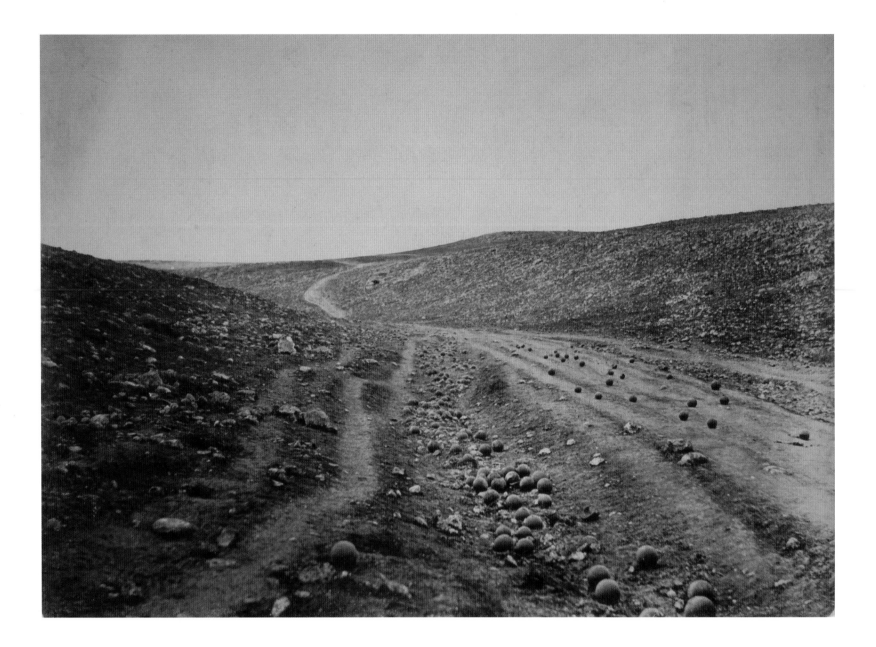

2

The Camera as Reporter
Valley of the Shadow of Death • Roger Fenton • April 23, 1855

As a British army sat stranded on Russia's Crimean Peninsula in the 1850s, Briton Roger Fenton, who had studied to be a painter after graduating from college, became one of history's first photojournalists. Funded in part by the royal family, the former lawyer took his cameras to the front to help sway public opinion in favor the war. To that purpose, Fenton generally recorded British troops looking composed, capable and in charge of the situation, as in the photo of a group of convivial troopers gathering with French allies at an encampment at right. But the image above, taken near the site where a British cavalry division was annihilated in the head-on assault celebrated in the patriotic poem *The Charge of the Light Brigade,* is charged with menace.

Some critics suspect that Fenton added to the number of cannonballs in order to increase the photo's impact. True or not, the long exposure times his cameras required meant he could only record war's aftermath, the shadow of death but not the killing.

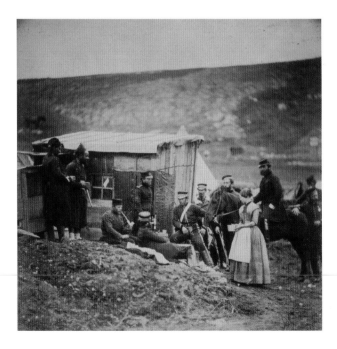

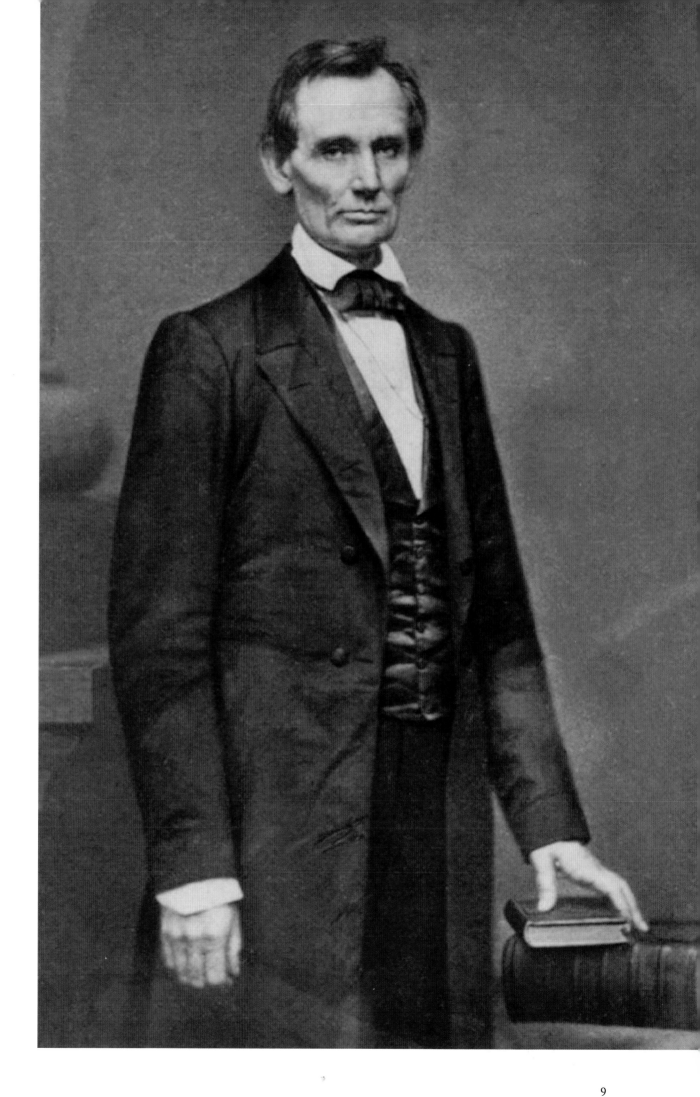

3

Seeing Is Believing

Abraham Lincoln
Mathew Brady • Feb. 27, 1860

Why is a simple portrait of a politician an influential image? When Abraham Lincoln walked into the New York City studio of the noted portrait photographer Mathew Brady in early 1860, the Illinois politician had a perception problem. Lincoln's goal was the presidency, and his powerful "House Divided" speech and his debates with Stephen A. Douglas in 1858 had made him a rising star in the new Republican Party—but few on the East Coast had seen the eloquent speaker in the flesh, and his political foes painted him as a rawboned, ill-clad, backwoods rube. Brady's portrait refuted those charges, and it was widely distributed by Lincoln's allies.

The night the photo was taken, Lincoln delivered a powerful speech at Cooper Union in Manhattan in which he claimed that "right makes might" in the battle to end slavery. Together, the memorable speech and Brady's photo helped Lincoln win his party's nomination. As for Brady, the portrait photographer went on to document for posterity the great conflict that ensued after Lincoln's election as President.

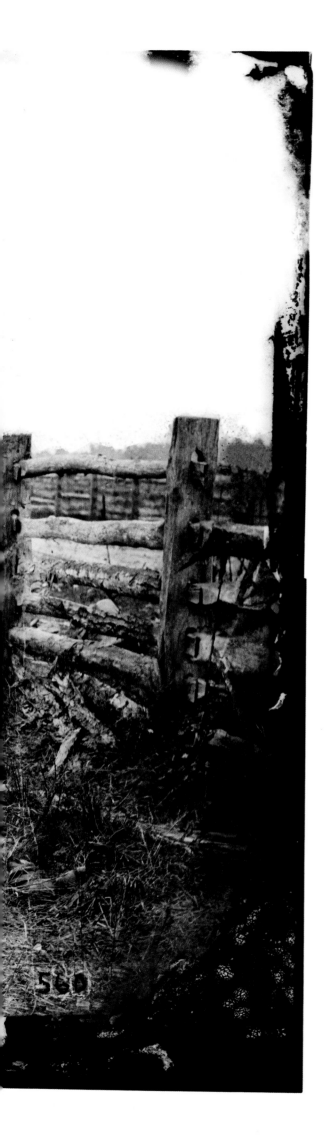

4

An Unflinching Eye
Confederate Dead at Hagerstown Road
Alexander Gardner • Sept. 19, 1862

"I had to go," photographer Mathew Brady declared of his decision to mount an enormous effort to capture the Civil War on film. "A spirit in my feet said 'Go,' and I went." Brady was America's best-known portrait photographer before the war, so popular that he operated studios in both New York City and Washington. His photos of the First Battle of Bull Run were lost amid the hasty "great skedaddle" back to Washington that followed the Union's rout. But his close encounter with battle and the gravity of the forces at play led the photographer, then nearing 40, to organize and fund Brady's Photographic Corps, a cadre of cameramen outfitted with wagons that served as darkrooms. Traveling with the Union armies, Brady's men compiled a massive, eye-opening archive that showed war for the first time in all its monotony, misery and muck, stripped of its patriotic, sentimental façade.

Only a month after the battle, the deadliest single day of the war, Brady presented in Manhattan "The Dead at Antietam," a show of the images taken by Corps member Alexander Gardner two days after the struggle. The rebels, pitifully sprawled in death, were a blunt reproof to the pieties of the Victorian era. Said the New York *Times* of the exhibit: "The living that throng Broadway care little perhaps for the Dead at Antietam, but we fancy they would jostle less carelessly down the great thoroughfare, saunter less at their ease, were a few dripping bodies, fresh from the field, laid on the pavement ... Mr. Brady has done something to bring home to us that terrible reality and earnestness of war. If he has not brought bodies and laid them in our dooryards and along the streets, he has done something very like it."

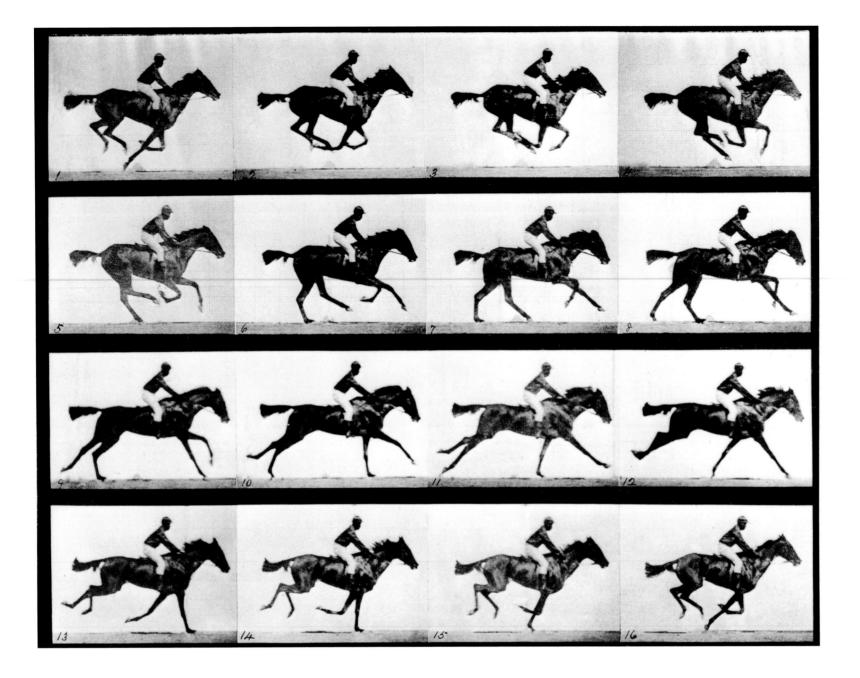

5

Time, Subdivided
Sallie Gardner at a Gallop
Eadweard Muybridge • June 19, 1878

The camera masters time, preserving history in its flight. British-born photography pioneer Eadweard Muybridge found a scientific application for this commonplace observation when he accepted a challenge from railway tycoon Leland Stanford to determine if all four hooves of a horse are off the ground at the same time during a gallop. Rigging up 24 cameras that were tripped in sequence as the racehorse Sallie Gardner ran past them on a track, Muybridge proved that the horse was at times fully airborne. His photo sequences led him to design an early form of motion picture technology, the Zoopraxiscope.

Soon, flexible film that could be ratcheted by sprockets past the camera lens allowed photographers to achieve the same results as Muybridge by moving the film inside a single camera at high speed rather than by setting up a battery of cameras: Enter the movies.

6

Exposing an Unseen World
X-Ray Image of a Hand
Wilhelm Conrad Röntgen • Jan. 23, 1896

Advancing rapidly as technology improved, photography took a fascinating and unexpected detour into the world of science and medicine late in 1895, when German physicist and electronics pioneer Wilhelm Conrad Röntgen produced a new kind of electromagnetic radiation he christened X rays. Passing these rays, generated by a cathode tube, across a cardboard screen painted with a barium salt allowed the scientist to capture images of the bones inside the human body. The photograph at right shows the hand (and wedding ring) of Röntgen's wife; it is the first X-ray picture ever taken. When she was first shown the image, Anna Röntgen declared: "I have seen my death!"

Röntgen was an idealist who refused to take out patents on his work, hoping his discoveries would benefit all peoples, and he refused to name the new form of radiation after himself, although in some nations X rays are still termed "Röntgen rays." The physicist was awarded the first Nobel Prize in Physics, in 1901. His pioneering work with X-ray photographs opened the way for an entire new use of cameras and photography: as tools of medicine that could be used to illuminate the workings of the human body and to diagnose illnesses without the need to perform surgery.

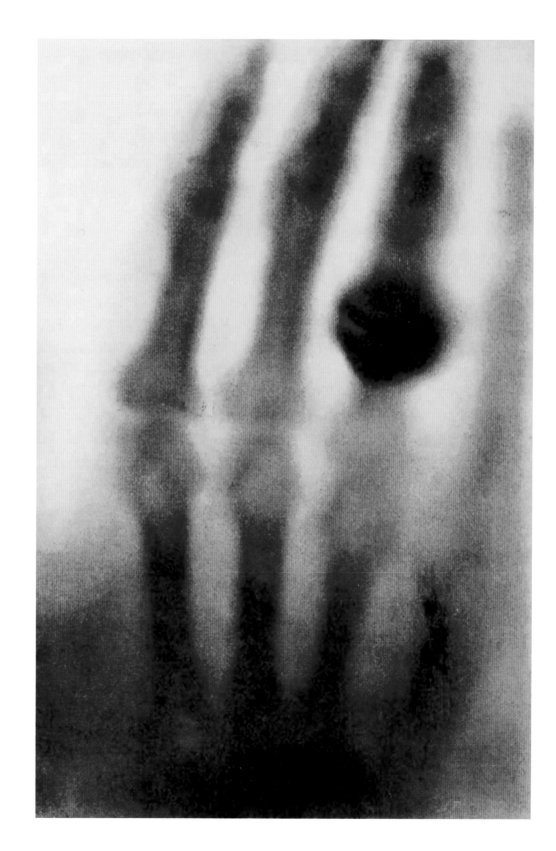

7

Camera with A Cause

Bandit's Roost
Jacob Riis • 1888

After immigrating to the U.S. from Denmark in 1870 at 21, Jacob Riis lived the life he later photographed. Suffering poverty and homelessness in the crowded slums of New York City, he raided trash bins for food. After rising to become a successful journalist, he fought social ills by exposing them with his camera. Like Mathew Brady, he enlisted other photographers in his cause, and, like Brady, he took credit for their work.

Riis' groundbreaking book, *How the Other Half Lives* (1890), documented scenes never put on film before, such as the crime-ridden Five Points slum in Manhattan. Riis titled this image of "Bottle Alley" off Mulberry Street *Bandit's Roost*.

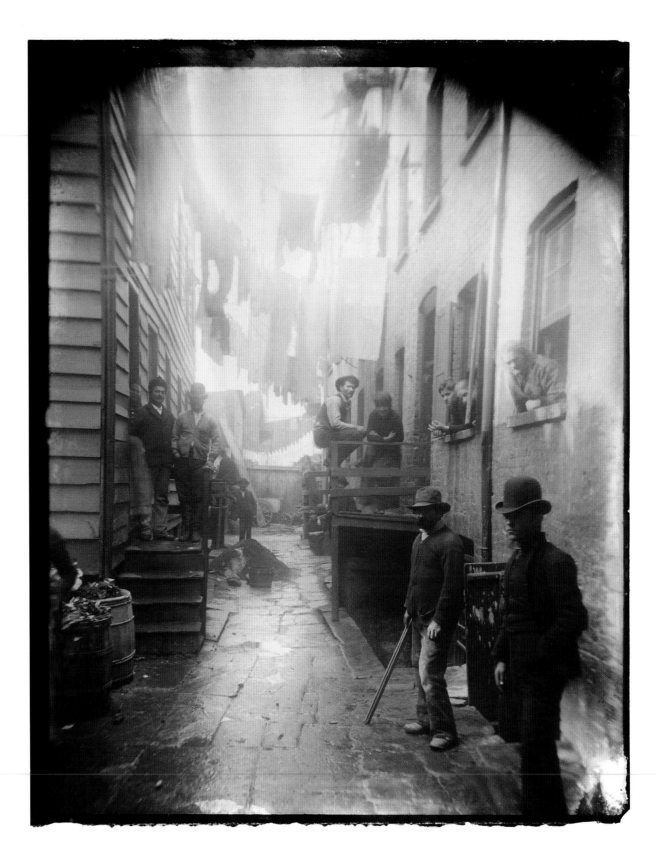

GALLERY

Jacob Riis

In the last decades of the 19th century, a band of progressive reformers fought to turn Americans' gaze on the wide gap between rich and poor. Crusading journalists like Lincoln Steffens and Ida Tarbell, adopting as a badge of honor the "muckraker" label that was hung on them, illuminated the woes of the poor in words. Jacob Riis, himself a survivor of life on the streets, was the first to enlist a camera in the progressive crusade. "There had been earlier efforts to photograph the conditions of the poor," observed TIME critic Richard Lacayo, "but none so stark or so widely seen. Riis' unflinching pictures of tenement life mark a turning point between the Victorian idea that poverty was an evil to be condemned and the reformer's conviction that it was a condition to be remedied."

For Riis, illumination was more than a metaphor: he was a pioneer of flash-lit photography, a delicate process in which the newly invented magnesium flash powder was poured into an open pan and then ignited with a flaming whoosh. "Twice I set fire to the house with my apparatus," Riis later wrote, "and once to myself."

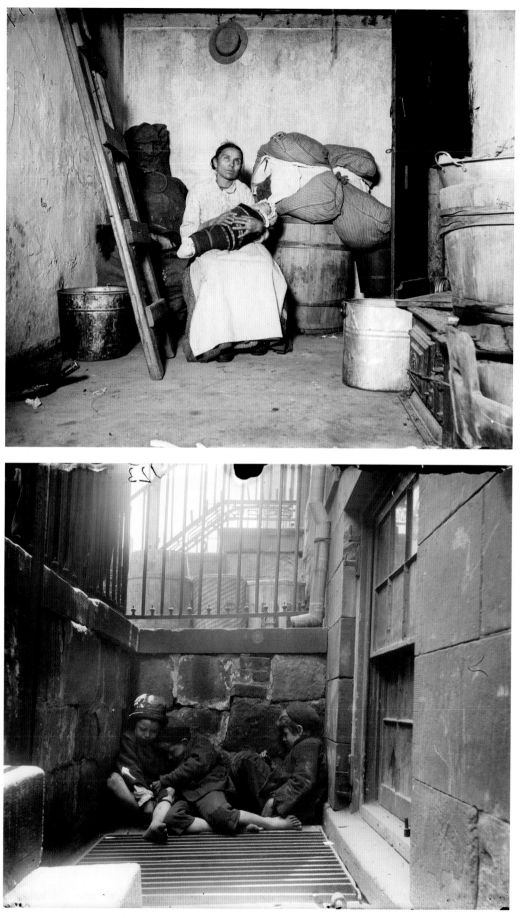

The other half *Riis poses for a portrait at top left, circa 1890. In the early 1900s, President Theodore Roosevelt described him as "the most useful citizen of New York [City]." At top are an Italian-American ragpicker and child, around 1890. At bottom, young boys, called "street Arabs," huddle over a warm grate, also circa 1890*

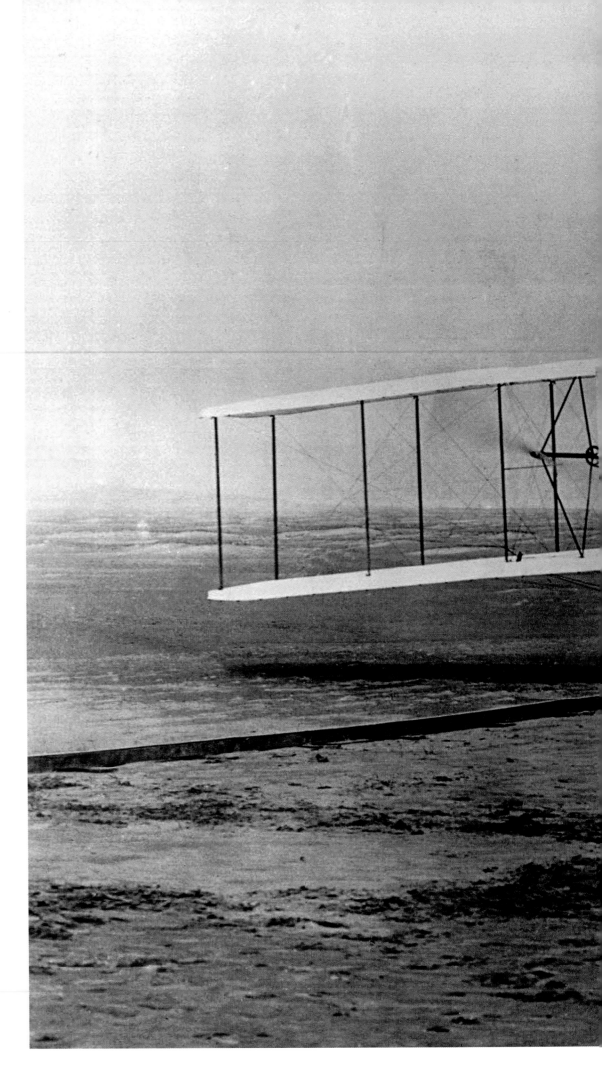

8

Prepare for Takeoff
First Flight of Wright Flyer 1
John T. Daniels • Dec. 17, 1903

What a moment! A local man, John T. Daniels, captured the first successful flight of a heavier-than-air craft in 1903, when the long years of experimentation by Orville and Wilbur Wright, inventive brothers from Ohio, reached fruition. That's Orville, lying prone, at the controls of the brothers' *Flyer 1,* with Wilbur near the right wing. The rudimentary airplane, whose engine produced 12 horsepower and weighed 152 lbs., stayed airborne for 12 seconds and traveled 120 ft. (37 m)—shorter than the length of a Boeing 747—before Orville managed to land the craft safely at Kitty Hawk, N.C.

Writing in TIME about this historic first flight, another pioneer, Bill Gates, noted that *Flyer 1* was the culmination of a long series of inventions by the Wrights. "When standard aeronautical data proved unreliable, they built their own wind tunnel to measure empirically how to lift a flying machine into the sky," Gates noted. "They were the first to discover that a long, narrow wing shape was the ideal architecture of flight. They figured out how to move the vehicle freely, not across land, but up and down on a cushion of air. They built a forward elevator to control the pitch of their craft and fashioned a pair of twin rudders in back to control its tendency to yaw from side to side. They devised a pulley system that warped the shape of the wings in midflight to turn the plane and to stop it from rolling laterally in the air. When they discovered that a lightweight gas-powered engine did not exist, they decided to design and build their own."

This image documents a milestone in technology, but the brothers kept this evidence of their success under wraps, fearing that competitors might steal their secrets, and only in retrospect has the picture become well known for recording one of history's authentic milestones.

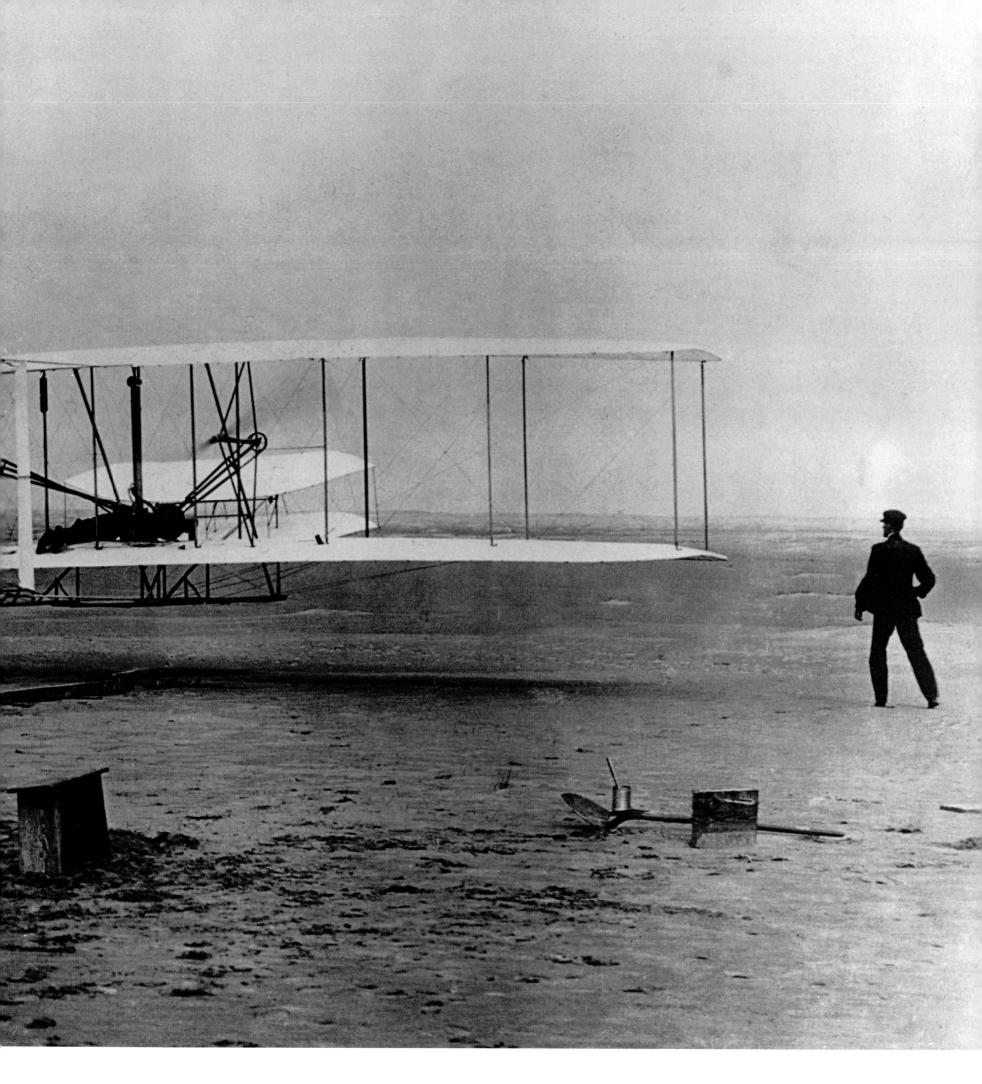

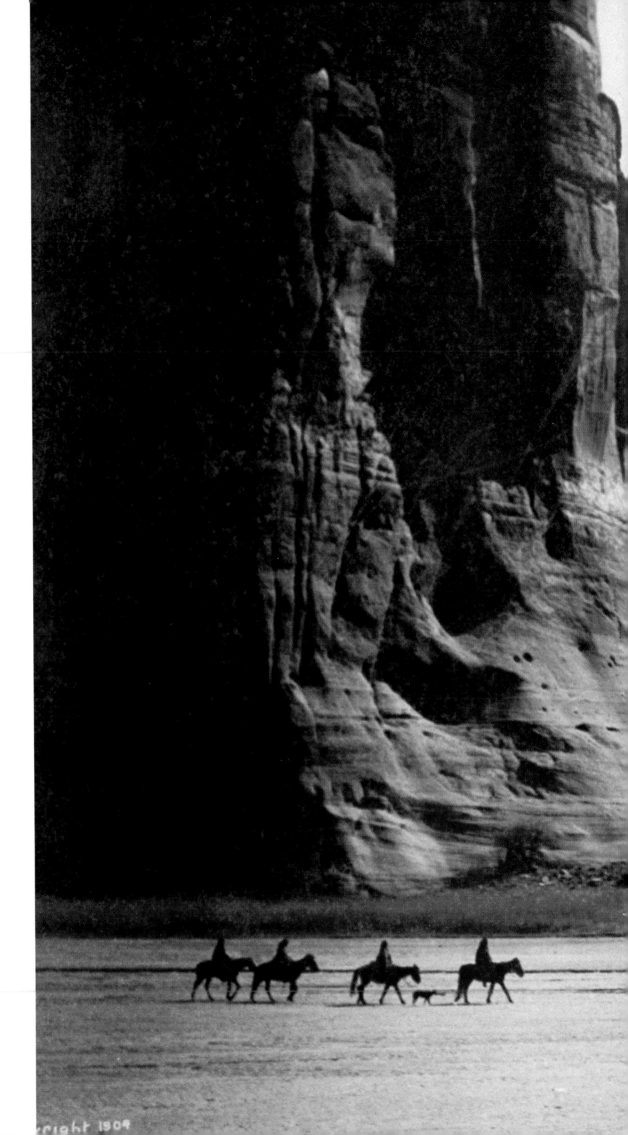

9

Twilight's Last Gleaming
Canyon de Chelly
Edward S. Curtis • 1904

Born in Wisconsin in 1868 and raised in
Minnesota, photographer Edward S. Curtis
grew up on America's Western frontier.
Fascinated by photography from his youth, he
opened a studio in Seattle, then was chosen to
document railroad tycoon Edward Harriman's
1899 expedition to explore Alaska, then largely
unknown. Curtis next appealed to financier J.P.
Morgan, who bankrolled his dreams, awarding
him a $75,000 commission to document Native
American life, then in rapid decline across the
West, in a lavish, 20-volume series of books.

Curtis was thrilled to have won the chance to
document what he called "one of the great races
of mankind," and he spent decades not only
photographing Indians but also recording their
songs and speech on wax cylinders and taking
copious notes and films of their activities. The
result is an extensive archive of Indian life and
society. His photos have been criticized for
perpetuating the image of Indians as "noble
savages," and critics have shown that he stage-
managed some of his images to conceal modern
objects. Yet despite the criticisms, few dispute
the value of Curtis' work in documenting the
vanishing details of Native American life.

There is no stage-managing involved in one
of Curtis' most famous images, which shows a
group of Navajo Indians passing through the
historic Canyon de Chelly in Arizona. The
subject of the photo is not so much the riders
as it is the Western landscape itself, whose vast
size and age seem to reduce human life to a
fleeting, insignificant passage through a
magnificent but indifferent world.

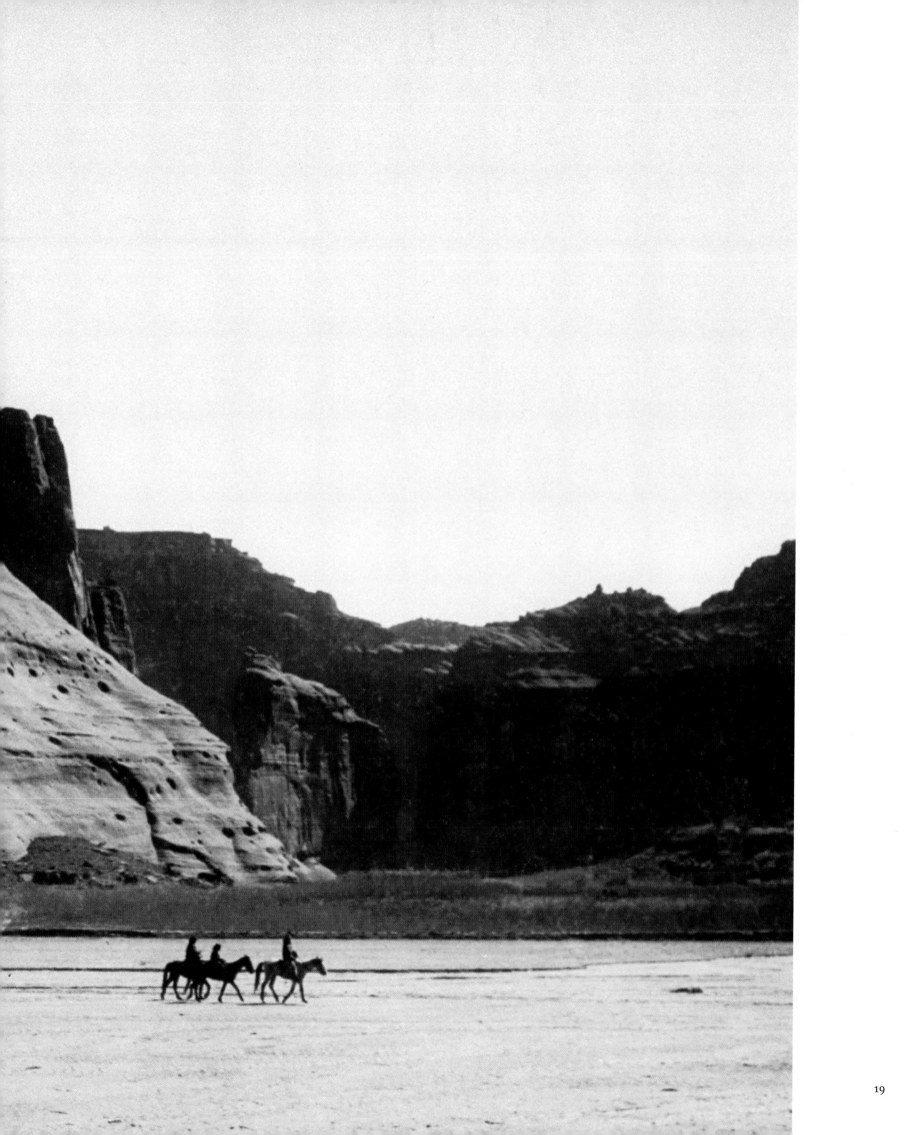

10

When the Earth Moved

Looking Down Sacramento Street
Arnold Genthe • April 18, 1906

When a devastating earthquake struck San Francisco in 1906, photographer Arnold Genthe's studio and equipment were destroyed. But Genthe had a job to do: documenting one of the greatest natural disasters in U.S. history. In the hours after the quake struck, as Genthe later recalled in his autobiography, "I went to Montgomery Street to the shop of George Kahn, my dealer, and asked him to lend me a camera. 'Take anything you want,' Kahn told me. 'This place is going to burn up anyway.'"

Genthe roamed the city with a small handheld Kodak Special during the excruciating hours after the quake when fires consumed many of San Francisco's buildings and neighborhoods. The photo at right is perhaps his most memorable, shot looking down at the flames as they climb Nob Hill along Sacramento Street. Fatalism gripped the survivors, Genthe reported, "The occupants are sitting on chairs calmly watching the approach of the fire. Groups of people are standing in the street, motionless, gazing at the clouds of smoke. When the fire crept up close, they would just move up a block."

Genthe documented the calamity, but he couldn't record the number of lives it claimed. Civic boosters quickly fabricated a bogus number—478 dead—to conceal the extent of the damage. Not until 2005 did the city officially admit the truth for the first time: the death toll likely surpassed 3,000. But even that figure is only an estimate.

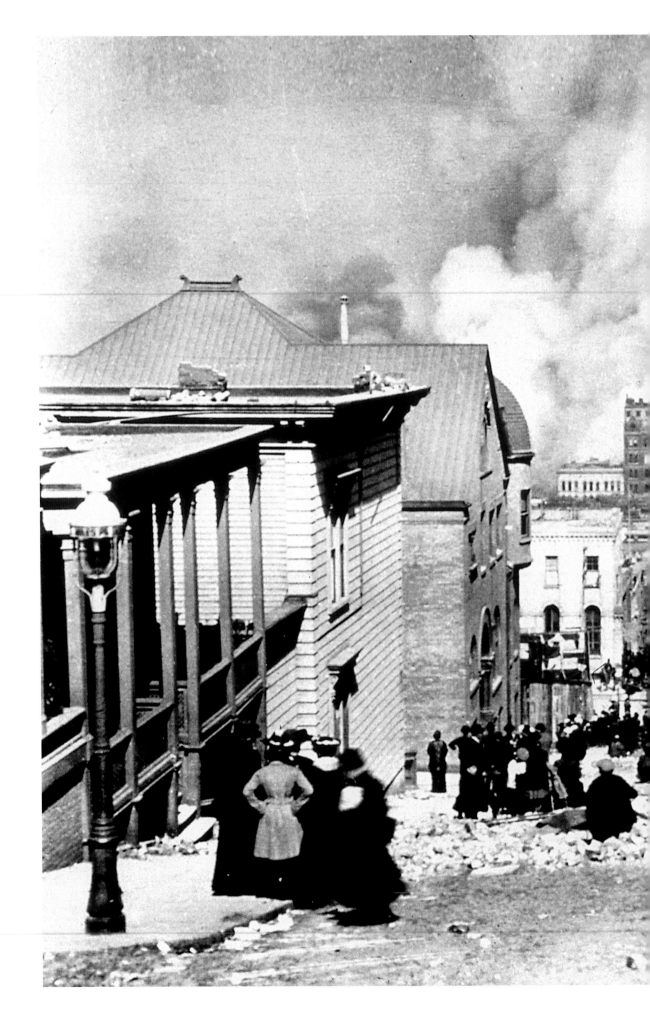

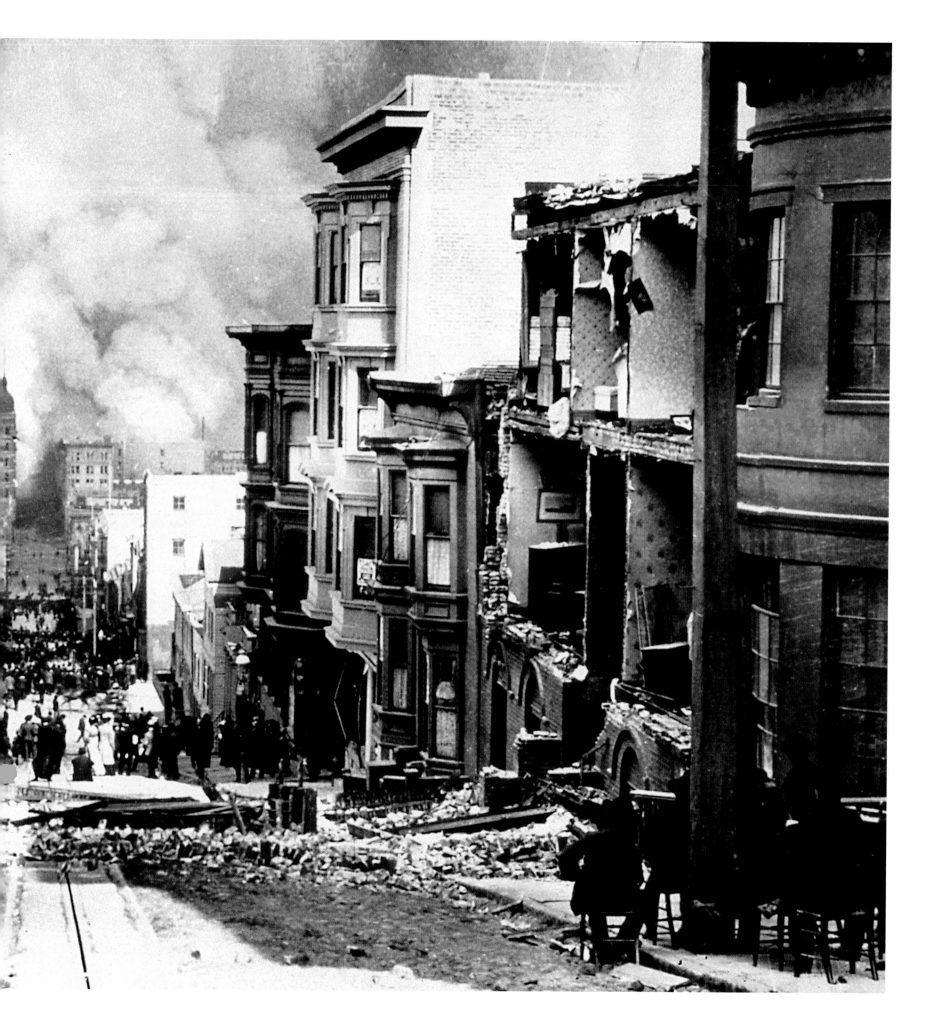

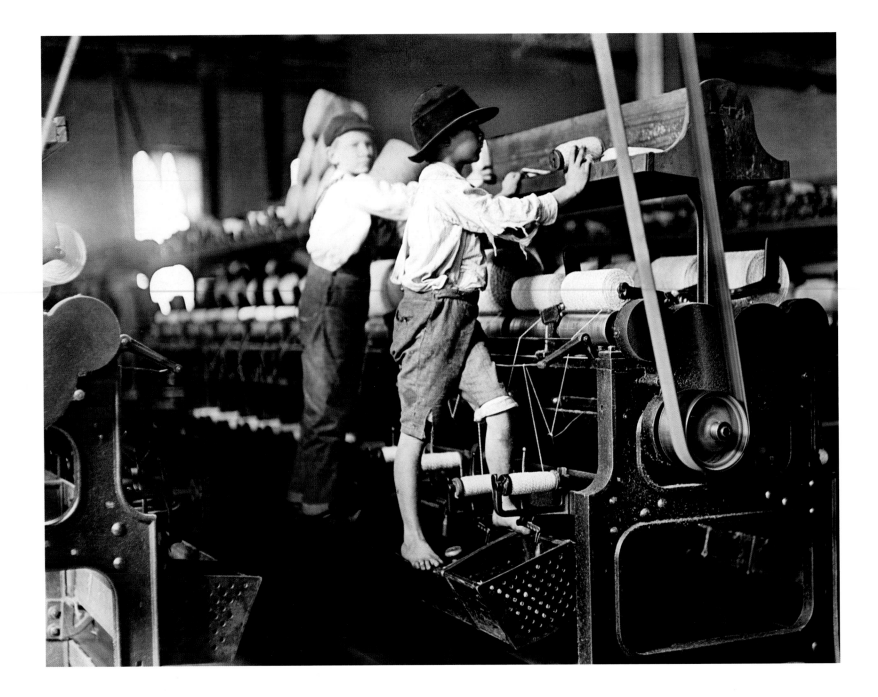

11

Crusader Behind the Lens

Children of the Loom • Lewis W. Hine • Jan. 19, 1909

Wisconsin-born Lewis W. Hine studied sociology, then taught school before taking up photography to document the widespread labor abuses in U.S. society. "If I could tell the story in words," he declared, "I wouldn't need to lug around a camera." Beginning in 1908, working for the National Child Labor Committee, Hine traveled the U.S. to capture indelible images of children as young as 6 who were toiling in the nation's factories and streets, often sneaking his camera into their workplaces to avoid detection by ruthless owners.

The photo above was shot at the Bibb Mill No. 1 in Macon, Ga., a textile factory. Hine's notes for it read, "Many youngsters here. Some boys were so small they had to climb up on the spinning frame to mend the broken threads and put back the empty bobbins."

GALLERY

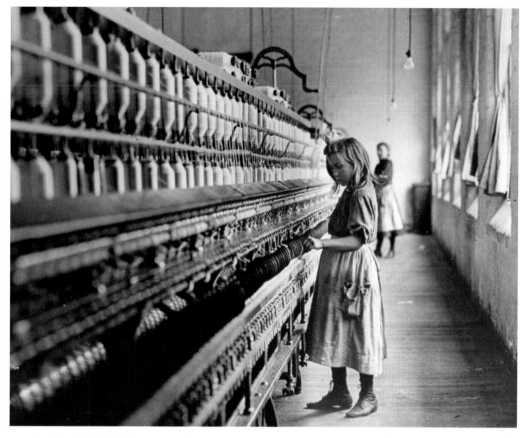

Lewis W. Hine

Like a slightly earlier student of society's ills, Jacob Riis, Lewis Hine experienced the life he later indelibly captured through his lens. Born in Oshkosh, Wis., in 1874, the son of a coffee vendor who died in an accident when Hine was young, he began working as a teen. "After grammar school in Wisconsin's 'Sawdust City,'" he recalled, "my education was transferred to the manual side of factory, store and bank. Here I lived behind the scenes in the life of the worker." He found his first great subject at New York City's Ellis Island, where for five years (1904-9) he photographed immigrants just arriving in the U.S. The results, said TIME critic Richard Lacayo, "rank among the greatest camera portraits ever taken."

Hine's next project, exposing the lives of child workers, took him across America to, in his words, "show the things that had to be corrected." A later commission gave him a chance to celebrate labor, as he took a series of "work portraits" of those building the Empire State Building in Manhattan. In his final years, the great visual historian documented the work of the Red Cross, the Tennessee Valley Authority and the New Deal's Works Progress Administration.

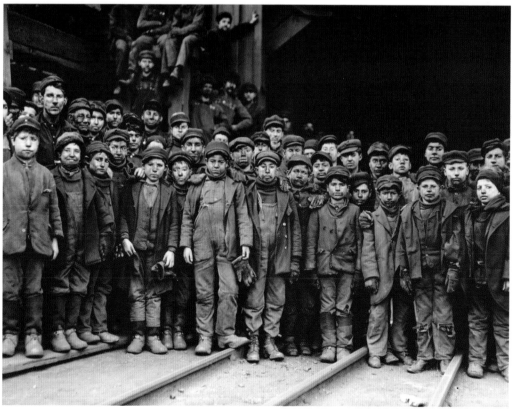

A hard-knock life *At top, Sadie Pfeifer works in a textile mill in Lancaster, S.C., in 1908. Hine reported that she was 48 in. (122 cm) tall, and that many other young children worked in the factory. Above, "breaker boys," who broke up rock and sorted pieces of coal from those of slate, pose for Hine at a mine in S. Pittston, Pa., in 1911*

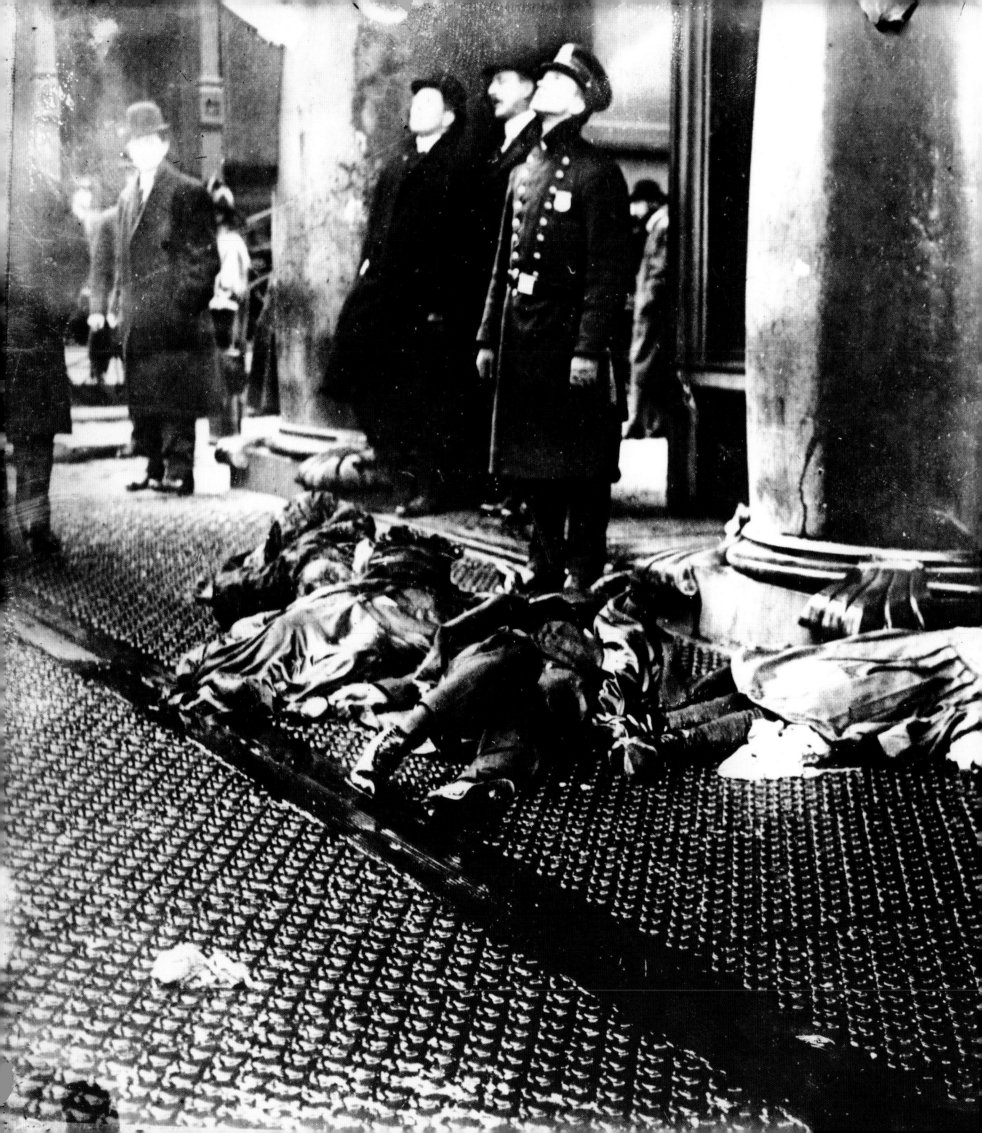

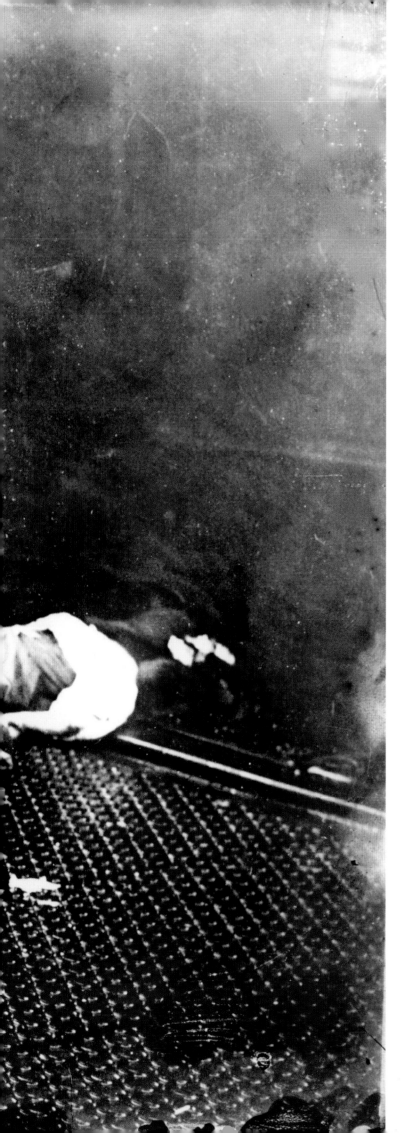

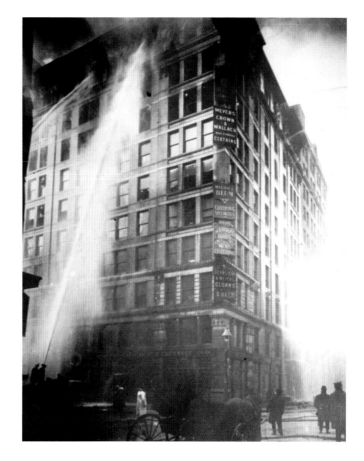

12

A Towering Tragedy Prompts Reform
The Triangle Shirtwaist Factory Fire
Brown Brothers Photographer • March 25, 1911

Early in 1911, a fire broke out at the Triangle Shirtwaist factory, a garment sweatshop near Manhattan's Washington Square Park where hundreds of young women worked nine hours each day and seven more on Saturdays, sewing ladies' blouses, called shirtwaists. Fueled by hundreds of pounds of highly flammable cotton and paper scraps, the blaze ripped through the 10-story building's top three floors; many workers, trapped inside by locked doors that violated safety codes, were unable to escape. A flimsy exterior fire escape collapsed, while fire department ladders were too short to reach the blaze, and fire hoses, above, were unable to quench it.

Scores of workers leaped to their death as police and a large crowd watched in horror; in all, 146 people, including 129 women, were killed. A United Press reporter wrote that he had learned "a new sound—a more horrible sound than description can picture. It was the thud of a speeding, living body on a stone sidewalk." The deadly disaster—and grim photos like the one at left, among the most graphic images yet published in contemporary newspapers—spawned strong new workplace safety legislation and helped labor unions gain new members and more power.

13

A Line of Wounded Warriors
British Gas Casualties • T.L. Aitken • April 10, 1918

In World War I many governments exercised tight censorship over the photographs they allowed to be published. As a result, many of the most compelling images of the sprawling, brutal conflict, in which some 8.5 million young men died, were not seen until after the war ended.

The war spawned revolutions, toppled empires and introduced potent new weapons, including poison gas. One of the best-known pictures of the conflict captures stricken gas victims; taken by T.L. Aitken, a British lieutenant, it shows soldiers of the 55th (West Lancashire) Division during the Battle of Estaires in France in 1918. Their eyes smarting from tear gas, the men gather in single file, awaiting medical treatment. This image speaks strongly to the condition of all the war's foot soldiers: blindly lining up to follow the orders of superior officers, they marched gallantly to meet whatever fate awaited them.

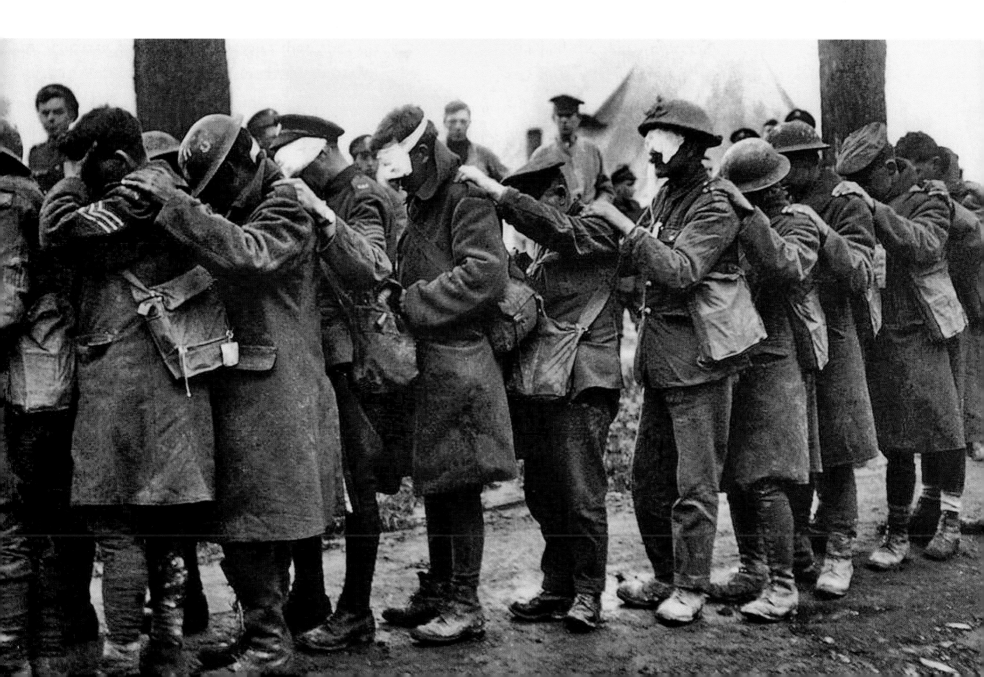

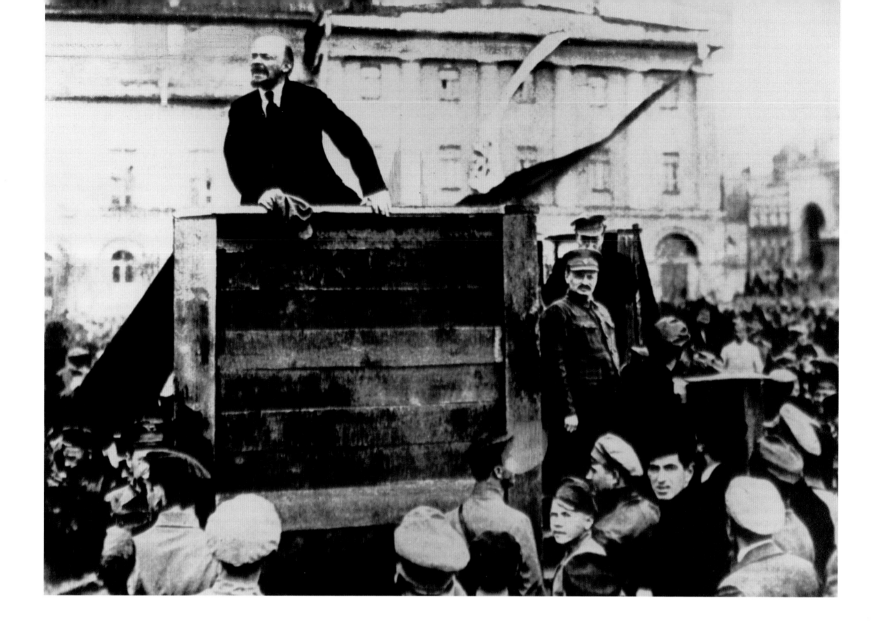

14

Recording a Revolution
V.I. Lenin Speaks in Moscow
Photographer unknown • May 5, 1920

Only a few photos survive from the early years of the Soviet
Union; perhaps our strongest mental images of the 1917 Russian
Revolution are drawn not from photos but from director Sergei
Eisenstein's powerful propaganda film *October* (1927). But the
picture above captures the intensity of the historic first years
of the new state. It shows V.I. Lenin, the Marxist revolutionary
and founder of the U.S.S.R., speaking with urgency to a crowd
in Moscow's Sverdlov Square.

The photo also documents something else: the close bond
between Lenin and his associate, Leon Trotsky, seen standing at
the right of the lectern in military garb. Following Lenin's death
in 1924, Trotsky and Joseph Stalin vied to control the Commu-
nist Party. When Stalin won that battle, Trotsky was exiled from
Russia—and was retouched out of the photo, as if he had never
existed, right. In Stalin's Soviet Union, photos were tools of disin-
formation, and citizens could no longer believe their eyes.

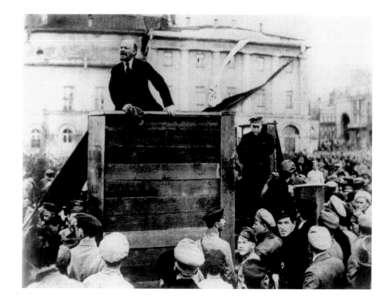

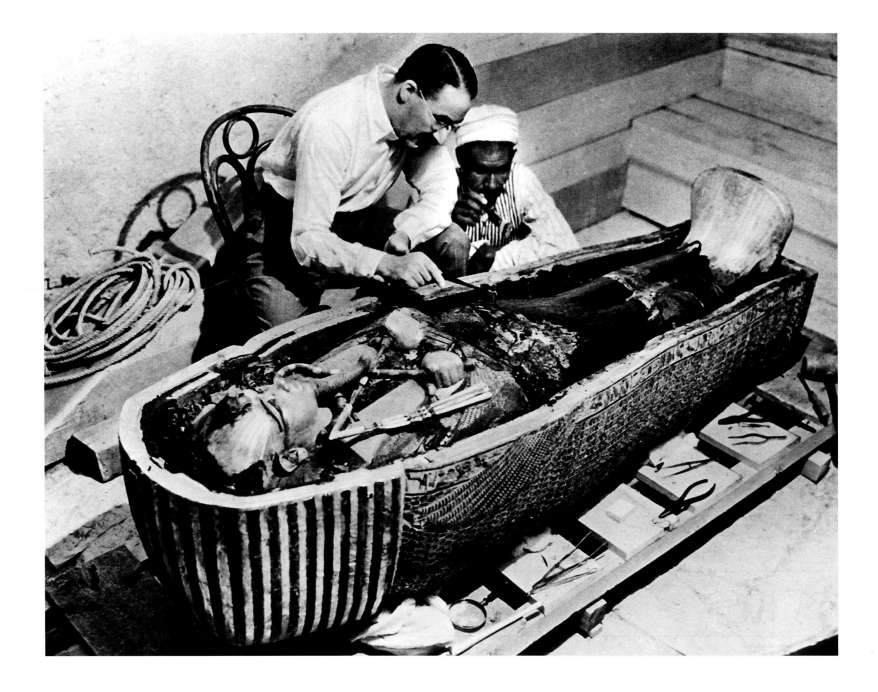

15

An Encounter with the Ancients
Examining the Innermost Coffin • Harry Burton • October, 1925

Trained in art photography in Italy, American Harry Burton (1879-1940) documented one of the most significant events in the history of archaeology, the exploration of the tomb of Egypt's "King Tut" after it was found, largely intact, by a team led by British archaeologist Howard Carter in 1922. Burton had been working as a photographer of U.S. expeditions in Egypt for New York City's Metropolitan Museum of Art; loaned to Carter by the museum, he made a detailed survey of the project, shooting some 1,400 black-and-white glass-plate negative images, many of which were shown at a 2007 exhibit at the museum, "Discovering Tutankhamun: The Photographs of Harry Burton."

Above, Carter and an Egyptian assistant have removed the solid gold third inner coffin of Tutankhamun's sarcophagus, revealing the young ruler's famed death mask, also made of gold. The Pharaoh, who is believed to have died around age 18, reigned from 1332-1322 B.C., during Egypt's 18th dynasty.

16

Racism's Harvest

The Lynching of Shipp and Smith • Lawrence Beitler • Aug. 7, 1930

Shining a light on injustices long hidden, photography became a powerful weapon to drive social change in the 20th century, as incendiary images like the one above helped sustain the long struggle for equal rights for African Americans. The picture documents the lynching in Marion, Ind., of two young black men accused of raping an 18-year-old white woman and murdering a 24-year-old white man who came to her defense. A mob of local whites overpowered authorities and hanged Thomas Shipp, 19, and Abram Smith, 18, on the courthouse lawn. A third young black man was released after the girl's father revealed that all three of the accused were innocent.

The photo is appalling not only in its depiction of a deadly injustice but also in its exposure of a white crowd celebrating the lynching. Local studio photographer Lawrence Beitler sold thousands of copies of the image as "souvenirs" of the deed.

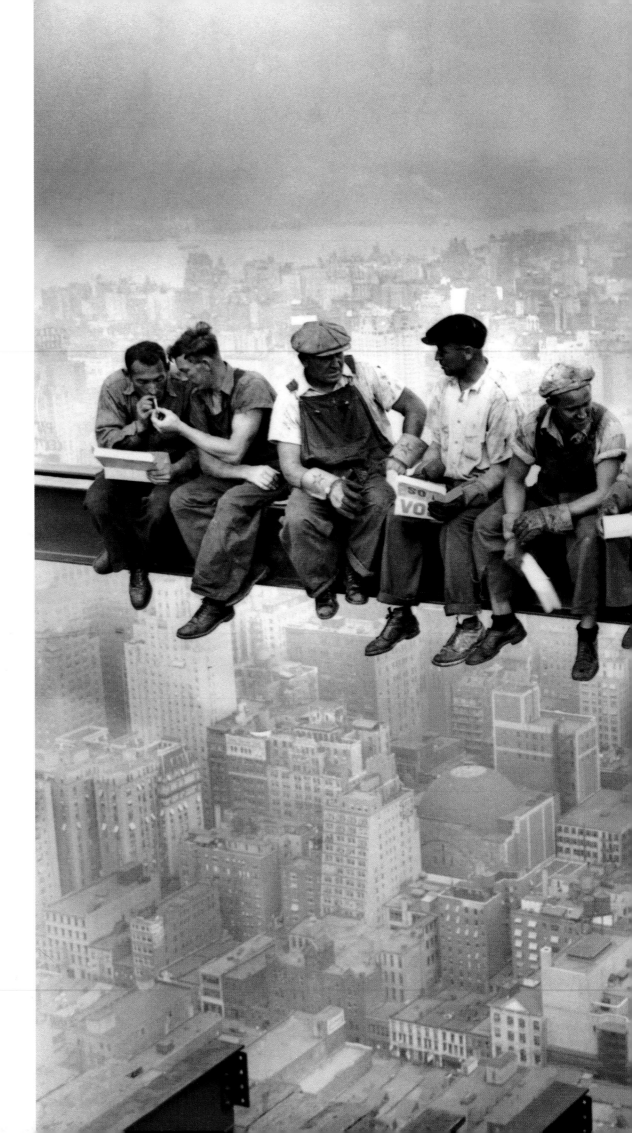

17

Steel Meal
Lunchtime Atop a Skyscraper
Charles C. Ebbets • Sept. 29, 1932

As the U.S. economy ground to a halt during the Great Depression of the early 1930s, the oil-rich Rockefeller family launched a potent stimulus package for New York City by creating Rockefeller Center, a gigantic development in the heart of the city that is still regarded as a model of urban planning. In 1932 photographer Charles C. Ebbets was hired to record the construction of the center. His magnificent image of a pack of insouciant steelworkers enjoying their lunch break atop a girder on the 69th floor of the rising RCA Building, some 800 ft. (244 m) above the street, is a fine example of photography's ability to escort viewers onto privileged turf—or, in this case, privileged space—to witness sights they would otherwise never be able to see.

For decades, this photograph was often attributed to Lewis W. Hine, the crusading social documentarian whose pictures of young workers earlier in the century had helped pass legislation outlawing child labor. The confusion is understandable: later in his career, Hine took powerful photos of the creation of both the Empire State Building and Rockefeller Center. Only in 2003 was the photo acknowledged to be Ebbets' work.

This image speaks to the building of America in more ways than one, for the names of some of the laborers shown in the picture have now been established: many of them were Irish immigrants to America, while the steelworker at far right came to the U.S. from Czechoslovakia.

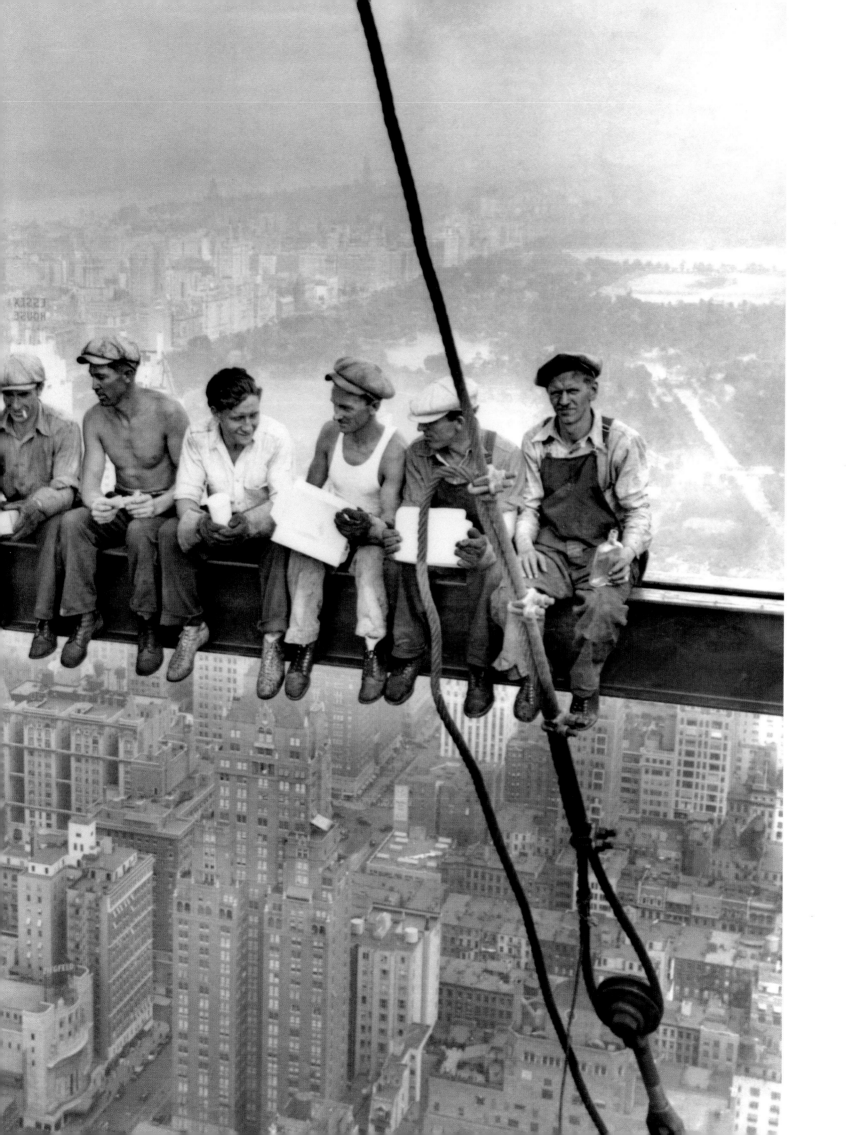

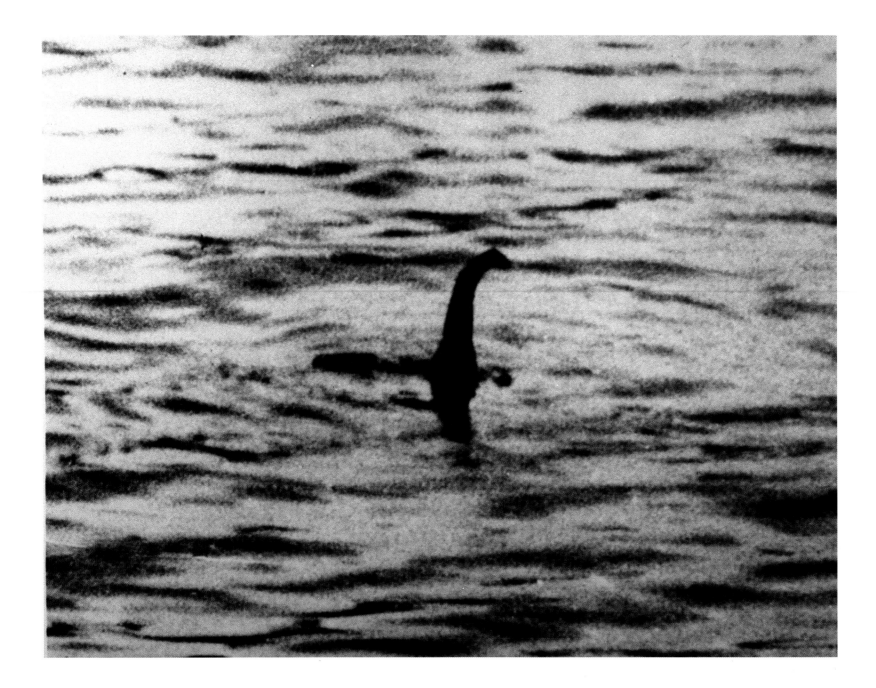

18

The Monster That Wasn't

"The Surgeon's Photograph" • Christian Spurling and Ian Wetherell • April 19, 1934

Seeing is believing. Or, more accurately, seeing used to be believing, thanks to photographs that appear to depict reality but do not. Perhaps history's most famous fake photograph is the one above, which reputedly shows the plesiosaur "Nessie," a supposed denizen of Scotland's sprawling Loch Ness. The photo, said to be taken by a London surgeon, caused a sensation when it was published in Britain's *Daily Mail* in 1934. But in 1993, 59 years later, it was revealed to be a hoax by Christian Spurling, a professional modelmaker who claimed that he; his stepfather, big-game hunter Marmaduke Wetherell; and Wetherell's son Ian had concocted the "monster" in order to discredit the *Daily Mail*, which had lampooned the hunter. But the photo raised such a fuss that the men decided to keep mum. As for what we're really looking at above, Spurling said it was a small, molded plastic neck and head placed atop a toy submarine.

OTHER VIEWS

The alleged photo of the Loch Ness monster at left is perhaps history's most conspicuous example of falsity in photography. But there have been numerous other examples, many of them featuring either unusual critters or UFOs. The photo at right purports to show Bigfoot, a.k.a. Sasquatch, a humanoid creature said to inhabit the woods of the Pacific Northwest. Most analysts believe it simply shows a man in an ape suit; local resident Bob Heironimus has long claimed to have been the person inside the disguise.

The photo at bottom right shows young Elsie Wright posing with a "fairy" in 1920; it is one of a series of five similar photos faked by Elsie and her cousin Frances Griffiths. The "fairies," as seems obvious, were simply illustrations copied from a children's book and held in place by hat pins, as the cousins eventually confessed. Sadly, the fakes fooled Arthur Conan Doyle, creator of the celebrated rationalist Sherlock Holmes, who became a believer in spiritualism late in his life.

The photo below, published in the British magazine *Country Life* in 1936, is said to show a famed spirit, the Brown Lady of Raynham Hall. The two men who took the photo, London photographers Hubert C. Provand and Indre Shira, clung to their story that the photo was not set up or maniuplated. But modern photo researchers have identified a number of anomalies in the image that strongly suggest it is a hoax.

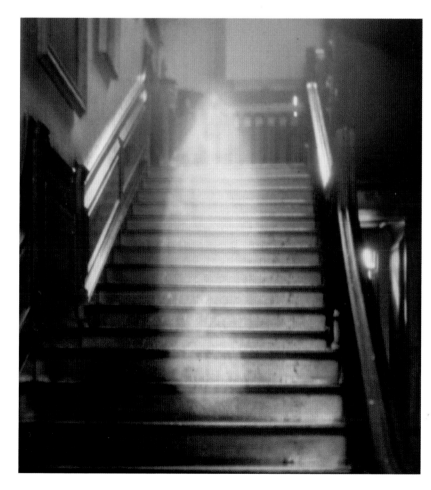

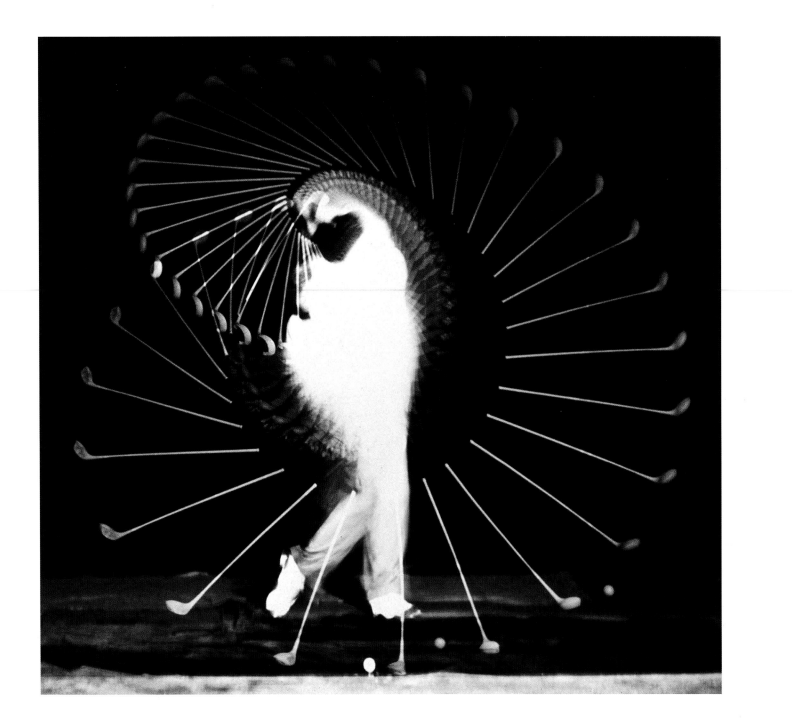

19

Exploring the Hidden Geometries of Time

Densmore Shute Bends the Shaft • Harold E. Edgerton • 1938

Harold E. Edgerton was a master engineer, a pioneer of stroboscopic photography and a longtime professor at the Massachusetts Institute of Technology. His students, who revered him, called him "Doc." Famed diver Jacques Cousteau, marveling at the scenes he captured by using a stroboscope—whose potent explosions of light subdivided time's passage into a series of discrete events—christened him "Papa Flash." Beginning in the 1930s, Edgerton explored a world that is right in front of our eyes and yet unseen: the second-by-second unfolding of everyday processes. Above, operating at 100 flashes per second for half a second, Edgerton's camera turns the swing of noted 1930s golfer Densmore Shute into a series of frozen poses that form an Archimedian spiral. His images are both scientific triumphs and aesthetic wonders, delighting the eye as they inform the mind, and they appear in art museums across the world.

GALLERY

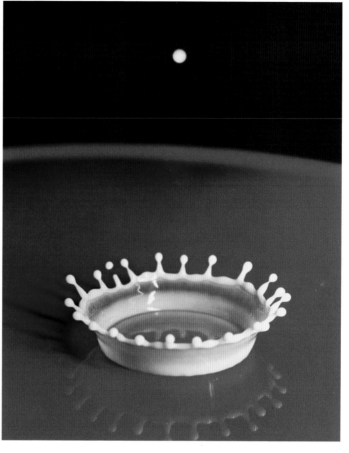

Harold E. Edgerton

"Don't make me out to be an artist," insisted Harold E. Edgerton. "I am an engineer. I am after the facts, only the facts." But it's fair to think of Edgerton not only as an artist—note how he used a cartridge as a mount in the image of the bullet piercing an apple at right—but also as one of history's great explorers. The first to use the power of stroboscopic light to divide time into split-seconds and capture the result on film, he showed us a world we had never seen before, one filled with surprising symmetries and strange beauty. "In many ways, unexpected results are what have most inspired my photography," he said.

Born in Nebraska, Edgerton was influenced as a child by a shutterbug uncle, who helped him set up a darkroom. He received his Ph.D. from the Massachusetts Institute of Technology, where he became a professor and began a life-long series of experiments in his lab, "Strobe Alley." In World War II he worked with the U.S. military to develop aerial cameras that helped record the nocturnal movements of German troops before D-day. After the war, he returned to his role as explorer, teaming up with Jacques Cousteau to develop underwater cameras as well as sonar devices. The first photos taken of the *Titanic* on the seabed were made with a camera he developed.

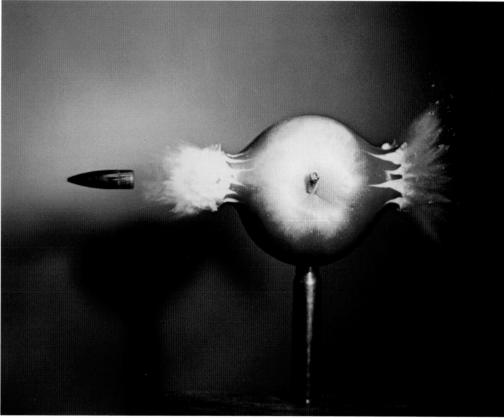

Where time doesn't fly *Edgerton, at top in 1967, was called "Doc" by generations of M.I.T. students before his death in 1990. At top right is "Milk Drop Coronet," his 1957 image of a drop of milk's regal spatter. The 1964 image at bottom is titled "Bullet Through Apple," but Edgerton called it "How to Make Apple Sauce"*

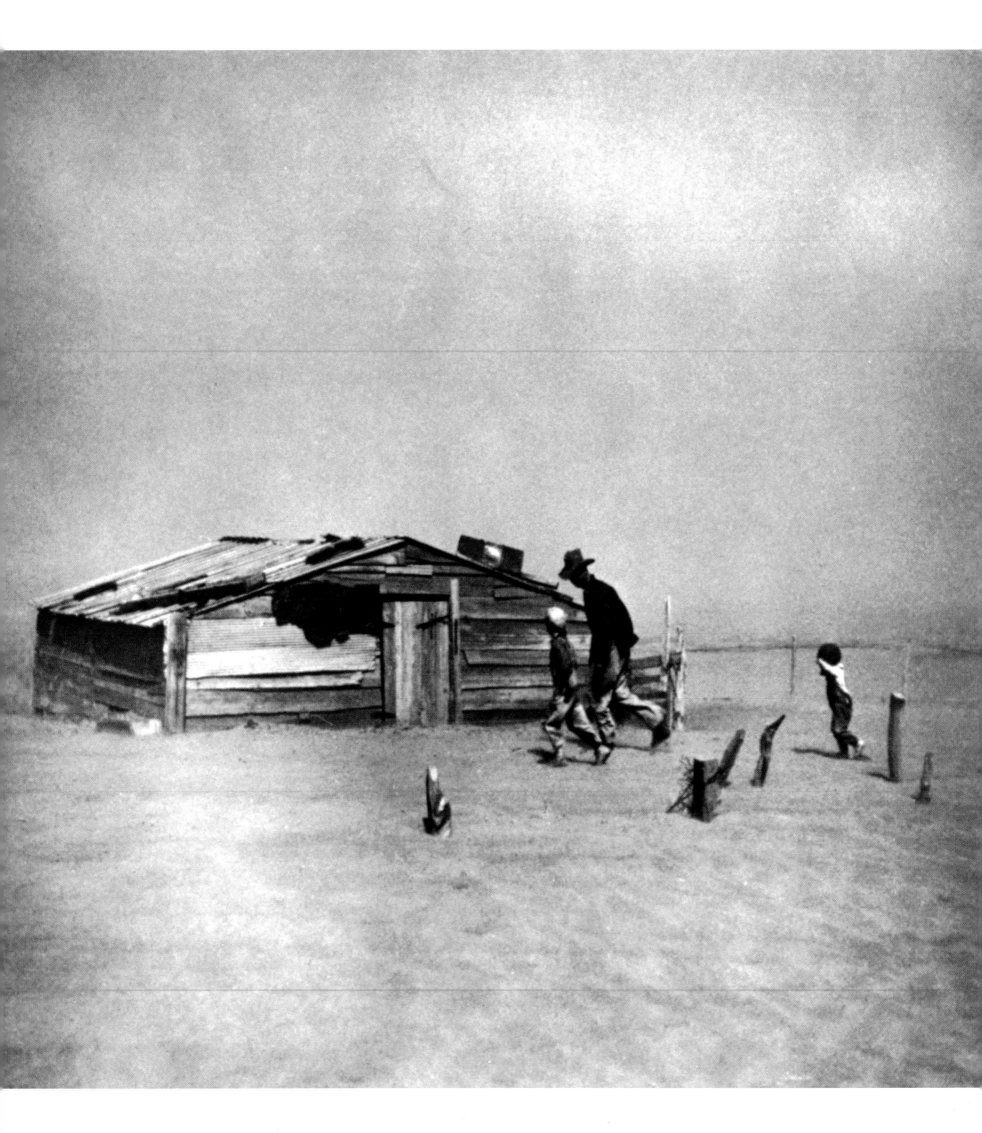

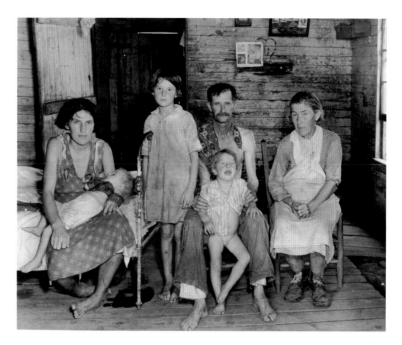

20
True Grit
Dust Bowl
Arthur Rothstein • April 1936

Just as Mathew Brady created a corps of photographers to document the Civil War, the Federal Government dispatched a cadre of photojournalists to capture the woes besetting America during the desperate internal crises of the 1930s: the Great Depression and the Dust Bowl drought, which drove tens of thousands of farmers from their homes.

This great documentary project was managed by Roy Stryker of the Resettlement Administration, later the Farm Security Administration (FSA). Among those who took to the roads to record the hardscrabble daily lives of Americans were Dorothea Lange, Walker Evans, Gordon Parks, Carl Mydans—and Arthur Rothstein, who had studied economics under Stryker at Columbia University.

Rothstein was the first FSA photographer to visit Dust Bowl sites; in 1936 he took this picture of a farmer in Cimarron County, Okla., and his two sons battling a storm of grit in the barren fields of their family farm. Rothstein also felt the effects of the Dust Bowl: the particulates in the air ended up destroying his camera.

OTHER VIEWS

The man who gave us indelible images of Americans struggling amid an economic depression was born into privilege. Walker Evans (1903-75) attended élite Eastern private schools, spent time in Paris with artsy expat Americans in the 1920s and worked for a Wall Street brokerage firm before finding his vocation as a photojournalist in his mid-20s. He joined the corps of FSA photographers in the 1930s, and in 1936 he took a leave of absence from the FSA and was assigned by FORTUNE magazine to document the lives of three farming families in Hale County, Ala. As it happened, the magazine never ran the article, which included prose by future TIME movie critic James Agee. Evans' photos, along with Agee's text, were finally published in 1941 in the book *Let Us Now Praise Famous Men*, now regarded as a classic work.

Evans' photographs of the Fields family, top, and Burroughs family, bottom, operate as both journalism and art: their quiet clarity gives their commonplace subject matter the impact and beauty of things seen for the first time. "Photography," Evans once said, "has nothing whatsoever to do with 'Art.' But it's an art for all that."

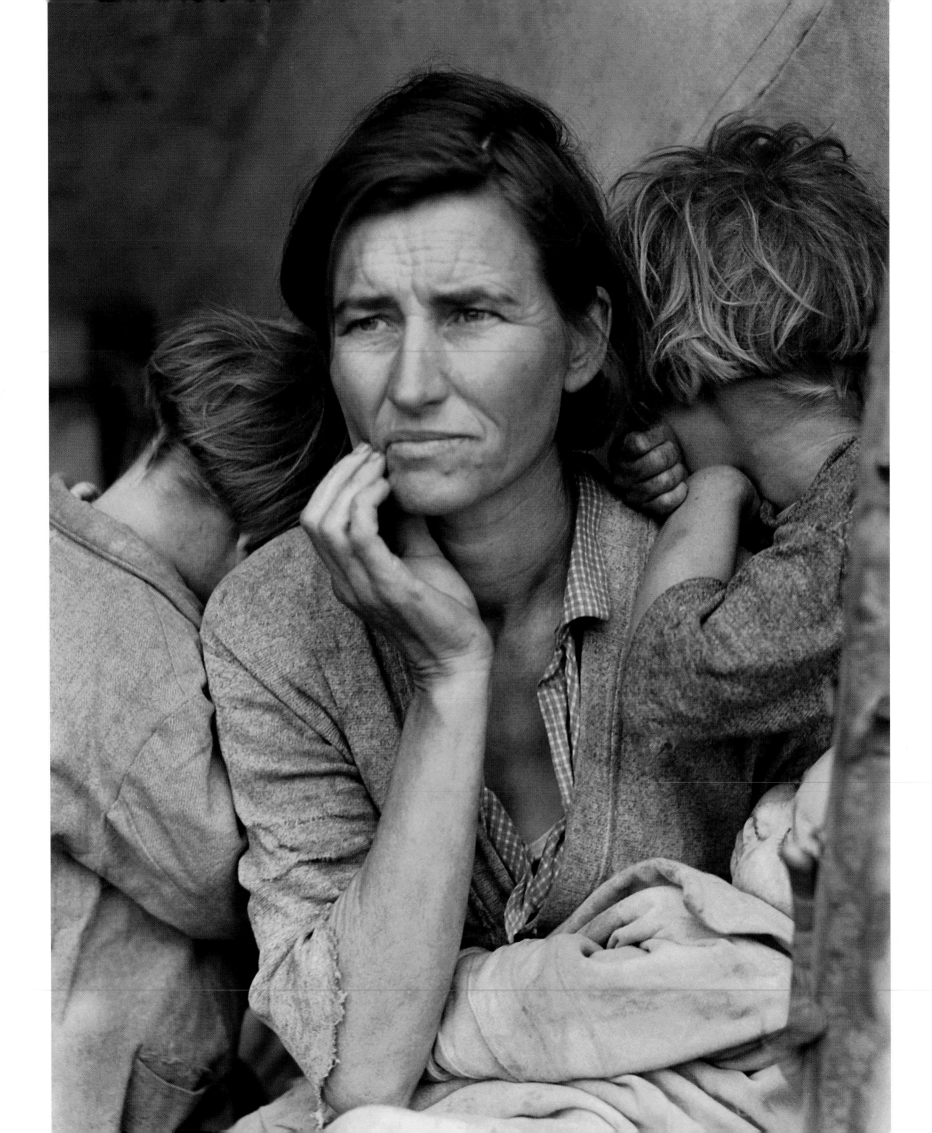

21

The Making of an Icon
Migrant Mother • Dorothea Lange • February 1936

All the misery of America's Great Depression seems etched in the face of Florence Owens Thompson, as recorded by Dorothea Lange, a photographer for the New Deal's Resettlement Administration. The photo was taken in Nipomo, Calif., at a time when thousands of desperate midwesterners, refugees from the Dust Bowl and the Depression, were descending upon California in hopes of finding work tending and harvesting crops. The journeys of these itinerant "Okies" were memorably recorded in John Steinbeck's 1939 novel *The Grapes of Wrath.*

Roy Stryker, head of the Resettlement Administration, called Lange's portrait the "ultimate" photo of the Depression era. "[Lange] never surpassed it," he declared. "To me, it was *the* picture … The others were marvelous, but that was special … She [Thompson] is immortal." The picture, christened "Migrant Mother," has become an American icon, although Thompson herself faded into obscurity after the photo was taken. When she was located in 1978, a wave of publicity ensued, and in the years that followed, her family put out an appeal for funds as she faced cancer and heart problems. The family received 2,000 letters of support and some $35,000 in donations. After Thompson's death in 1983, her son Troy Owens declared, "For Mama and us, the photo had always been a bit of a curse. After all those letters came in, I think it gave us a sense of pride."

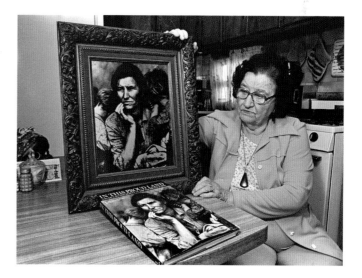

Looking Back

The caption that originally ran under Dorothea Lange's photograph of Florence Owens Thompson described her as a "destitute peapicker" and noted that she was 32 and the mother of seven. In 1960 Lange recalled that day for *Popular Photography* magazine: "She [Thompson] said that they had been living on frozen vegetables from the surrounding fields, and birds that the children killed. She had just sold the tires from her car to buy food."

Thompson's whereabouts were unknown for 42 years, until an enterprising reporter located her in 1978 living in a trailer park in Modesto, Calif., where the picture above was taken. Recalling her meeting with Lange, Thompson emphatically denied having sold the tires to her car and took issue with the famous photographer who had immortalized her: "I wish [Lange] hadn't taken my picture. I can't get a penny out of it. She didn't ask my name. She said she wouldn't sell the pictures. She said she'd send me a copy. She never did." Even icons, it seems, can be iconoclastic at times.

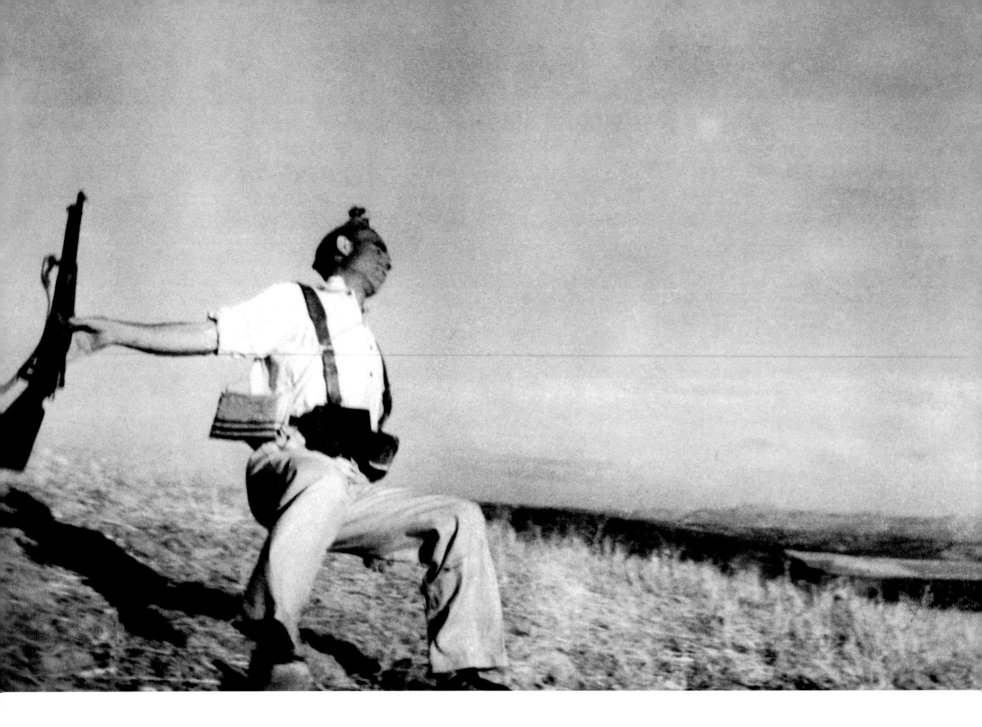

22

An Enduring Mystery

Loyalist Militiaman at the Moment of Death • Robert Capa • Sept. 5, 1936

"If your pictures aren't good enough, you're not close enough," declared one of history's great combat photographers, Robert Capa. Few would argue that Capa didn't get close enough to Federico Borrell García, the Loyalist fighter Capa said he photographed just as García was hit in a skirmish amid the Spanish Civil War. Capa said the photo was taken outside Cerro Muriano, but some critcs dispute that, arguing from landscape clues in the image that it was taken some 35 miles (56 km) away, near Espejo.

Capa was a committed leftist and a Loyalist supporter who strongly opposed the Nationalists, right-wing rebel forces led by General Francisco Franco, who were receiving aid from Adolf Hitler's Nazi regime in Germany and other fascist nations. Capa was not above creating propaganda pictures to support the causes he believed in. Some experts believe the militiaman was posing for Capa when he was suddenly hit by a shot from an enemy sniper, making Capa complicit in his death. More than 75 years after this famous picture was taken, the heated debate remains unresolved.

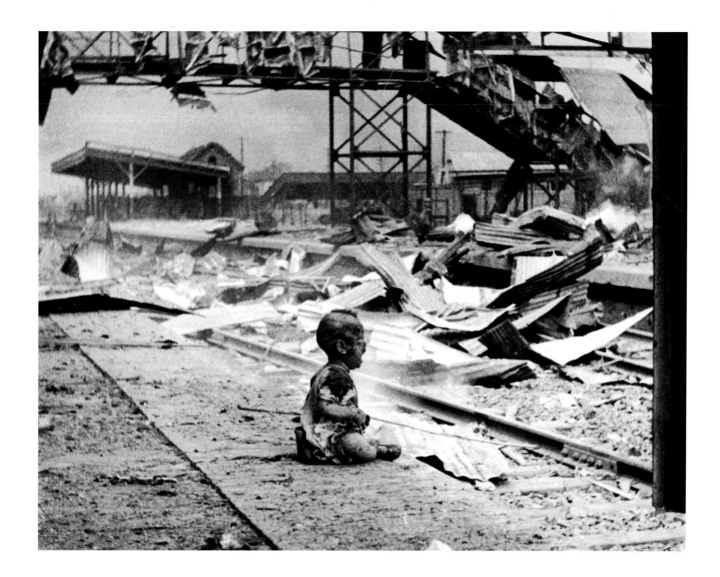

23

Worth a Thousand Words
Bloody Saturday • H.S. Wong • Aug. 28, 1937

A great photograph can focus all the unruly facets of a highly complex issue into a single, powerful image. There is no better example than the photograph above, which brought home the agonies suffered by the Chinese people after Japan's unprovoked invasion of 1937. This picture was taken by H.S. Wong, who was best known as a cameraman for newsreels, which at the time were shown in movie theaters and filled the role later taken by TV news. But Wong also shot still images with a small Leica camera.

Wong photographed this baby, whose mother lay dead nearby, shortly after Japanese airplanes bombed unarmed civilians crowding the Shanghai South Rail Station to flee the besieged city. Widely published around the world, the image of the orphaned child with no one to ease its plight turned global sentiment strongly against the Japanese, who charged the image had been faked. After the photo was taken, the baby was given medical treatment, then disappeared from history's gaze.

24

Shooting from the Hip
The Crash of the Hindenburg
Sam Shere • May 6, 1937

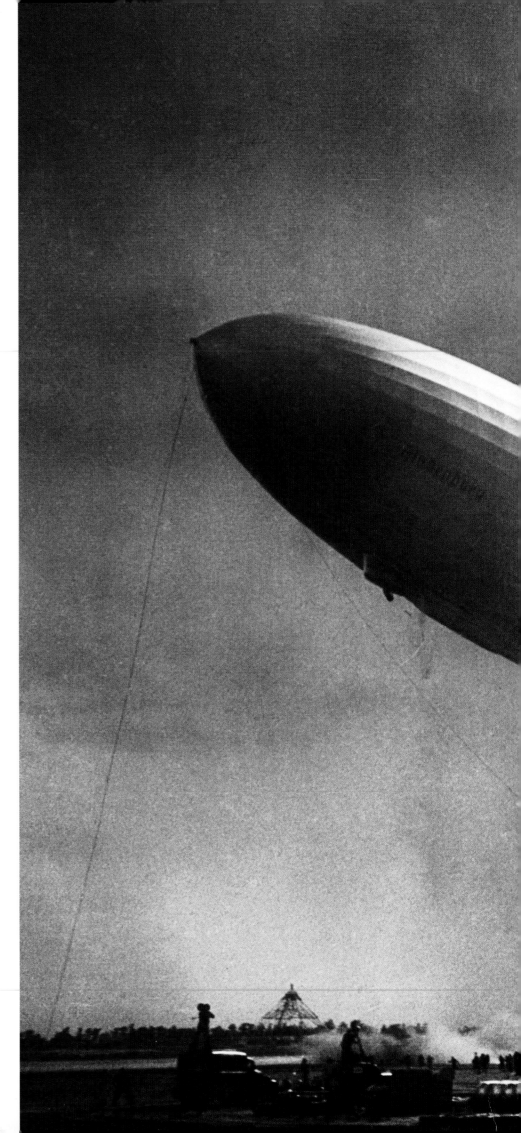

When the German zeppelin *Hindenburg* arrived at its U.S. base at Lakehurst, N.J., not far from New York City, in May 1937, fascination with this innovative and luxurious new form of air travel was at a peak, and representatives of many media had gathered to record the event. The airship had departed from Frankfurt three days earlier on the first of 18 planned transatlantic passages that year. But as a large crowd of spectators looked on, the hydrogen chambers in the stern caught fire, the dirigible was quickly consumed by flames, and it crashed to the ground, killing 35 of the 97 passengers and crew aboard and one landing-crew member on the ground.

Time's original account of the tragedy still packs a punch. "With a Cra-a-a-ack! the ship buckled," the magazine reported. "The stern hit the ground first, in a peculiarly gentle crash amid clouds of dust and smoke. As the still undamaged bow tilted up at 45°, the flame rushed through the middle of the ship and geysered in a long bright plume from the nose. For an instant the *Hindenburg* seemed a rearing reptile darting its tongue in anger. Then it was a gigantic halfback tackled behind the knees and falling forward on its face. The huge bag settled slowly to earth with fire roaring across it at a speed of some 50 yards a second ... Silhouetted by the holocaust, passengers began dropping out of the windows like peas from a collander. As the bow hit the ground, struggling figures emerged from the blazing hulk, stumbled, rose, fell again in fiery suffocation or from broken legs, shock, concussion. The enormous incandescent mass collapsed on the slowest of them, smashing in a blazing blizzard of fabric, crashing girders, melted metal. Still out of the inferno crept struggling figures, afire from head to foot, some stark naked, their clothes burned away, their skin and flesh in sizzling tatters."

The disaster was captured by motion-picture and still cameras and quickly appeared in movie newsreels and in newspapers and magazines. Radio reporter Herbert Morrison's well-known account of the event offers a gut-wrenching eyewitness view of the disaster, though it was recorded as he delivered it and was not broadcast until the day after the calamity, contrary to widespread impressions. The photographer who took this picture, Sam Shere, later noted, "I had two shots in my big Speed Graphic [camera] but I didn't even have time to get it up to my eye. I literally 'shot from the hip'—it was over so fast there was nothing else to do."

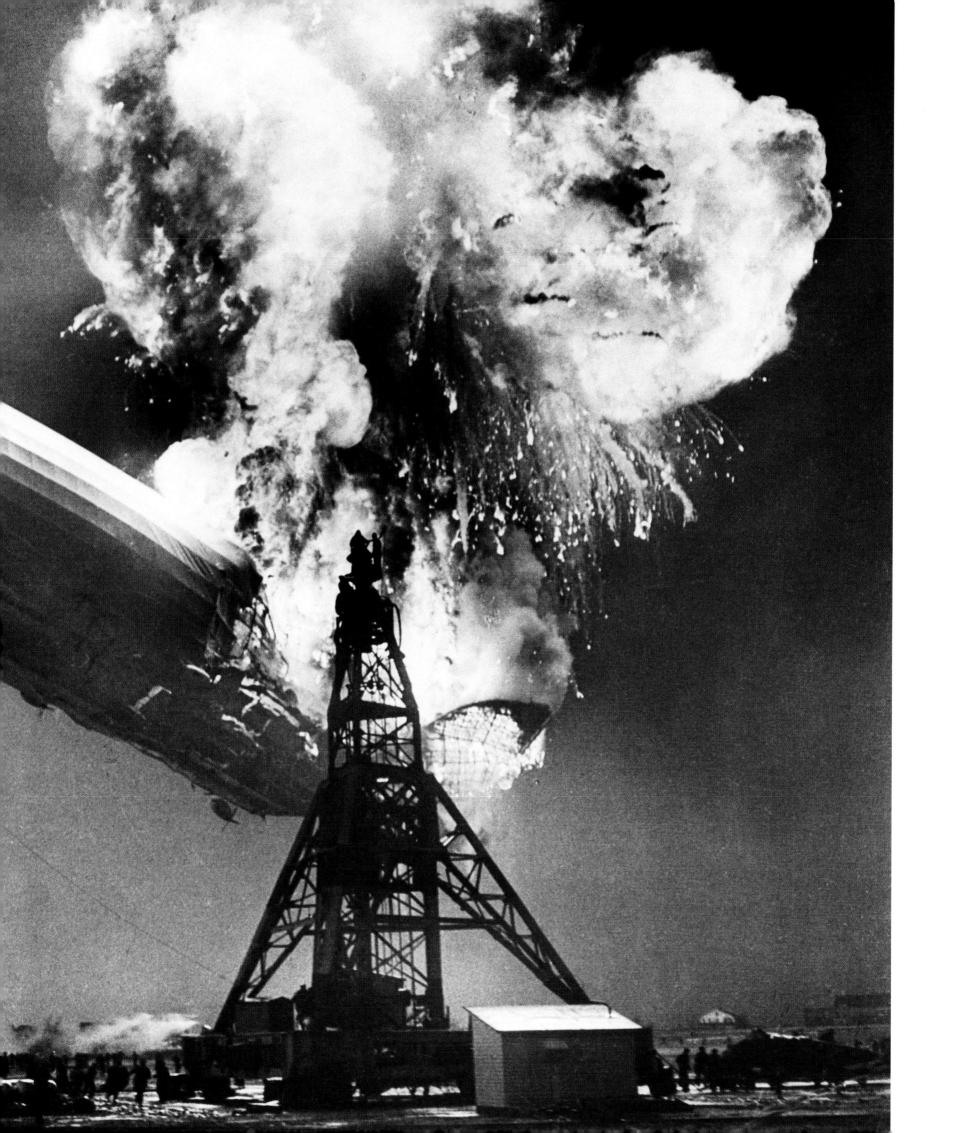

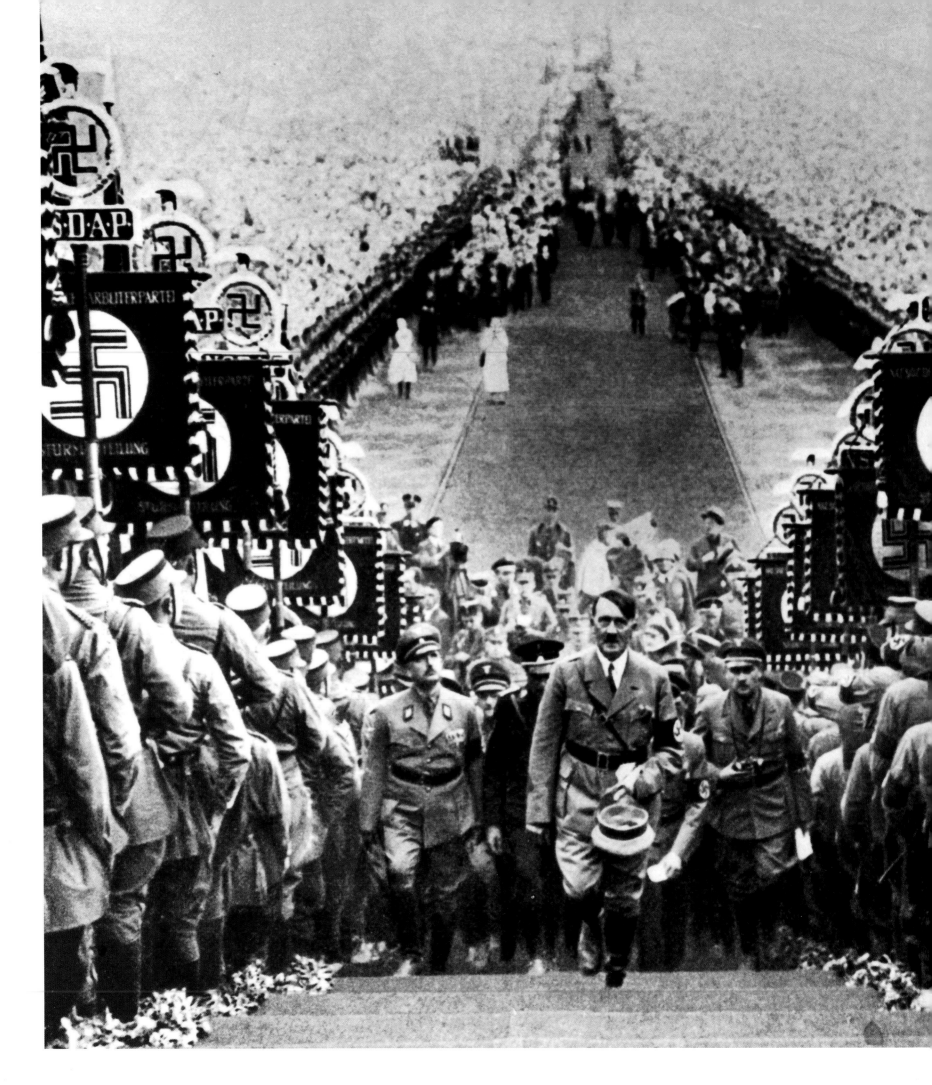

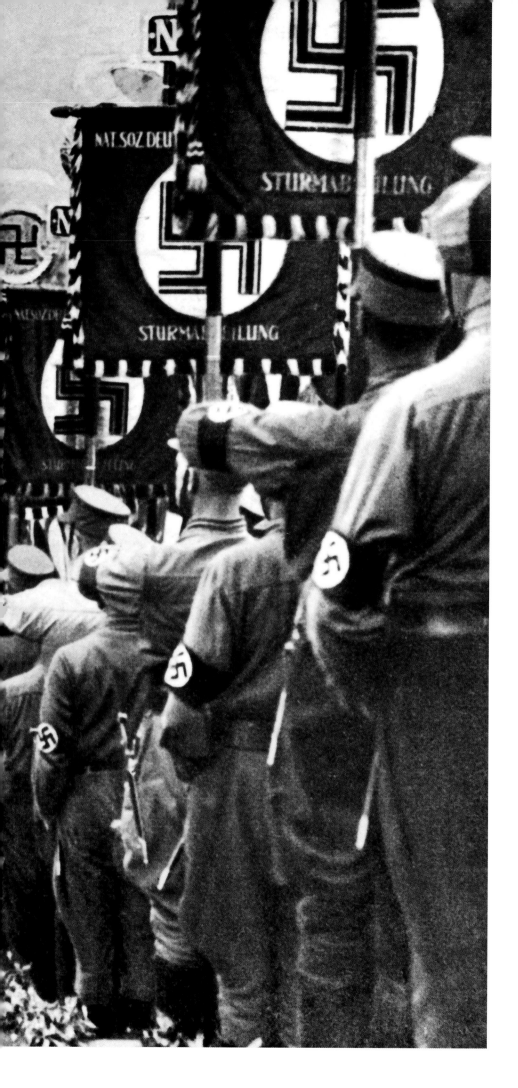

25

Staging History
Adolf Hitler at a Nazi Party Rally
Heinrich Hoffmann • Sept. 30, 1934

In this picture, German Chancellor and National Socialist Party leader Adolf Hitler mounts the stairs at a party rally in Bückeburg in the nation's north in 1934, one year after he came to power. Hitler and his associates, led by Dr. Joseph Goebbels, Reich Minister for Public Enlightenment and Propaganda, fully grasped the power of new communications technology to shape perceptions and opinions. In their hands a corrupted media became an essential tool of totalitarian control, as Goebbels dished out far more propaganda than enlightenment.

The party's control ran both ways. Hitler's censors outlawed books and newspapers that conflicted with their views and concocted spectacles that dramatized their intolerance in the form of book burnings—a rebuke to Germany's longstanding liberal and humanistic values that shocked the world. To burnish the party's image, Goebbels staged massive outdoor rallies that provided potent scenes of Nazi power and public adulation of Hitler. The vast rally at left was created not only to fire up Nazi loyalists but also to yield the picture itself, orchestrated to depict Hitler as a magnetic leader who was leading Germany's masses into an ascendant position in the global arena.

The spectacles were also staged for motion-picture cameras: Leni Riefenstahl's infamous documentary *Triumph of the Will,* filmed at a similar 1934 rally in Nuremberg, endures as a chilling reminder of how totalitarian states can not only dampen the power of the free press but also turn mass media into a potent lever with which to move public opinion.

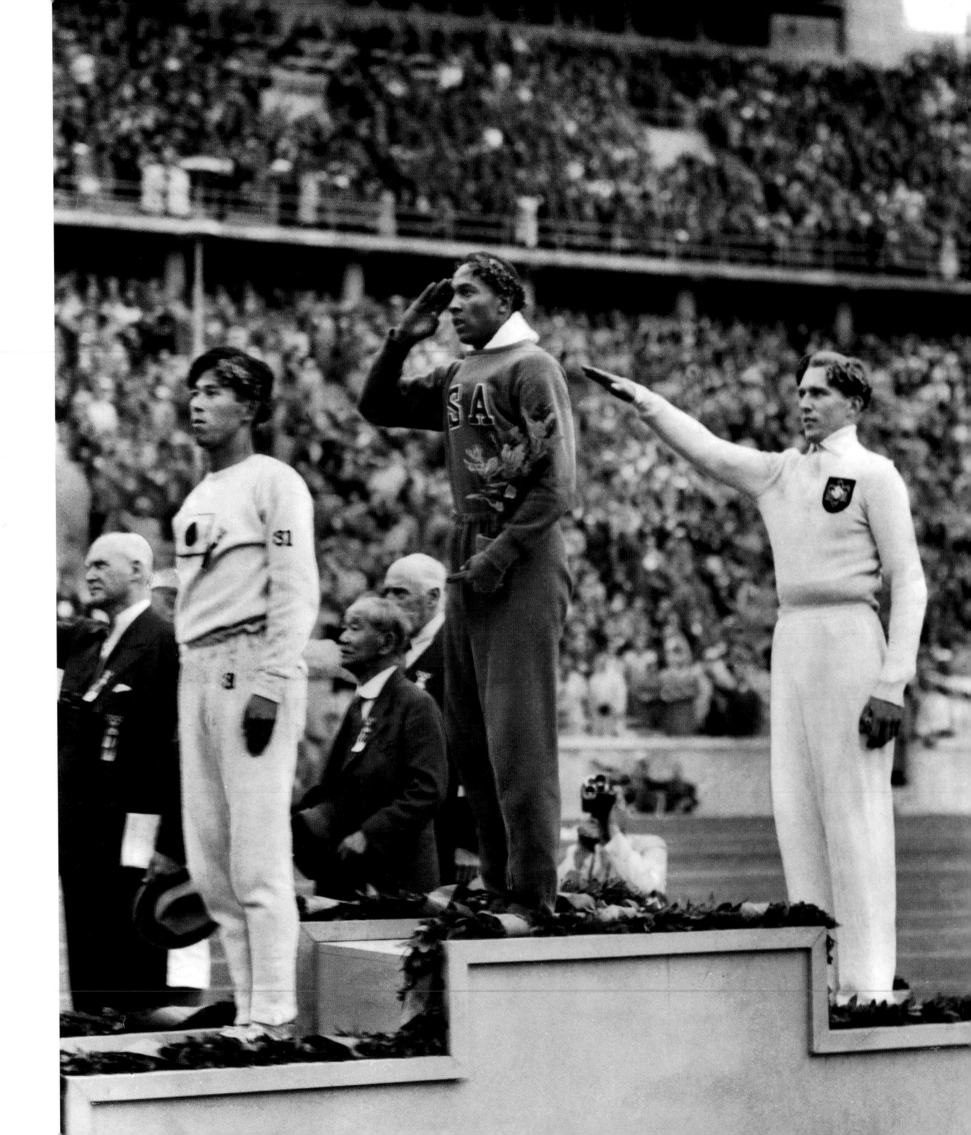

26
A Race Against Racism
Jesse Owens at the Berlin Olympics
Photograph from AP • Aug. 11, 1936

Adolf Hitler and his propaganda chief, Joseph Goebbels, anticipated that the 1936 Olympic Games in Berlin would offer an opportunity to craft dramatic scenes of Nazi power and German glory for a captive global audience. But they seem to have forgotten that in this case they were not in full control of the actors on their stage. The gifted U.S. athlete Jesse Owens dominated the Games, taking first place in the 100-m and 200-m dashes, as well as the long jump and 400-m relay, to become the first competitor in history to win four gold medals in a single Olympics.

The image at left utterly refuted Hitler's widely publicized views on the physical superiority of the so-called Aryan race. Owens, an Alabama-born African American, stands atop the podium in first place, the victor in the long jump, while German Lutz Long, giving the stiff-armed Nazi salute, was the second-place competitor, and Japan's Naoto Tajima finished third.

The magnitude of Owens' achievement was captured in TIME's initial report on the Games. The magazine quoted the reaction of Goebbels' state-controlled newspaper *Der Angriff* (The Attack) to the results: "The Yankees, heretofore invincible, have been the great disappointment of the Games ... Without these members of the black race—these auxiliary helpers—a German would have won the broad jump ... The fighting power of European athletes, especially the Germans, has increased beyond all comparison ..." Or not.

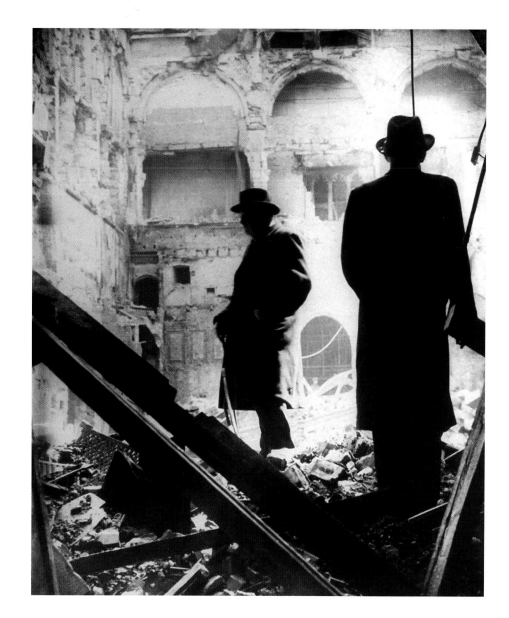

27
Bombed but not Broken
Winston Churchill in the House of Commons
Photographer unknown • May 11, 1941

On the night of May 10-11, 1941, Germany's Luftwaffe launched the single largest attack against London of the Blitz aerial campaign. Some 711 tons of bombs were dropped by 507 airplanes on London, starting more than 2,100 fires and destroying the famed debating chamber of the House of Commons. Above, Winston Churchill, who had become Prime Minister a year before, on May 10, 1940, surveys the damage; the camera captures his characteristic resolve, essential to Britain's morale.

Churchill declared that following the war and the eventual victory of Britain and its allies, the chamber would be rebuilt to its previous specifications. The early May attacks were the last gasp of the Blitz, as Hitler turned his attention to the invasion of Russia he would launch later that month. The new chamber, per Churchill's vow, duplicated the shape of its predecessor; when it opened on Oct. 26, 1950, one bomb-scarred arch was preserved as a relic of Britain's ordeal.

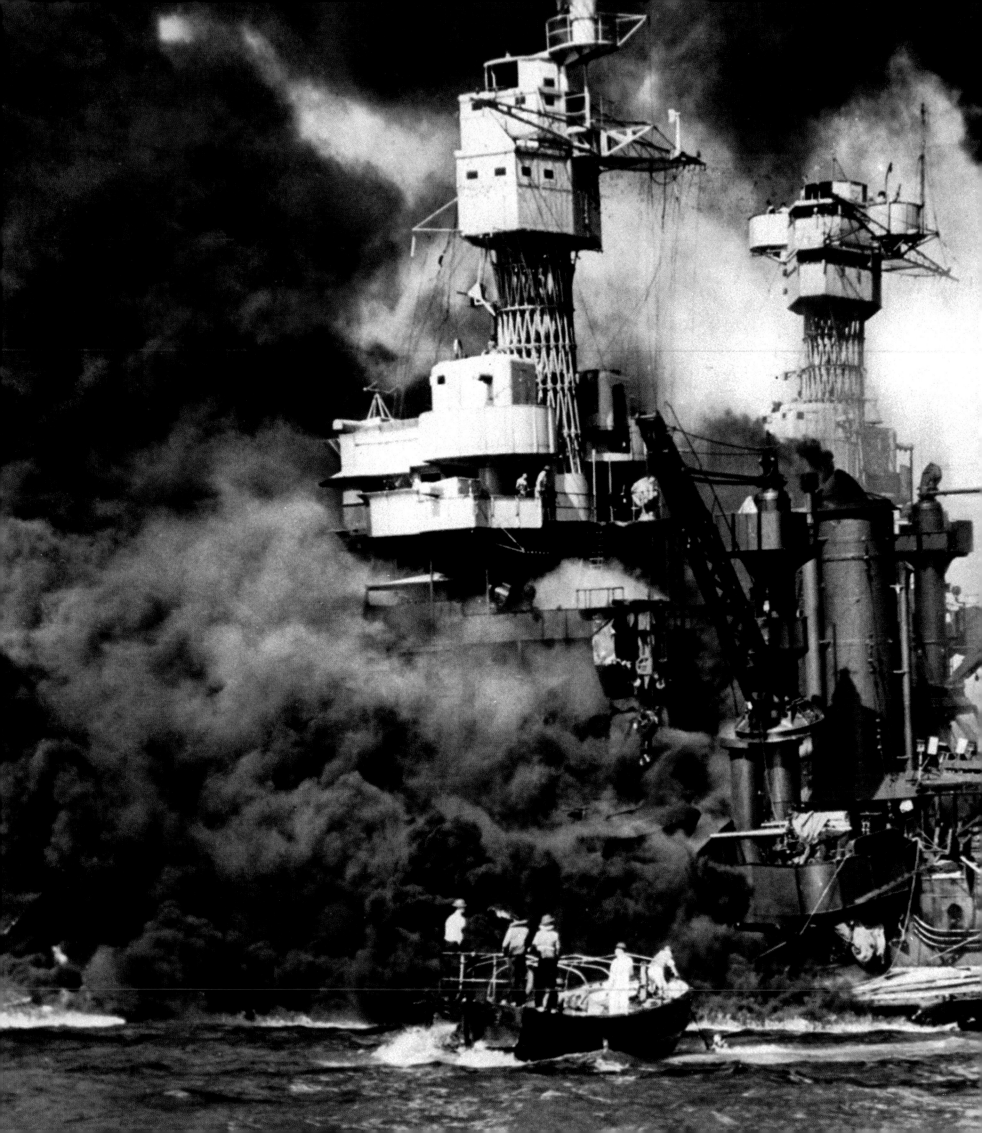

28

Caught Off-Guard
The Bombing of Pearl Harbor
U.S. Navy Photographer • Dec. 7, 1941

Japan's surprise attack on the U.S. naval base at Pearl Harbor in Hawaii was one of the most pivotal events of the 20th century. The attack, in which 2,403 Americans were killed and 1,178 wounded, plunged the U.S. into the middle of World War II and ensured that the war, already under way on two fronts in Europe, would also be fought across a host of fronts in a new Pacific Theater, becoming a truly global conflict.

There are many powerful photos of Japan's stunning coup, but no single one is an icon. The picture at left captures much of the drama of the strike, as a squad of U.S. sailors in a small motor launch come to the aid of a colleague thrown from the sinking battleship U.S.S. *West Virginia,* foreground. Another battleship, the U.S.S. *Tennessee,* also hit, is behind.

The disparity between the enormous floating fortresses and the rescuers in their tiny vessel is telling: the humans seem dwarfed by the machinery of war. Indeed, the conflict that began on this day would be shaped by advanced new technologies, embodied here by the gigantic smokestacks, bridges and gantries of the smoking ships. Japan's assault was launched from a new kind of fighting ship, the aircraft carrier, that would play an outsize role in the war in the Pacific. The U.S. Navy was fortunate indeed on this day, for the American aircraft carriers normally docked at Pearl Harbor were out at sea on maneuvers and escaped destruction.

Fittingly, the war in the Pacific would only end when the U.S. employed an even more advanced weapon, the atom bomb, against a pair of Japanese cities to force Japan's leaders to surrender.

29

Grace Under Pressure
U.S. Soldier Reaches Shore on D-Day • Robert Capa • June 6, 1944

Yes, the photograph below is blurred. But its intensity conveys all the chaos, danger and urgency of history's largest sea-land invasion, D-day, and it is the best-known photo of the Allied landing at Normandy. It was taken by Robert Capa, the gutsy combat photographer, who landed with the second wave of U.S. troops at the scene of the deadliest fighting of the day, Omaha Beach, and turned around to capture an American soldier making his way to shore. Students of photography are familiar with the tragedy that befell Capa after he risked his life to capture the historic invasion: when he returned to England with his film, a laboratory accident by a LIFE magazine technician in London ruined all but 11 of the photos Capa took that morning. Capa was further insulted when a LIFE editor described the blurring in some photos as the result of Capa's hands shaking in fear: the photographer's retort appeared in the title of his wartime memoir, *Slightly Out of Focus* (1947).

When World War II ended, Capa swore he would never photograph combat again. Yet while he was traveling to Japan in the 1950s for a photo exhibit, he accepted an offer from LIFE to cover the French war with anticolonialist rebels in Vietnam. On May 25, 1954, after he moved ahead of two colleagues to cover a skirmish, Capa stepped on a land mine and was killed.

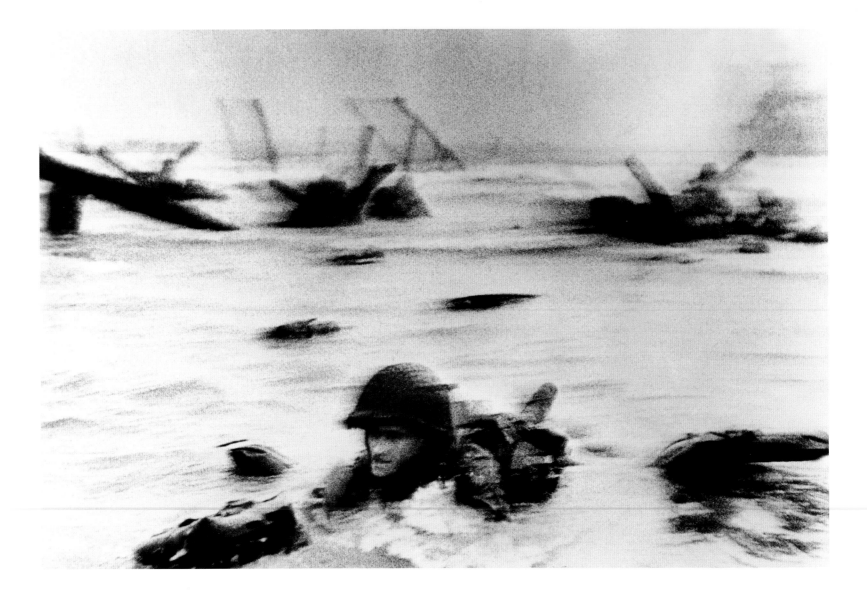

GALLERY

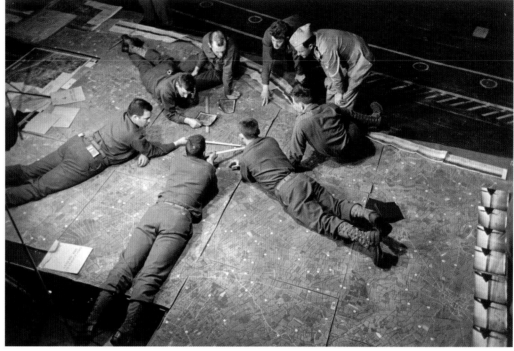

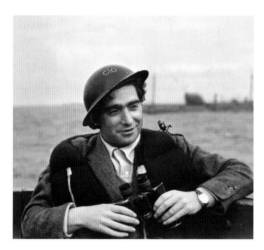

Robert Capa

Technically speaking, there was no Robert Capa; the name was a nom de plume created by Hungarian photographer Andre Erno Friedmann and his girlfriend and fellow photographer in the 1930s, Gerda Taro. They not only invented the name, chosen in part because it resembled the name of popular U.S. film director Frank Capra; they also concocted a persona for "Capa" as a brilliant American photographer. Gradually, Friedmann began to fill the role he had imagined for himself, earning acclaim for his powerful photos of the Spanish Civil War. Taro also covered that war with her camera, becoming one of the first female combat photographers; she was killed while covering a battle in 1937.

Capa is the most famous photojournalist of World War II. His memoir, *Slightly Out of Focus*, should be better known; written in hopes it might become the basis of a Hollywood film, it captures Friedmann/Capa still playing the role of a larger-than-life combat photographer who shrugs off danger and conducts a doomed romance with a beautiful British woman even while he risks his life to document the lives of soldiers in wartime.

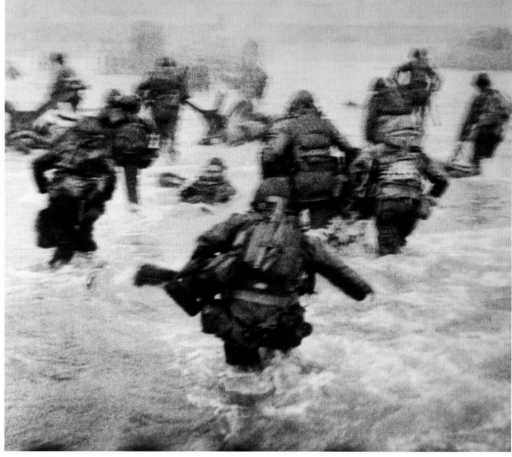

Into the jaws of death *At top left, Capa is shown aboard a ship after the Normandy landings. At top above, he photographed officers reviewing landing plans on the deck of a ship shortly before the invasion. Just above, U.S. troops leave their landing craft and begin wading ashore, under heavy fire from entrenched German artillery*

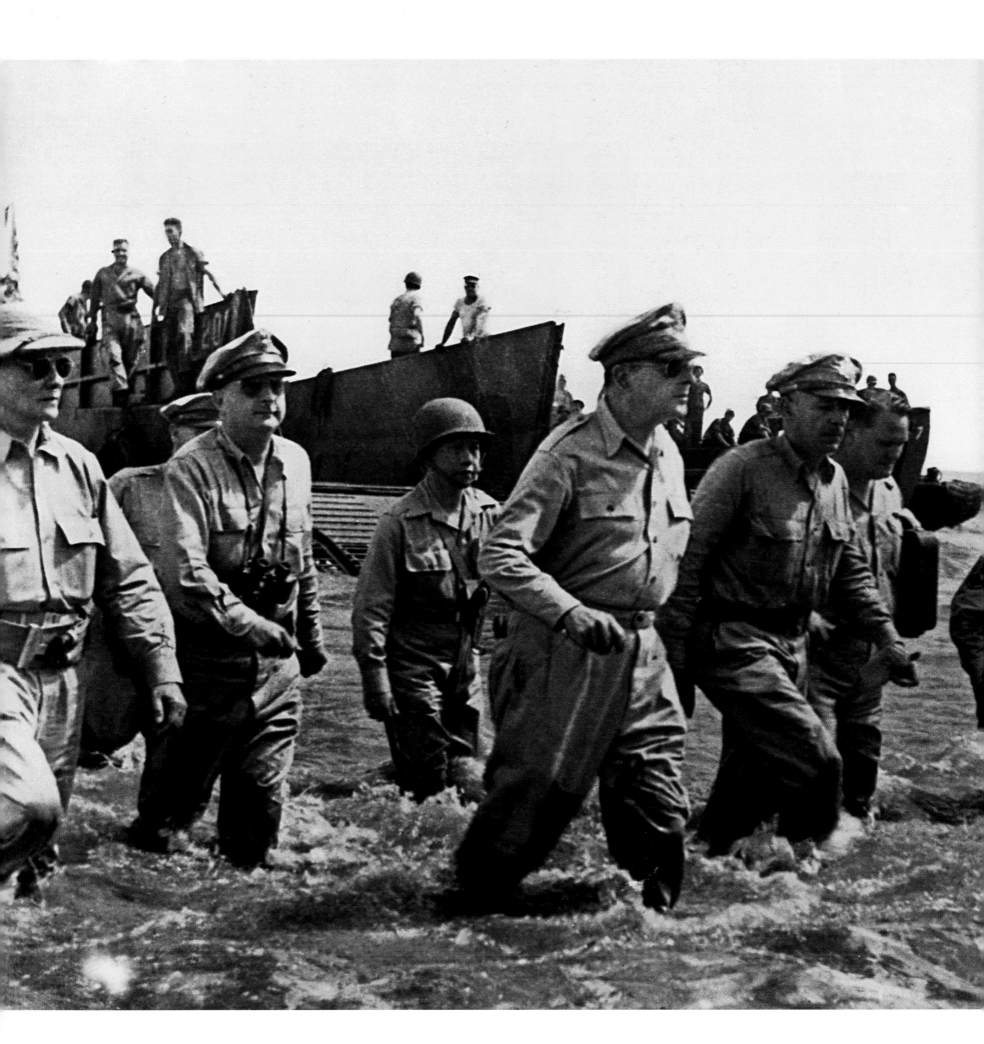

30

Ready, Aim, Click
MacArthur Wades Ashore at Leyte
U.S. Army Signal Corps Photographer
Oct. 20, 1944

When he fled the Philippines as a Japanese army overwhelmed his forces in March 1942, U.S. General Douglas MacArthur vowed, "I shall return." When he fulfilled his promise, leading U.S. troops onto the island of Leyte in October 1944, no small landing craft was at hand, so an exasperated MacArthur, eager to keep his appointment with destiny, waded ashore, accompanied by Philippine President Sergio Osmeña, to the right of MacArthur in the photo.

The picture of the determined general striding through the waves crystallized his image as a man who kept his promises, no matter the obstacles. A few months later, when MacArthur led troops onto another island, Luzon, he took care to re-create the scene, which by now had become his trademark. LIFE photographer Carl Mydans took the photo of MacArthur wading ashore at Luzon, at top right. "No one I have ever known in public life had a better understanding of the drama and power of a picture," said Mydans.

OTHER VIEWS

For photographers and journalists, World War II was a moveable—and highly dangerous—feast. LIFE photographer Carl Mydans and wife Shelley, above, began covering the war in Europe two weeks after Germany invaded Poland in 1939, reporting on the war in Finland and the fall of France. They then traveled to China, covering the run-up to the war in the Pacific from Chongqing. They arrived in the Philippines in October 1941, two months before the attack on Pearl Harbor.

Trapped in the Philippines when MacArthur left the islands, the Mydanses were captured by Japanese troops. They spent eight months interned at Manila's University of Santo Tomas as prisoners of war, followed by another year at a Japanese POW camp in Shanghai, before they were freed. They returned to the U.S. in December 1943; four months later Carl was off for the Italian front. He went back to the Pacific to cover MacArthur's return to the Philippines and the liberation of Manila.

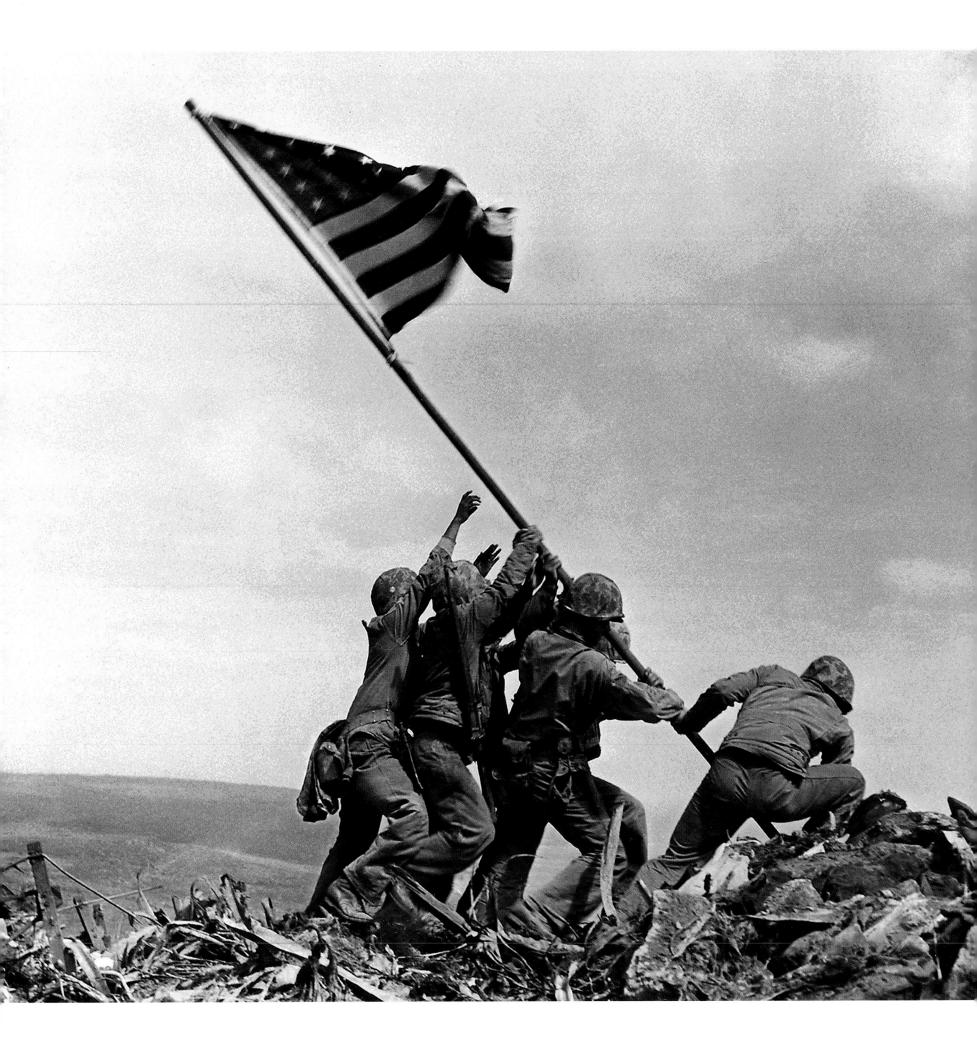

31

A Moment of Glory
Raising the U.S. Flag on Iwo Jima
Joe Rosenthal • Feb. 23, 1945

This photograph is surely the most famous picture of World War II, and it has become an iconic image of American patriotism and of the bravery of U.S. servicemen. So it's unfortunate that some people still regard the photo as slightly bogus. Yes, this was the second flag raised atop Mount Suribachi on Iwo Jima after U.S. Marines took control of the peak. But the first flag wasn't replaced for the benefit of the camera: U.S. Navy officers sent a team of men to replace the flag because hoisting a bigger one would make a larger statement of the American advance to both U.S. and Japanese troops, still fighting to control the island. Associated Press photographer Joe Rosenthal tagged along and ended up snapping this indelible image.

Everything that is great about the photo, notably the composition of the straining soldiers, was impromptu. Readers interested in knowing more about this famous image, and about the men shown in it, can consult *Flags of Our Fathers* (2000), an illuminating treatment of the event by James Bradley, the son of one of the flag-raisers.

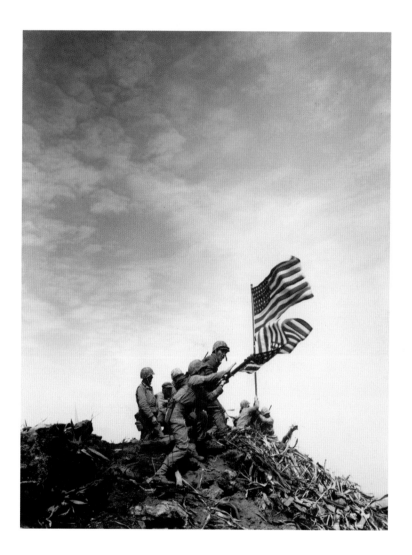

OTHER VIEWS

Marine Corps photographer Bob Campbell was among the small group that followed the team assigned to change the flag atop Mount Suribachi. He snapped the photo above, which shows the smaller flag after it was taken down, even as the larger banner was still being positioned.

Campbell's picture of the scene is instructive, showing the extent to which Joe Rosenthal's famous photo of the flag-raising relies on its composition to achieve its powerful effect. The photo above is little more than a snapshot, while Rosenthal's image has the simplicity, energy and grandeur of a classical statue. In fact, Rosenthal's picture served as the model for the statue by Felix de Weldon that is the centerpiece of the U.S. Marine Corps War Memorial near Arlington National Cemetery in Virginia.

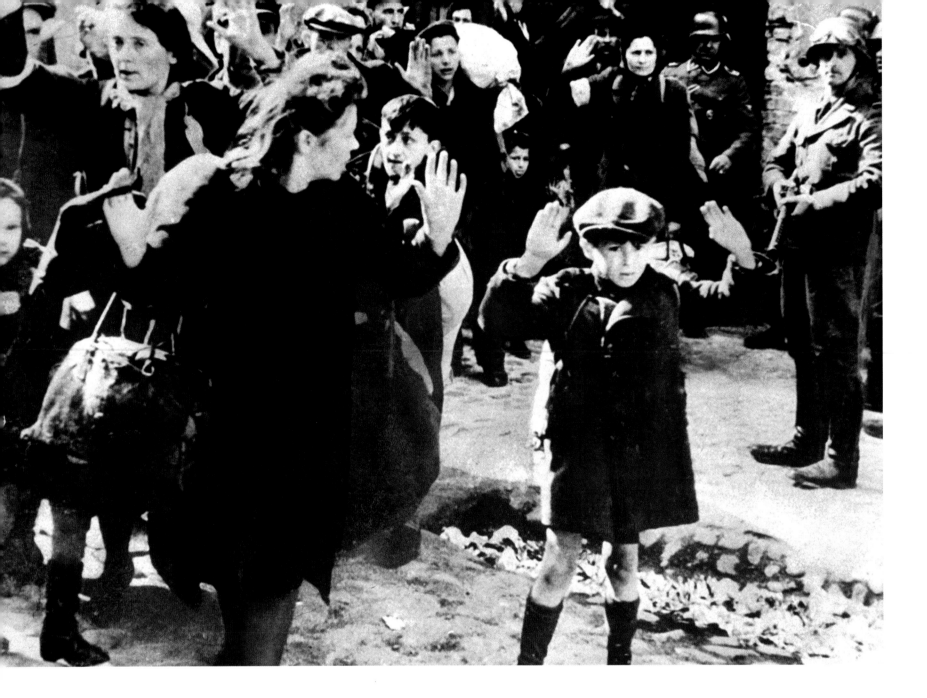

32

The Image as Evidence
Jewish Boy Surrenders in Warsaw • Photographer unknown • 1943

Behold the powerful enemies against whom Adolf Hitler and his fellow Nazis hurled the full might of the German army: unarmed, defenseless Jewish mothers and children rounded up in the Warsaw Ghetto. The young boy at the center of the photo is a stand-in for all the innocents who have suffered from forces far beyond their understanding or control. The exact date of the picture is unknown, but it was taken during the four weeks when the beleaguered residents of Warsaw's Jewish quarter rose up against their occupiers. In response, the Germans, commanded by General Jürgen Stroop, systematically burned the district's buildings, killed some 7,000 residents of the ghetto and sent survivors to concentration camps. Stroop included this photo in a report he sent his superior, SS leader Heinrich Himmler, to show the success of his efforts.

Stroop was captured in the spring of 1945, tried by an Allied military tribunal and sentenced to death. But Allied leaders, sensitive to the desire of Poland's citizens for justice, allowed the officer to be tried again in a Polish court—where this photo was used as evidence against him. Stroop was found guilty of war crimes and was executed by hanging on March 6, 1952.

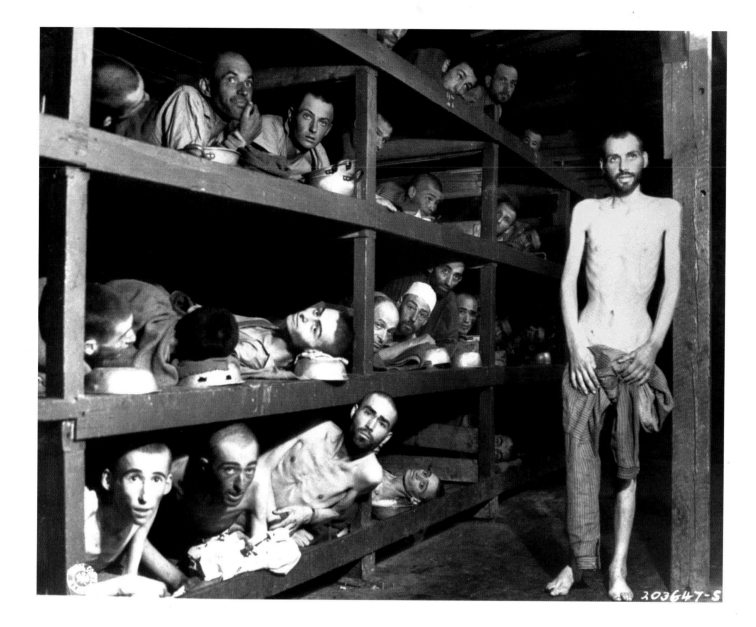

33

Bearing Witness

Prisoners at Buchenwald Concentration Camp • H. Miller • April 16, 1945

When General Dwight D. Eisenhower entered the Buchenwald concentration camp in Germany in 1945, as the war was ending, he made a fateful decision to document the horrors he saw. Sixty-four years later, U.S. President Barack Obama visited the camp with German Chancellor Angela Merkel and recalled, "[Eisenhower] knew that what had happened here was so unthinkable that after the bodies had been taken away, that perhaps no one would believe it. And that's why he ordered American troops and Germans from the nearby town to tour the camp. He invited congressmen and journalists to bear witness and ordered photographs and films to be made ... so that—and I quote—he could 'be in a position to give firsthand evidence of these things if ever in the future there develops a tendency to charge these allegations merely to propaganda.' "

Sadly, Eisenhower anticipated correctly: despite a wealth of evidence, some still deny the reality of the Holocaust. One man who continues to bear witness is Elie Wiesel, the acclaimed author who survived Buchenwald and has identified himself as the seventh person from the left on the second row of bunks in this photo. Wiesel accompanied Obama and Merkel to the camp on their 2009 visit.

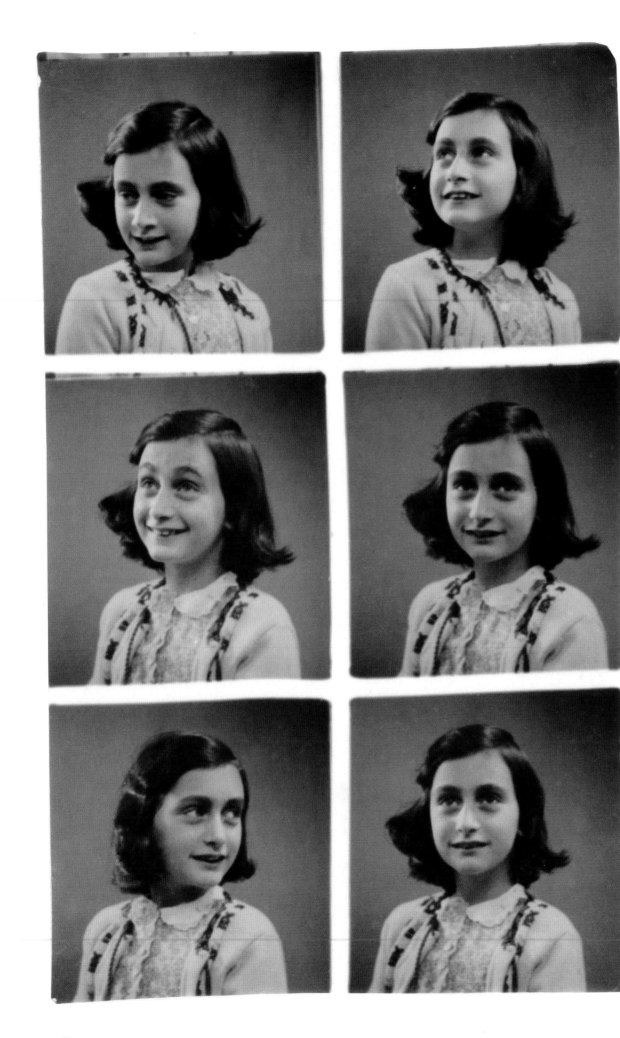

34

A Face in the Crowd

Portraits of Anne Frank
Photographer unknown • 1939

Among all the millions of photographs ever taken, a contact sheet of a child's studio portrait session might seem to be among the least destined for posterity's gaze, however much parents might admire the pictures. But the photos at left are something special: they show Anne Frank, a young citizen of Amsterdam, as she looked at age 10 in 1939, the year World War II began.

As Jews, Frank and her family were forced underground to escape Holland's rabidly anti-Semitic Nazi occupiers. But after hiding for two years in a hidden annex in her father's office building, where she recorded her story in a diary, Anne and her family were apprehended, and she was sent to the Bergen-Belsen concentration camp, where she died of typhus in March 1945. In 1947 her father Otto, the family's lone survivor, published the diary, and the young girl who had lived in hiding gave a voice—and a face—to the millions who died in the Holocaust.

Notes from the Secret Annex

The red-plaid cover of Anne Frank's diary suggests an air of breezy informality that is entirely at odds with its contents. The diary and other artifacts from the young girl's life in hiding are preserved at the Anne Frank House in Amsterdam, which has been visited by millions of people eager to learn more about her story.

On March 28, 1944, Frank heard a radio appeal broadcast from London by exiled Dutch government minister Gerrit Bolkestein, asking listeners to preserve their impressions of the war. Realizing that her diary bore witness to history, she began to entertain notions of turning it into a novel. "Just imagine how interesting it would be if I were to publish a novel about the Secret Annex," she mused. "The title alone would make people think it was a detective story." In May 1944, she wrote, "At long last after a great deal of reflection I have started my *Achterhuis (The Secret Annex),* in my head it is as good as finished, although it won't go as quickly as that, if it ever comes off at all." Writing on colored sheets of notepaper, Anne worked on revising her original diary entries until her family's arrest on Aug. 4, 1944. This rewritten version is the basis of the text that was published in 1947.

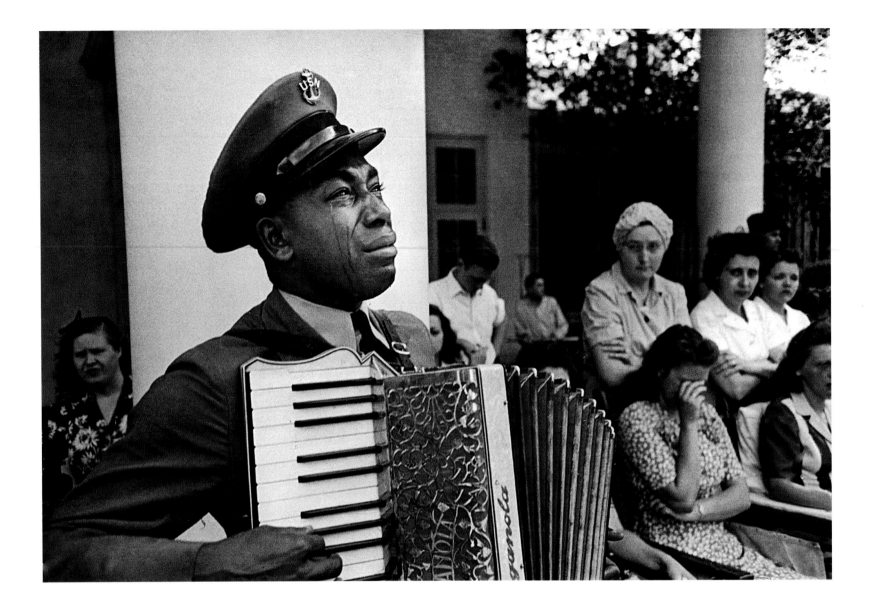

35

Tears for a Fallen Leader

Going Home • Ed Clark • April 12, 1945

The death of President Franklin D. Roosevelt in April 1945, even as the war in Europe was drawing to a close, reminded many Americans of the death of Abraham Lincoln just as the Civil War was ending, 80 years before. Roosevelt, like Lincoln, was deeply mourned by his countrymen; in November 1944, he had been elected to a fourth term in the White House, and after leading the country through two of its greatest crises, the Great Depression and World War II, the President had come to be seen as the embodiment of his nation.

This photo was taken in Warm Springs, Ga., where Roosevelt kept a vacation home; the town's hot mineral springs were a balm to the President, disabled by a polio attack in his late 30s. The man playing the accordion is former U.S. Navy Chief Petty Officer Graham Jackson, who had become a Navy recruiter. Only the night before, Jackson had entertained Roosevelt and his guests at the "Little White House," where the photo was taken. Jackson was playing *Going Home,* a haunting melody from Czech composer Antonin Dvorak's symphony "From the New World."

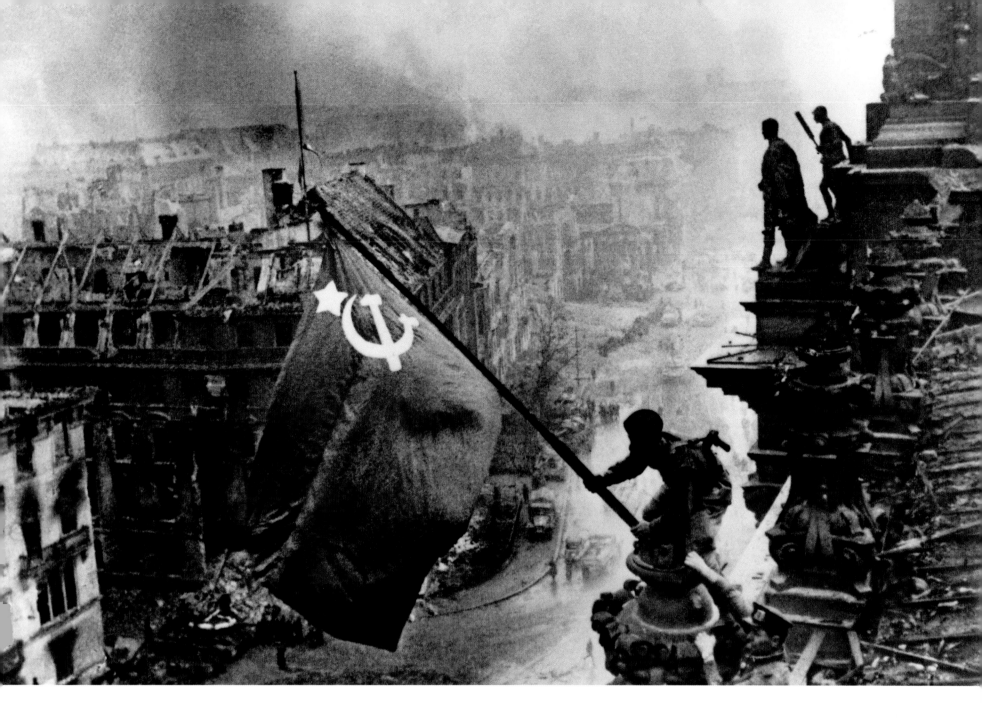

36

Berlin Armageddon
The Soviet Flag Flies Over the Reichstag • Yevgeny Khaldei • May 2, 1945

This is the Soviet Union's version of the Iwo Jima photograph: after almost four years of some of the most brutal fighting of World War II, and a last stand by desperate Germans in the streets of Berlin, the hammer and sickle of the U.S.S.R. is placed atop Germany's Reichstag building. Two days earlier, Adolf Hitler had committed suicide in his bunker, close to this site. Meliton Kantaria, the Georgian soldier placing the flag, seems to belong to the ranks of the statues of German heroes behind him: this Russian has taken a place in history. Photographer Yevgeny Khaldei brought the homemade flag along with him when he joined Soviet troops entering Germany, hoping to find an opportunity for a triumphant photo; in fact, Khaldei added smoke to the image in the darkroom to add impact. Today the Reichstag building has been restored and is crowned by a great glass dome, from which visitors can marvel at the modern German capital. But as with Britain's House of Commons, graffiti and bullet holes from the war were retained in its walls as witnesses to history.

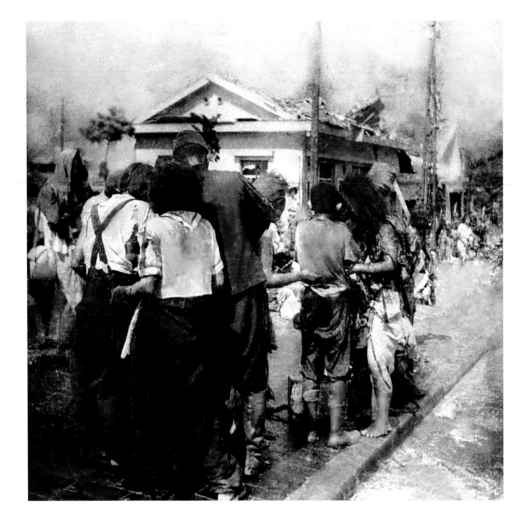

37
Shock Effect
Hiroshima After the Atom Bombing
Yoshito Matsushige • Aug. 6, 1945

The picture above is not well known, but it should be. Most photographs that depict the destruction of the Japanese city of Hiroshima by a U.S. atom bomb are panoramas that focus on the extent of the devastation days after the event. They are powerful but feel detached and aloof, failing to give us a sense of how the bombing affected those on the ground. The image above, taken in the first hours after the new weapon was detonated, has the punch of immediacy: it captures the horror of that morning on an individual level, as Japanese civilians, numb with shock, gather and face the direction of the bomb blast, which has left surrounding buildings in ruins.

Yoshito Matsushige was a newspaper photographer who took this picture about 1.4 miles (2.3 km) from Hiroshima's center, where the bomb was detonated. The five pictures he took that day are the only visual evidence we have of the city's residents reacting to the blast in the hours after it occurred. Matsushige died in 2005.

38
A Sign in the Sky
Mushroom Cloud over Nagasaki
U.S. Army Air Force Photographer
Aug. 9, 1945

In the decades that followed the end of World War II, the world was haunted by a single image, one first seen by the general public early in August 1945: the mushroom-shaped cloud that follows the explosion of an atom bomb.

U.S. scientists and military personnel were the first to see the unusual cloud when they detonated the first atom bomb, code-named Trinity, in the desert sands outside Socorro, N.M., on July 16, 1945. The cloud that issued from the Trinity blast rose some 38,000 ft. (11.6 km) into the sky; the cloud at right, which formed over Nagasaki, rose to about 60,000 ft. (17.7 km).

The bombing of Hiroshima and of Nagasaki three days later forced Japan to surrender, bringing World War II to an end—and ushering in a new "Age of Anxiety." The distinctive cloud became the shorthand visual symbol of nuclear war, the fear of which dominated global politics as the U.S. and U.S.S.R., allies against Germany and Japan in World War II but now enemies, built large arsenals of deadly nuclear weapons.

John Foster Dulles, Secretary of State under President Dwight D. Eisenhower, coined the term brinksmanship to describe diplomacy in the nuclear age, in which the two rival superpowers traded threats that led them to the brink of unleashing the potent new weapons. Beyond that brink lived a nuclear ogre: the fungus-shaped cloud.

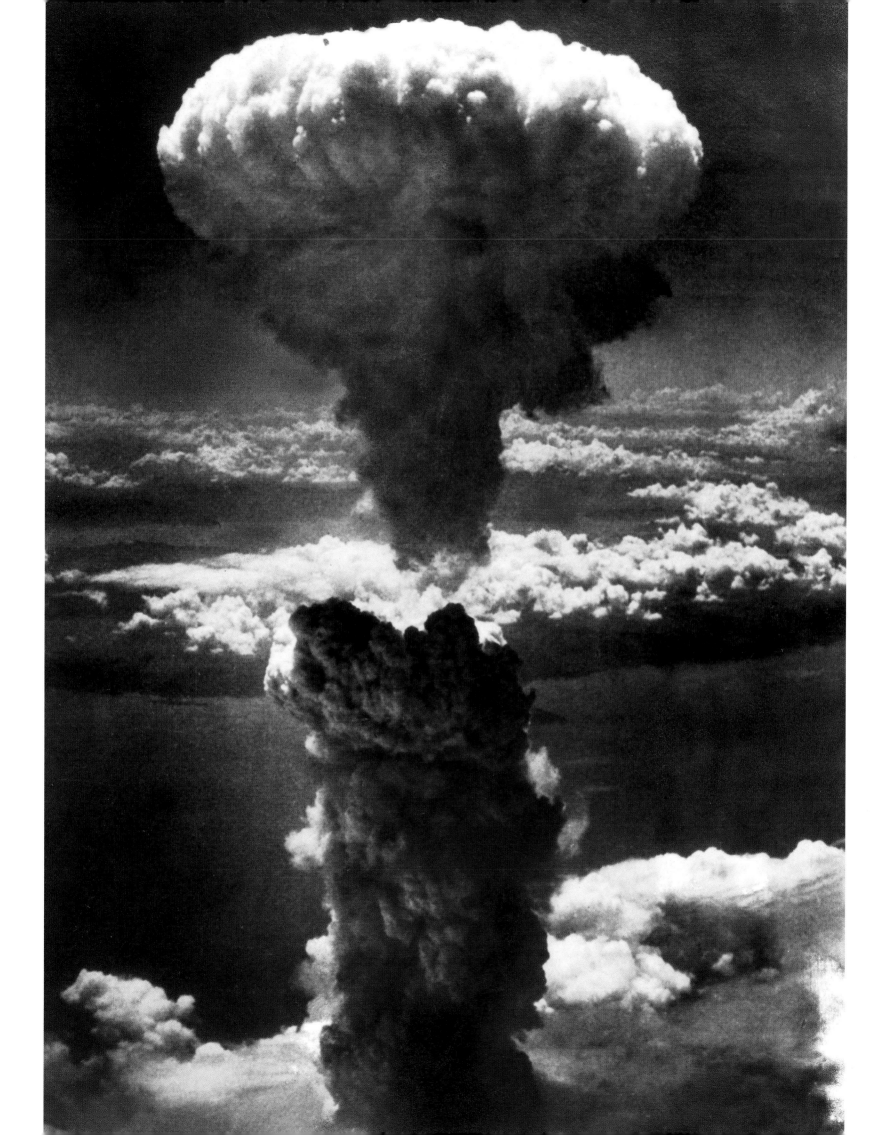

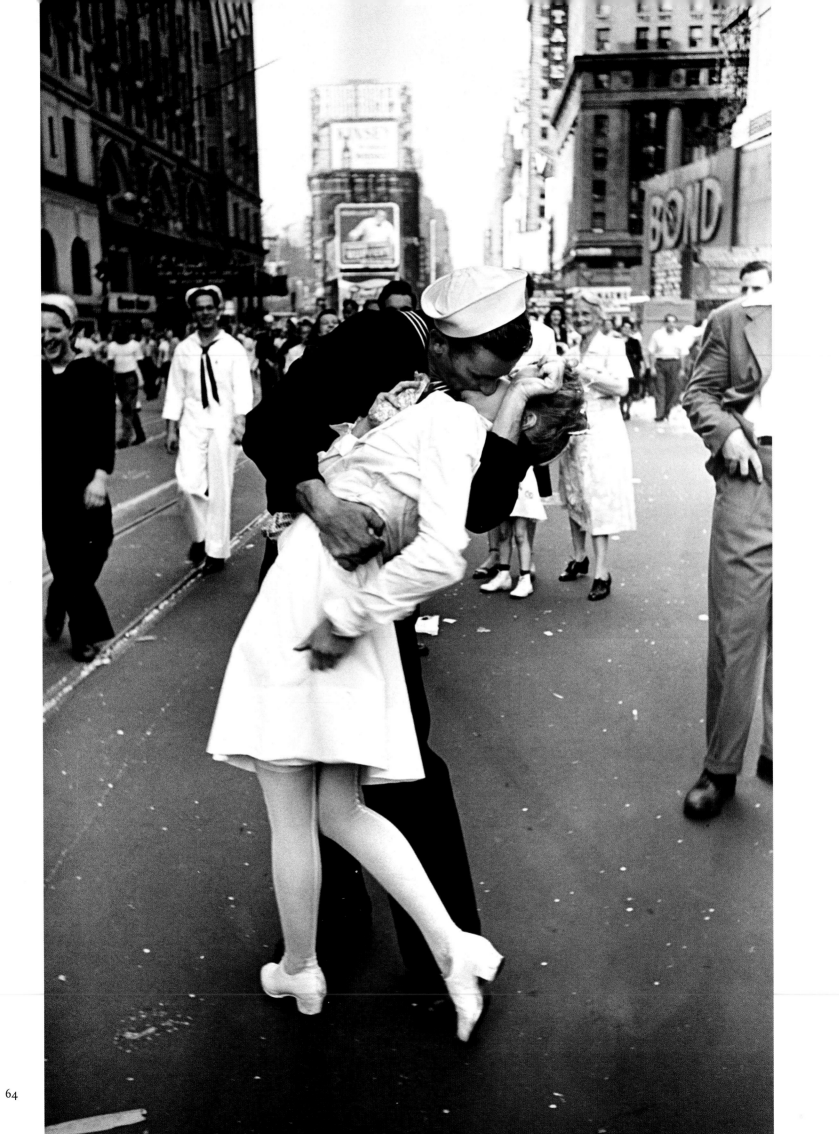

 39

The Decisive Moment
V-J Day in Times Square
Alfred Eisenstaedt • Aug. 14, 1945

Veteran photographer Alfred Eisenstaedt traveled around
the world for LIFE magazine, but to get his most famous
photo he only had to take a short stroll from his Manhat-
tan office to Times Square, where giddy Americans were
celebrating victory over Japan with a military parade. As
Eisenstaedt later recalled, he saw an exuberant sailor
"grabbing any and every girl in sight" and kissing each of
them. Eisenstaedt followed the sailor for a few moments
and ended up snapping this memorable image.

As with the picture of the flag-raising at Iwo Jima, it's the
composition of the figures, with the woman bending her
back to receive the kiss, that makes the scene so memorable.
A U.S. Navy photographer also captured this exact scene,
but his image isn't framed as well and lacks impact, while
Eisenstaedt's version shows what French photographer
Henri Cartier-Bresson called "the decisive moment."

40

Rough Justice
A Collaborator Is Scorned in France
Robert Capa • Aug. 18, 1944

Unlike World War I, in which the front lines became a
no-man's-land of trenches and defensive barriers that few
civilians ever saw firsthand, World War II swept local
residents into the fabric of the conflict. After the Allies
landed at Normandy and began to move slowly across
France, liberating towns and villages as they went, the
passions of the French people, freed from German rule after
four years, created vivid scenes like the one above, whose
drama is so profound that it almost needs no explanation.

In Chartres, near Paris, a local woman had become the
mistress of a German officer and had given birth to his
child. When the Germans withdrew, the townspeople took
their revenge for her collaboration. The young mother's
head was shaved in public, and Capa's camera recorded
the scene as a posse of townspeople, hooting and jeering,
hounded the outcast and her child through the streets.

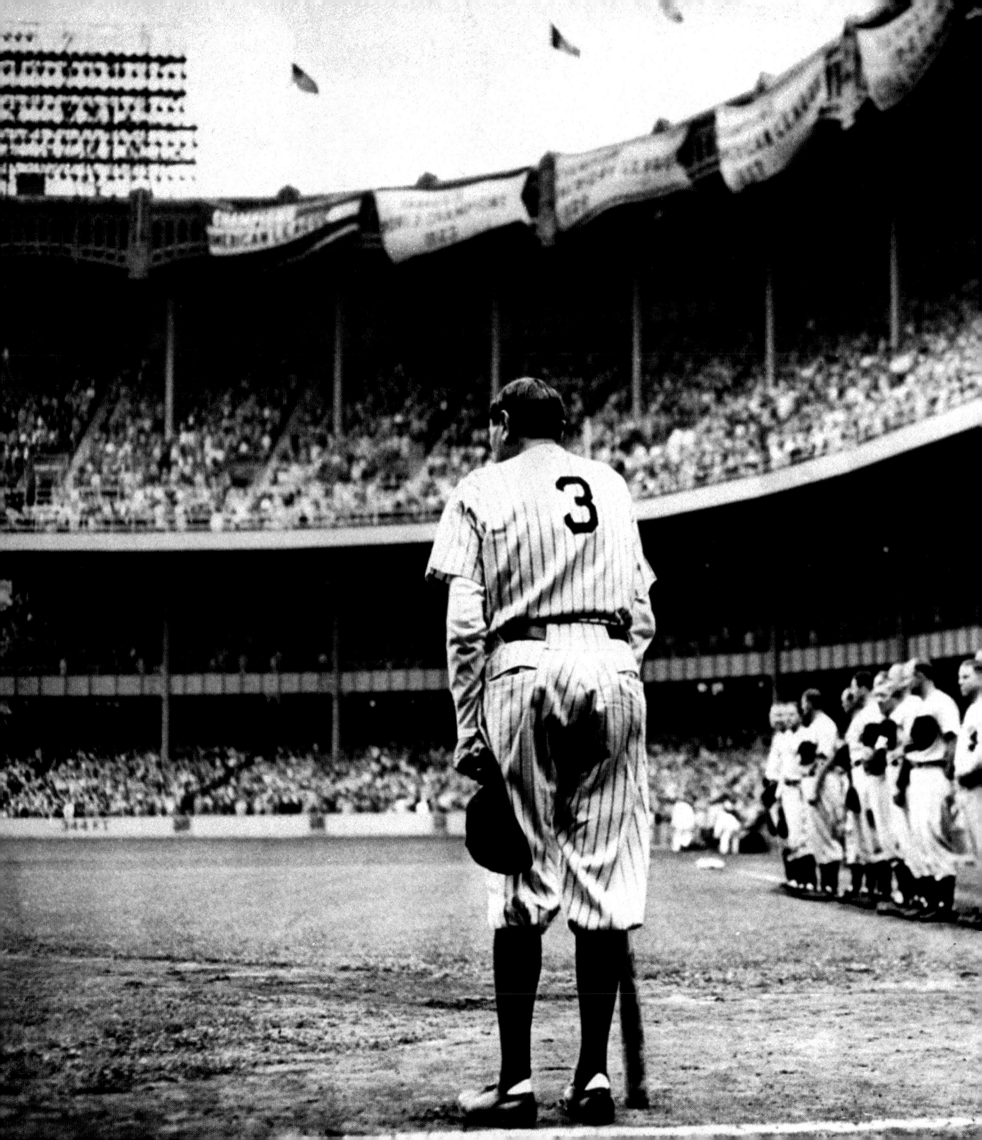

41

Last Hurrah
The Babe Bows Out
Nat Fein • June 13, 1948

Stricken for years by the throat cancer that would kill him, baseball's greatest player, Babe Ruth, returned to Yankee Stadium only two months before he died to celebrate the 25th anniversary of the opening of the ballpark, long since christened the House That Ruth Built. It was a gloomy day, but New York *Herald Tribune* photographer Nat Fein chose not to use a flash bulb to lighten his photo, whose subject is the darkness that eventually overtakes even those who live in the spotlight.

What is most fascinating about this photo, the first sports picture to win the Pulitzer Prize, is what it doesn't show. In contrast to the cameramen it captures at right, who are aiming to get a good portrait of Ruth, Fein did not show the player's familiar face: his subject is the legendary Ruth who transcends time, not the aging man wearing Ruth's uniform. And so it shows the world from Ruth's perspective, focusing on the stadium filled with fans, eager to pay their homage.

This is also a haunted photograph: the invisible presence in it is the young Ruth—the gifted, smiling, irrepressible Bambino—the Ruth of our memories, who no longer exists but is enshrined in our hearts. As former AP photo editor Hal Buell noted, the photo "allows the reader to take his own imagination and experience into the story." It's not a stretch to say that the subject of the photograph isn't Ruth himself; it is rather a meditation on the process of aging, the power of memory and the nature of fandom.

42

Truman 1, *Tribune* 0
Harry Truman Mocks a Newspaper's Error
W. Eugene Smith • Nov. 4, 1948

This photograph of President Harry Truman gleefully brandishing an edition of the Chicago *Tribune* that incorrectly reported his defeat by Republican Thomas E. Dewey in the 1948 presidential election is a classic. Aside from poking fun at every journalist's most dreaded nightmare, it also illustrates the President's good cheer and Happy Warrior persona. Right up to Election Day, both national polls and the majority of analysts had agreed that Dewey, then governor of New York State, would win the election easily over the Democratic incumbent.

Yet the experts had underestimated the appeal of Truman, who cast himself in the role of the plucky underdog and barnstormed the nation fighting against a "do nothing" Congress. Due to a printers' strike that forced early deadlines for the next day's paper, the *Tribune* went to press with an erroneous headline. Hours later Truman won, in one of the greatest upsets in a presidential race.

Two days after the election, as Truman was returning to Washington after his trip home to Independence, Mo., to vote, he was handed a copy of the paper in St. Louis and held it aloft for all to see. Photographer W. Eugene Smith snapped the moment.

GALLERY

W. Eugene Smith

Numerous news photographers captured the classic image of President Truman mocking the Chicago *Tribune* for its false headline. The cameraman behind the picture at left, W. Eugene Smith, was one of the foremost photojournalists of the 20th century.

A native Kansan who began his career at age 14 on Wichita's newspapers, Smith was critically injured on Okinawa in 1945 while on wartime assignment for LIFE magazine. After 32 operations and two years of convalescence, Smith returned to work on a series of memorable LIFE photo essays, including "Country Doctor" (1948), "Spanish Village" (1951) and "Man of Mercy" (1954).

In 1971 Smith moved to the Japanese fishing village of Minamata to begin a three-year task of recording the anguish of townspeople poisoned by mercury dumped into local waters by a chemical company. Although he was severely beaten and nearly blinded by company goons, he documented the tragedy in his book *Minamata*, published in 1975. Smith died in 1978. An intense, uncompromising craftsman, he strove to make timeless, pointed statements about the human condition. "Photography is not just a job to me," he once explained. "I'm carrying a torch with a camera."

Visual storyteller *Smith's powerful photo essays in* LIFE *magazine influenced a generation of young photojournalists. At top are three members of Spain's Guardia Civil. At bottom left is the "country doctor," Ernest Ceriani, in Kremmling, Colo. At bottom right is the German-French medical missionary Albert Schweitzer*

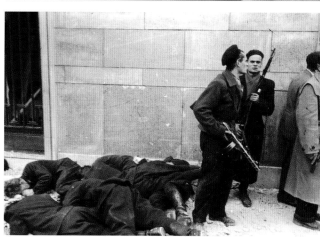

43

Deus ex Machina

The Berlin Airlift
Walter Sanders • July 1, 1948

After the capital city of Adolf Hitler's Third Reich, Berlin, fell to the Soviet army in 1945, its citizens confronted fresh challenges. The occupied city was divided into quarters whose governance was assigned to the U.S.S.R., the U.S., Britain and France. In effect, however, the city soon consisted of two sectors, East Berlin, under Soviet control, and West Berlin, controlled by the three Western nations. The city reflected the state of the German nation itself, now divided into East and West Germany.

On June 24, 1948, Soviet leader Joseph Stalin tightened the noose around Berlin, landlocked inside Soviet-controlled East Germany, shutting down railroad and highway access to the city. The Allies' brilliant solution was to airlift supplies into the besieged city. Allied planes conducted some 250,000 flights into Berlin in the next 12 months, providing as much as 7,000 tons of supplies to West Berliners each day.

LIFE photographer Walter Sanders carefully composed this photograph, which shows a U.S. C-47, illuminated by the rays of the sun, bringing in supplies as Berliners—their nation's plight indicated by the rubble they are standing upon—look to the heavens (and the West) for salvation. The original caption of the photo underscored the propaganda message, describing the citizens as "tattered," although in fact they appear to be well attired.

OTHER VIEWS

During the 1950s, many nations of Eastern Europe were landlocked under Soviet control behind what Winston Churchill memorably described as an "Iron Curtain." As a result, very little information—and almost no photographs—emerged to bear witness to life in the Warsaw Pact nations under the domination of the Kremlin.

One man who managed to penetrate the Iron Curtain was LIFE photographer John Sadovy, a Czech by birth, who crossed the border into Hungary (disguised as an ice-cream salesman) during the failed uprising of 1956. Among the pictures he smuggled out of Budapest is the sequence above, which shows members of the regime's police force emerging from their headquarters, where they were confronted by a large contingent of freedom fighters and quickly cut down by gunfire in cold blood.

In a LIFE editorial, Sadovy, who had photographed World War II for the British army, declared he had seen, "nothing to compare with the horror of this ... the tears kept running down my face and I had to keep wiping them away." Sadovy's photos of the doomed rebellion stirred the world, but it would be 34 more years before Hungary emerged from Soviet rule.

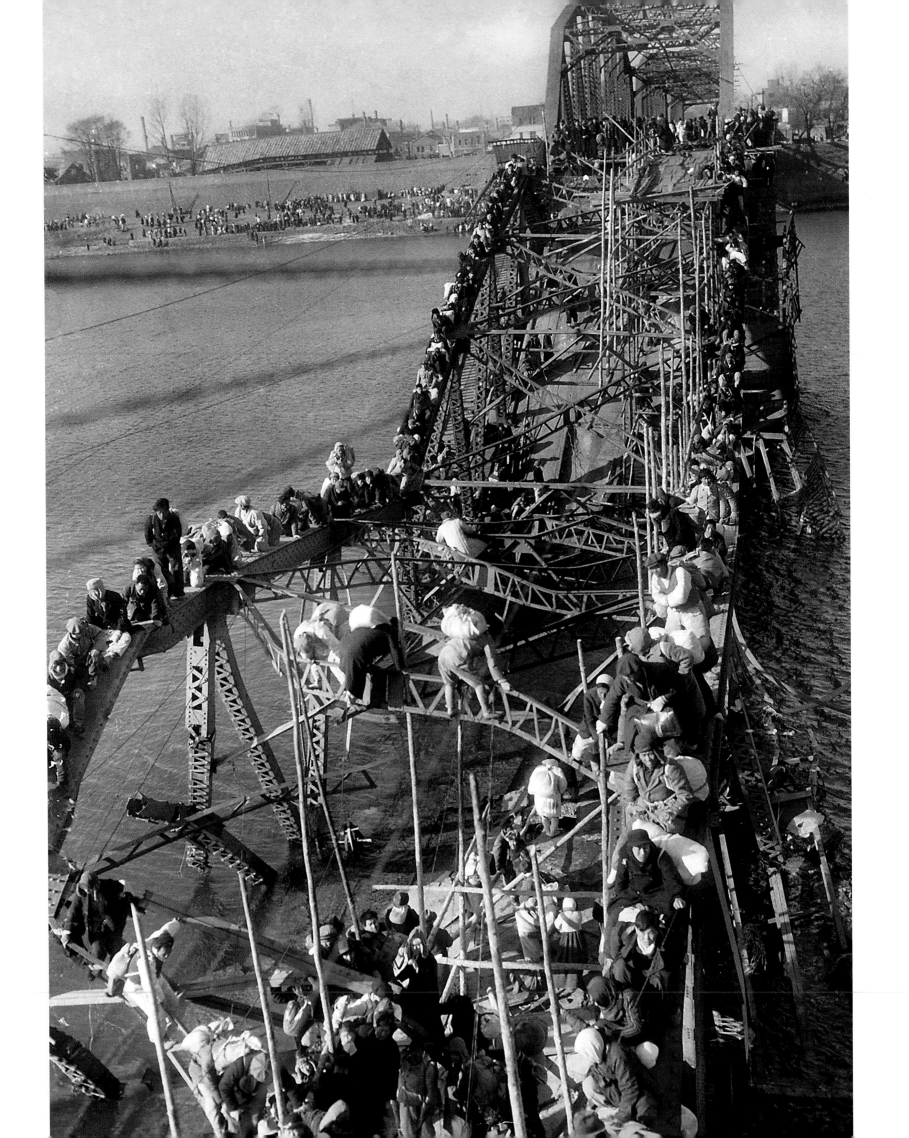

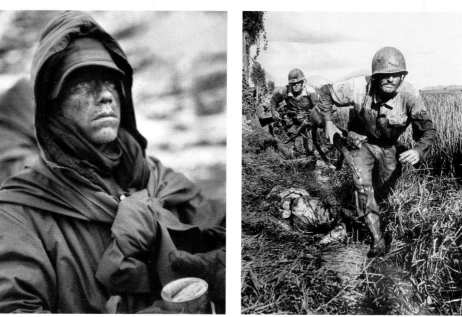

Crossing Over
*Flight of Refugees Across
Wrecked Bridge in Korea*
Max Desfor • Dec. 4, 1950

The photograph at left was taken by Associated Press cameraman Max Desfor, then 37, outside Pyongyang, North Korea's capital, during the Korean War. When troops from China joined the conflict on the side of North Korea, U.S. forces hastily retreated from the area and residents seized a last chance to escape their land before its communist rulers reasserted their authority. Capturing in arresting detail the appeal of democracies over dictatorships, the photo was awarded the Pulitzer Prize.

At a 2010 ceremony in Washington marking the 60th anniversary of the conflict, Desfor recalled the scene: "[I saw] Koreans fleeing from the north bank of the Taedong River, crawling like ants through and into and above and onto the broken-down bridge; it was like ants crawling through the girders. They had what little possessions they had strapped to their shoulders, and on the north side I saw thousands more lined up, waiting to do the same thing." What struck Desfor about the scene, he recalled, was not only the way it looked but also the way it sounded—or didn't sound: the exodus, he said, was conducted amid "deathly silence."

OTHER VIEWS

Max Desfor's magnificent image of North Koreans escaping to South Korea won the Pulitzer Prize, but the photographer most closely associated with the Korean conflict is David Douglas Duncan. Born in Kansas City, Mo., Duncan joined the U.S. Marine Corps in World War II, where he served as a photographer but also fought in an engagement on Bougainville Island, part of Papua New Guinea in the Solomon Islands.

After President Truman dispatched U.S. troops to the Korean Peninsula, Duncan completed a tour of duty as a photographer, then raced back to Korea when the war took a critical turn: Chinese troops entered the conflict, and a large contingent of U.S. troops had to execute a fighting retreat from the Chosin Reservoir in December 1950, during extreme winter conditions. Duncan's photos of the U.S. forces, including the three above, were collected in his 1951 publication *This Is War!* TIME called Duncan's images "the best and truest pictures of the Korean War." As of early 2012, Duncan, age 96, was still active—and still brimming with ideas for new books.

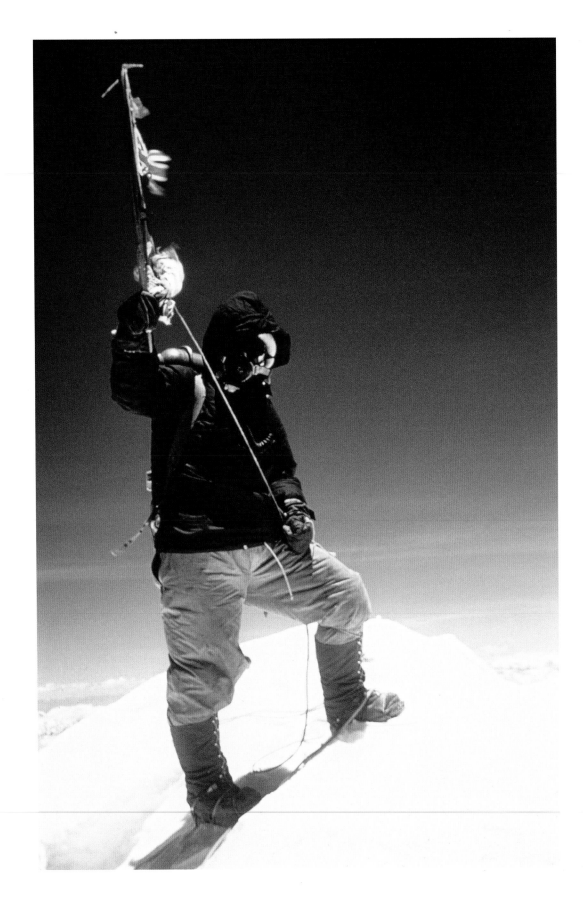

45

Reaching the Summit
Tenzing Norgay Atop Mount Everest
Edmund Hillary • May 29, 1953

Just as photographs can bear witness
to such human horrors as Buchenwald,
they can also serve as visual records of
the heights of human achievement.
The picture at left represents just such
a moment, when New Zealand bee-
keeper Edmund Hillary photographed
Sherpa mountaineer Tenzing Norgay
as they became the first climbers to
reach the summit of the world's highest
peak, Mount Everest, standing 29,035 ft.
(8,850 m) above sea level. In one of
history's more providential conjunc-
tions, news that the long-awaited
conquest of Everest had been achieved
by a citizen of the British Common-
wealth reached London on the morning
Queen Elizabeth II was crowned.

The two men's feat was one of the last
landmarks in old-fashioned exploring;
the men later sent into space by the U.S.
and U.S.S.R. were the tip of a gigantic
pyramid of effort, their flights made
possible by hundreds of scientists and
engineers. In contrast, when Hillary
and Tenzing returned from the summit
to the advance camp high on the
mountain, where other expedition
members awaited them, there was
little formality involved. "Well, George,"
Hillary said to fellow climber George
Lowe, "we've knocked the bastard off!"

46

A Barrier Broken

Roger Bannister Runs a Sub-Four-Minute Mile
Norman Potter • May 6, 1954

In the days when the term "amateur athlete" was not an oxymoron, a British medical student, Roger Bannister, then 25, achieved a landmark that had been pursued by runners for decades: he became the first person to run a mile in less than four minutes. His time: 3 min., 59.4 sec. The achievement came at a track meet held at Britain's Oxford University. Bannister, who later became the master of Pembroke College at Oxford, claimed that the chief barrier to his feat was psychological, not physical. His point was driven home when legions of runners soon began matching, even outpacing, his record time, and a goal that had once seemed unattainable became commonplace.

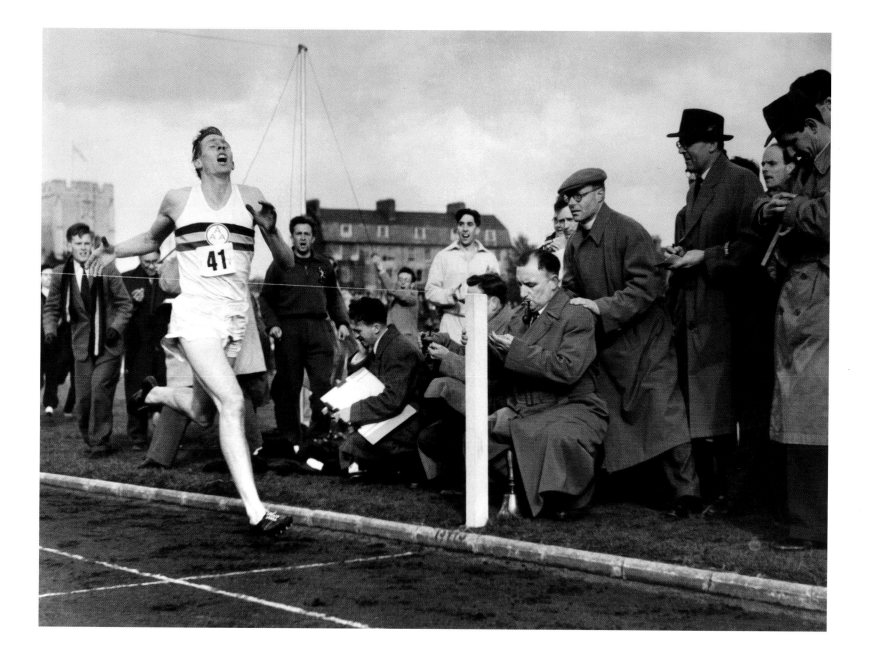

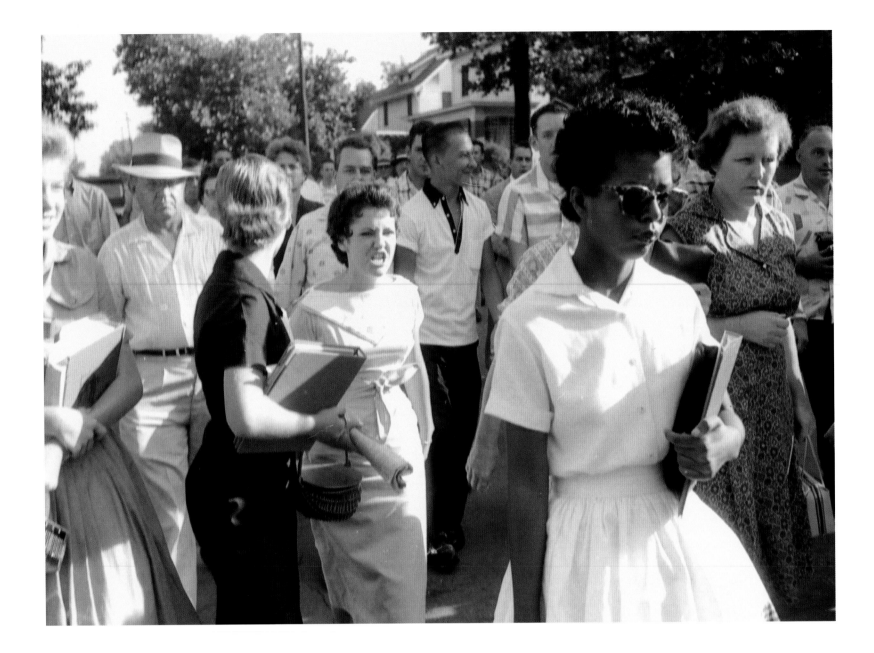

47

Hatred and Grace
First Day of School in Little Rock • Will Counts • Sept. 4, 1957

Wearing her Sunday best, African-American student Elizabeth Eckford, 15, walks
bravely toward Central High School in Little Rock, Ark., weathering the taunts of locals
opposed to the school's integration, mandated by the U.S. Supreme Court. Eckford was
one of nine black students, dubbed "The Little Rock Nine," who attempted to enroll in
the all-white school that day. The black students had planned to meet up earlier that
morning and enter the school together, but Eckford faced a hostile crowd of hundreds
of people alone: her parents didn't own a telephone, and she wasn't informed of the
meeting place. As tensions mounted in Arkansas, President Dwight D. Eisenhower
sent federal troops to ensure the students' safety. In a happy coda to this scene of racial
prejudice, the white student yelling insults behind Eckford, Hazel Bryan, later apolo-
gized to Eckford and for some years the two were allies in the cause of racial justice.

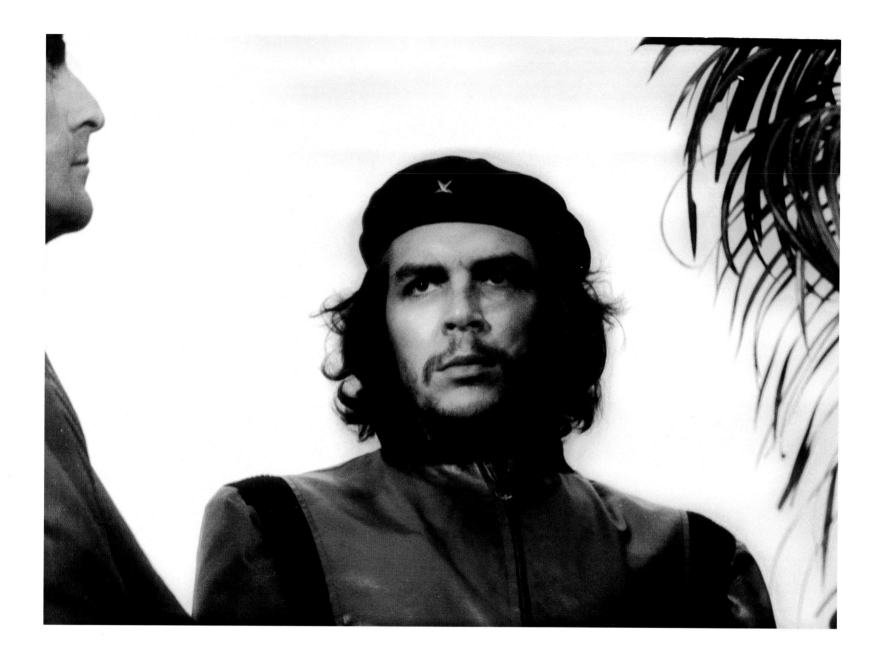

48

Constructing an Icon

Che Guevara • Alberto Korda • March 5, 1960

Argentine physician Ernesto ("Che") Guevara joined the Cuban revolutionaries led by Fidel Castro in time to take part in their 1956 attempt to unseat dictator Fulgencio Batista, a failed invasion of the island by boat. Castro and Guevara regrouped their forces and succeeded in ousting Batista on Jan. 1, 1959. The photo of Guevara above was taken by Alberto Korda, a favorite photographer of the revolutionaries, at a memorial service for workers who died in the explosion of the French munitions ship *La Coubre* in Havana Harbor. Guevara's biographer, Jon Lee Anderson, said it captured Che's air of "absolute implacability."

In 1967 Irish artist Jim Fitzpatrick adapted Korda's black-and-white photo into the red-hued graphic portrait of Guevara that has become a global symbol of revolution, an image that has often been described as one of the most compelling and widely recognized visual icons of the 20th century. An ardent supporter of the revolution, Korda helped spread the image around the world by refusing to charge royalties for its use—although in 2000 he successfully sued the makers of Absolut Vodka for using it in an ad campaign.

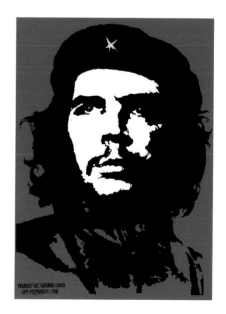

Enter Charisma

John F. Kennedy at Inaugural Ball
Paul Schutzer • Jan. 20, 1961

The watershed years of the 1960s were jump-started by one of the great generational changes in U.S. life, as Massachusetts Senator John F. Kennedy, only 43, was elected to the presidency in 1960, replacing World War II hero Dwight D. Eisenhower, 71. The new President reinforced the message of change in his Inaugural Address, in which he declared, "The torch has been passed to a new generation of Americans—born in this century, tempered by war, disciplined by a hard and bitter peace, proud of our ancient heritage …"

Everything about Kennedy—his good looks and glamorous wife, his large Irish clan, his Boston accent, his wealthy and notorious father, his heroism in the South Pacific in the war, his Hollywood connections—conspired to make him fascinating. In the photo of Kennedy's Inaugural Ball at the National Guard Armory in Washington at left, even the light that spills down the central corridor seems to surround the young President with a shining aura, an effect perhaps assisted by slight retouching in the darkroom. So powerful was J.F.K.'s magnetism that political journalists began using a then little-known term derived from Greek, *charisma,* to describe it.

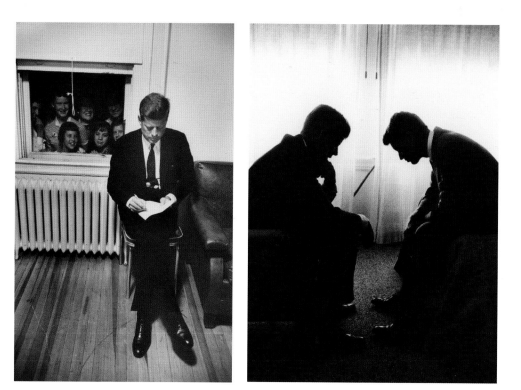

OTHER VIEWS

Paul Schutzer, the Time-Life photographer who took the picture of the new President on the opposite page, also took the photo above left of J.F.K. going over notes for a speech on the road during the 1960 presidential campaign. The backstage view of the candidate and his giddy window-peepers has the sort of charm often found in the paintings of Norman Rockwell.

The new President's closest adviser and campaign manager was his younger brother, Robert F. Kennedy. After J.F.K. was elected, he surprised Americans by naming R.F.K. to be his Attorney General. Another Time-Life photographer, Hank Walker, captured the two brothers conferring in a hotel room on the campaign trail in July 1960 in a photo that has become well known.

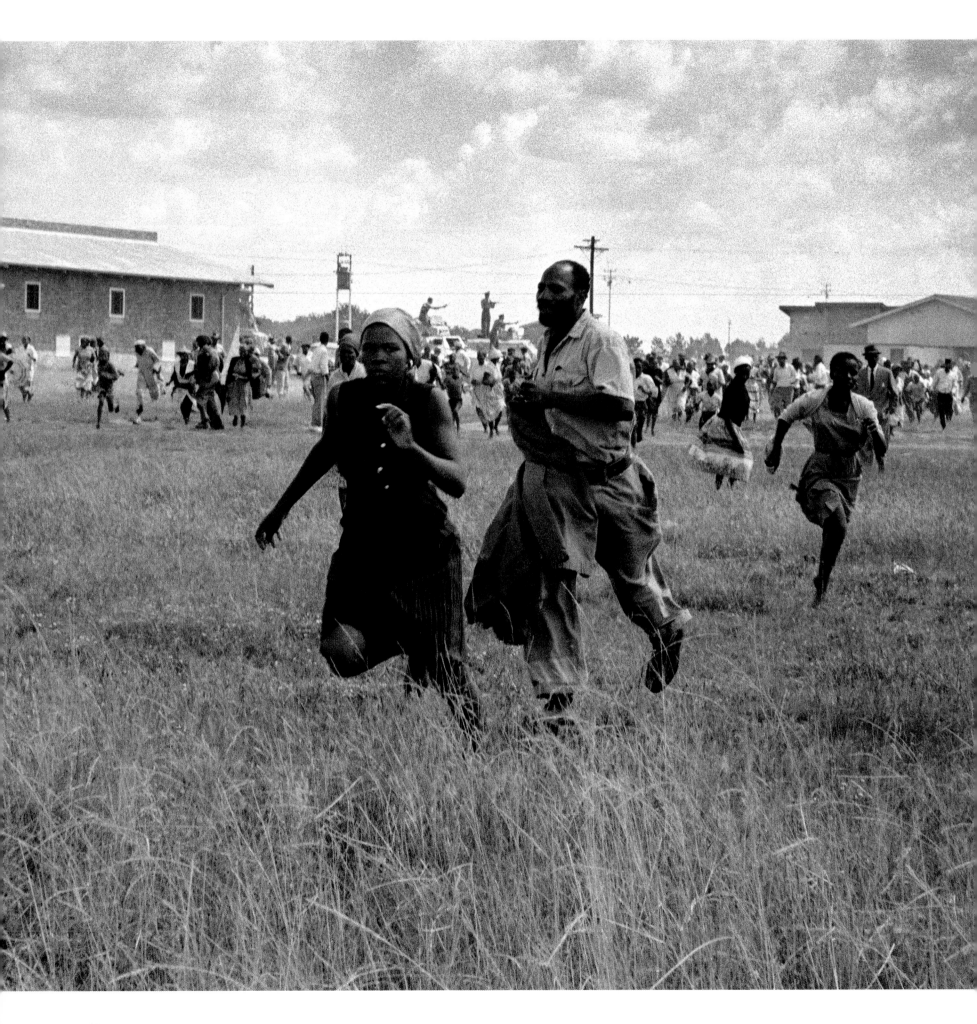

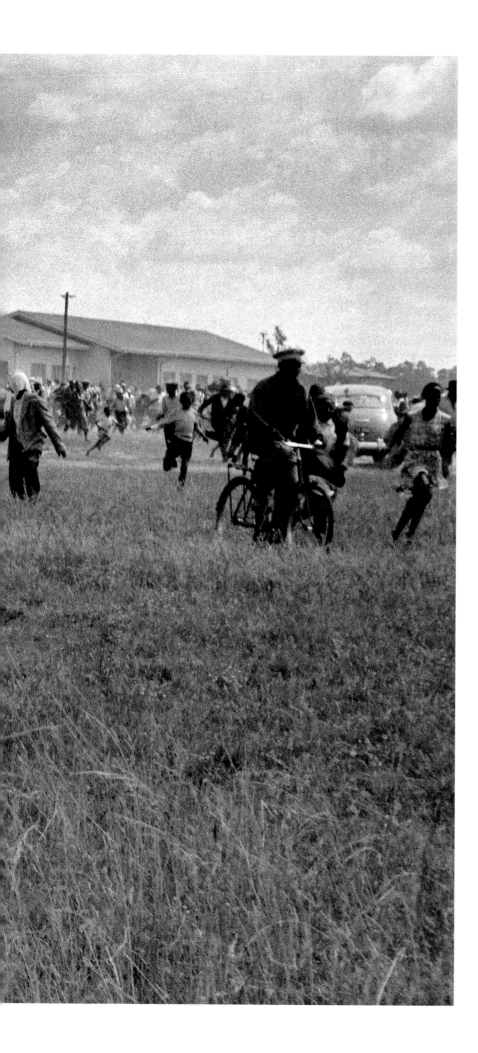

50

South Africa's Shame
The Sharpeville Massacre
Ian Barry • March 21, 1960

The Sharpeville Massacre was a turning point in South Africa's history, galvanizing opposition to its racist apartheid regime both inside and outside the nation. In March 1960, as antiapartheid sympathies were rising among native blacks, the Pan Africanist Congress organized a day of nationwide protest against the pass laws, under which South African blacks traveling outside bogus native "homelands" created by the regime were ordered to carry passbooks listing their name and address. The laws were used to enforce racial segregation, restrain blacks' movement and harass those working against the government.

On the protest day in Sharpeville, in the Transvaal region (now Gauteng), some 20 white policemen were assigned to control a crowd of black citizens demonstrating at the police station that grew to number in the thousands. When some 130 reinforcements arrived, along with armored cars, matters got out of hand, and the police fired repeatedly into the crowd; in Ian Barry's powerful picture, the police can be seen atop the cars, firing, as the panicked citizens run directly toward the photographer's lens.

By day's end, 69 people were dead, many shot in the back while fleeing, and 180 were injured. Thirty-six years later, the nation's first black President, Nelson Mandela, came to Sharpeville to sign South Africa's new constitution, which enshrines equal justice under law for citizens of every race.

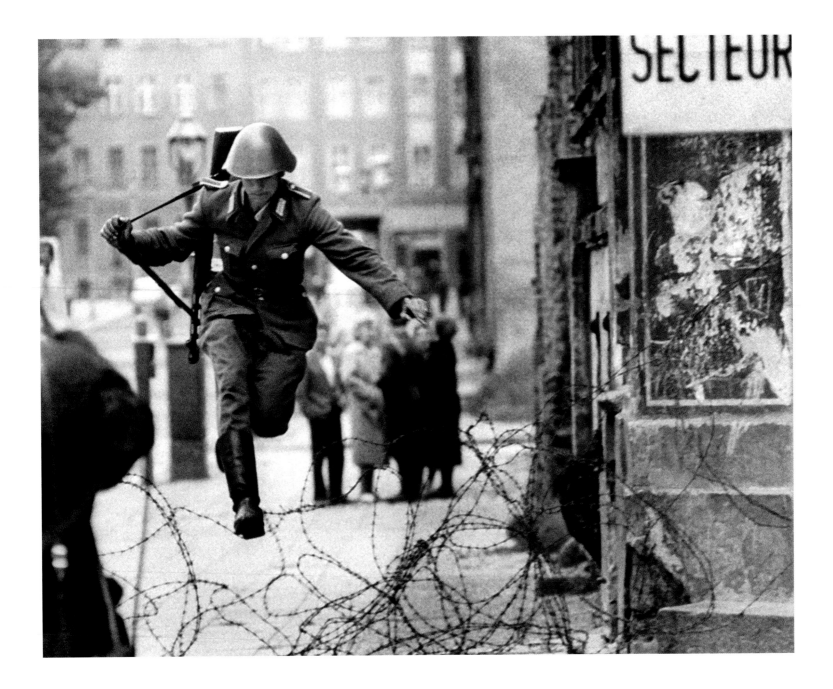

51

One Small Step for a Man ...

An East German Soldier Leaps to Freedom • Peter Leibing • Aug. 15, 1961

As the 1960s began, Soviet leader Nikita Khrushchev was determined to take the measure of the untested young U.S. President, John F. Kennedy. The two held a summit meeting in Vienna in June 1961, where Khrushchev spooked Kennedy with a show of bluster. "I never met a man like this," Kennedy told Hugh Sidey, TIME's longtime White House correspondent. "[I] talked about how a nuclear exchange would kill 70 million people in 10 minutes, and he just looked at me as if to say, 'So what?'"

Convinced Kennedy was an idealist with no spine for conflict, Khrushchev tightened the screws on Berlin. In August he ordered the East Germans to create a barrier to separate the Soviet sector of the city, occupied since World War II, from those of the Western Allies. In its early days, the barricade was only a barbed-wire fence, and East German soldier Conrad Schumann leaped over it, defecting, as a crowd of West Germans chanted *Komm rüber!* ("Come on over!"). Cameraman Peter Leibing caught the moment.

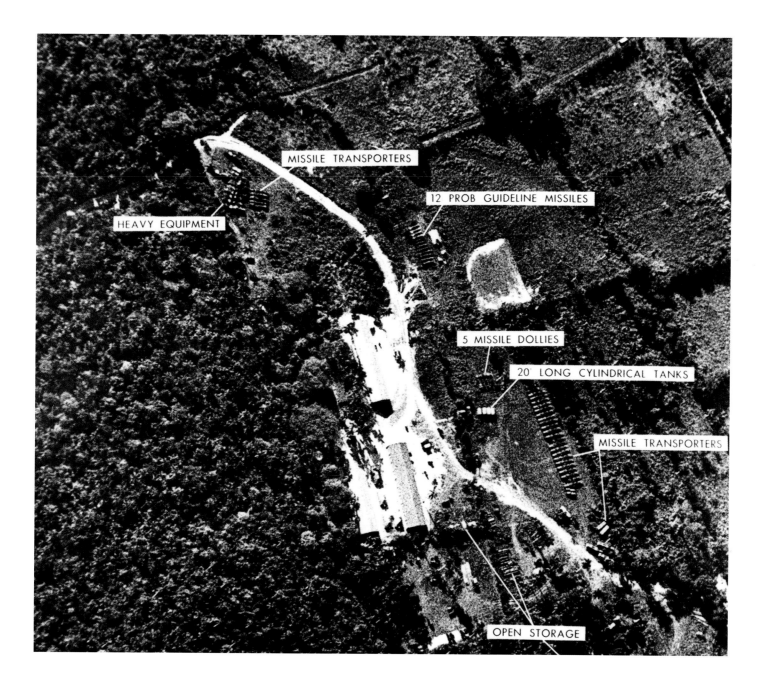

Labels on image: MISSILE TRANSPORTERS · 12 PROB GUIDELINE MISSILES · HEAVY EQUIPMENT · 5 MISSILE DOLLIES · 20' LONG CYLINDRICAL TANKS · MISSILE TRANSPORTERS · OPEN STORAGE

52

A Crisis Driven by Photography

Soviet Missile Base in Cuba • Camera aboard U-2 aircraft • Oct. 14, 1962

War is often the mother of invention, and during the cold war the technology of photography advanced rapidly as the world's two superpowers vied to improve the surveillance of each other's military activities. In 1957 the U.S. began deploying the U-2, a reconnaissance airplane designed to fly at heights far above the reach of Soviet artillery. The secret aircraft carried a new camera that could resolve images of objects as small as 2.5 ft. (76 cm) from an altitude of 70,000 ft. (21,336 m). In the early fall of 1962, U-2 images showed Soviet missiles being deployed in Cuba, within striking distance of the U.S. mainland; further evidence of the presence of the missiles was offered by cameras aboard lower-flying U.S. Navy aircraft.

The U.S. government provided the photos to the media to back up President John F. Kennedy's demand that the U.S.S.R. remove the missiles. As Dino Brugioni, the CIA imagery expert who interpreted the images, later recalled, "One of the things that was very impressive to me was that the photography was driving the crisis."

53

No Words Required
Birmingham Police Dog Assaults a Student
Bill Hudson • May 3, 1963

Drawing on the playbook of Mohandas Gandhi, Martin Luther King Jr. and other leaders in the fight for black civil rights found that the power of their cause was amplified when they created situations that forced the evils of racism into plain view. In the spring of 1963, King led a campaign to desegregate the businesses of Birmingham, Ala., sending protesters, many of them young children, to march in support of integration and more jobs for local blacks. The city's police chief, Bull Connor, dispatched police dogs to intimidate the marchers and turned fire hoses on them.

The picture at right shows high school senior Walter Gadsden, 17, being assaulted by a police dog. Gadsden was not among the marchers; he was playing hooky from school and watching his classmates demonstrate. The picture ran in large format on the front page of the New York *Times* on May 4, 1963, causing President John F. Kennedy to call the events "shameful" and to declare that they were "so much more eloquently reported by the news camera than by any number of explanatory words."

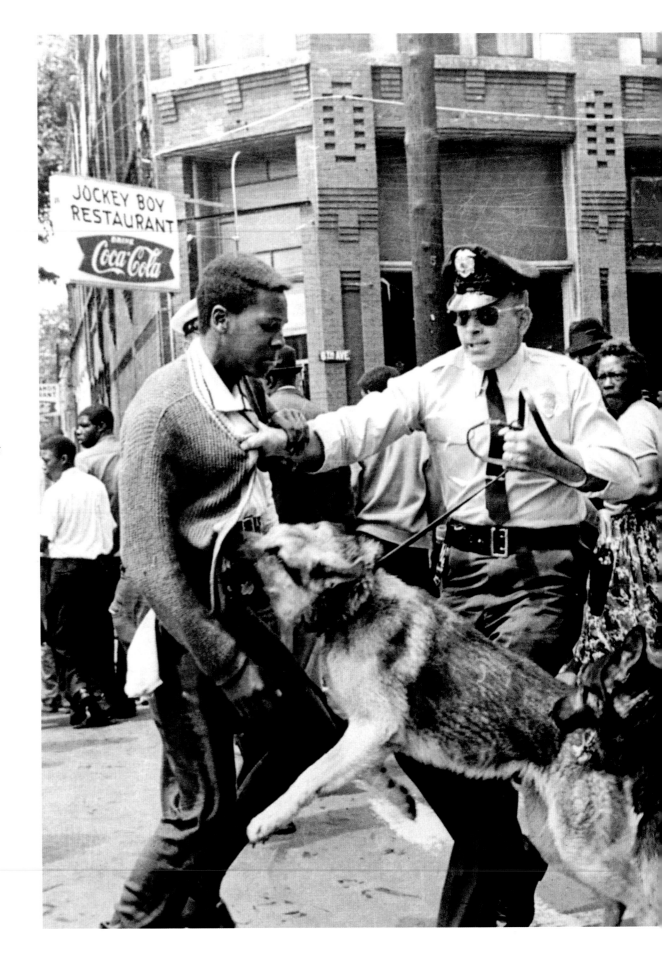

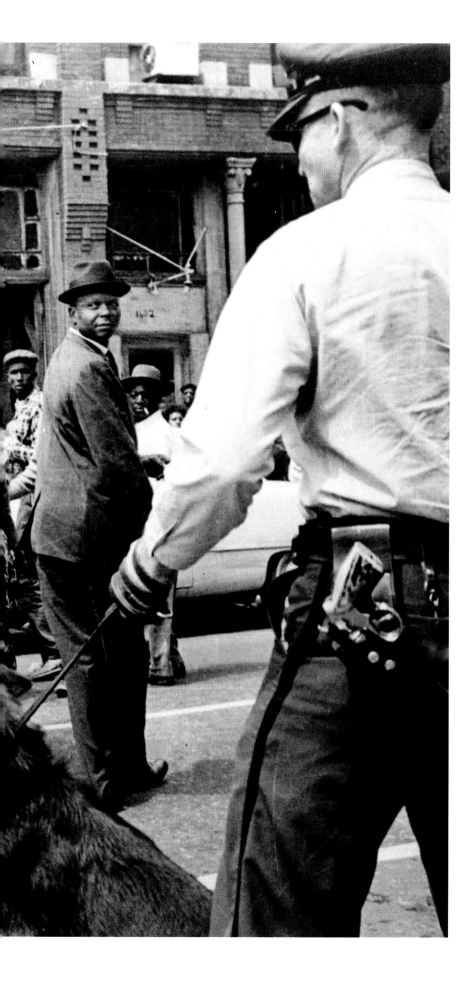

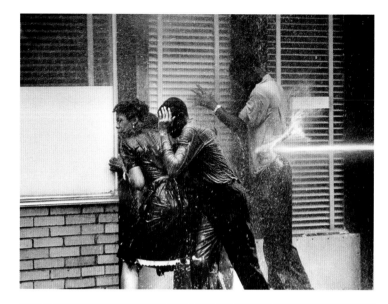

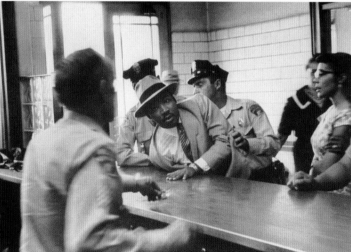

OTHER VIEWS

Many of the most memorable photos of the 1963 civil rights battle in Birmingham, including the top picture above, were taken by Alabama-born Charles Moore and published in LIFE magazine. Moore began covering the civil rights movement when he was working as a photographer for a Montgomery, Ala., newspaper in 1958. It was that year when he shot the famous photo above of Rev. Martin Luther King Jr. being roughed up by police when he was booked for "loitering" as he led a protest march in Montgomery. In 1962 Moore became a freelancer; he spent the next few years documenting the struggle for civil rights, a mission that took him from the streets of Birmingham to a Ku Klux Klan rally in North Carolina.

When Moore died in 2010 at 79, Paul Hendrickson, author of *Sons of Mississippi: A Story of Race and Its Legacy*, wrote in TIME: "If great photojournalists know where to stand, Charles Moore knew where to be. He was there in all the right places of our civil rights imagination. This small, wiry white Southerner had his lens, and his courage, at the ready."

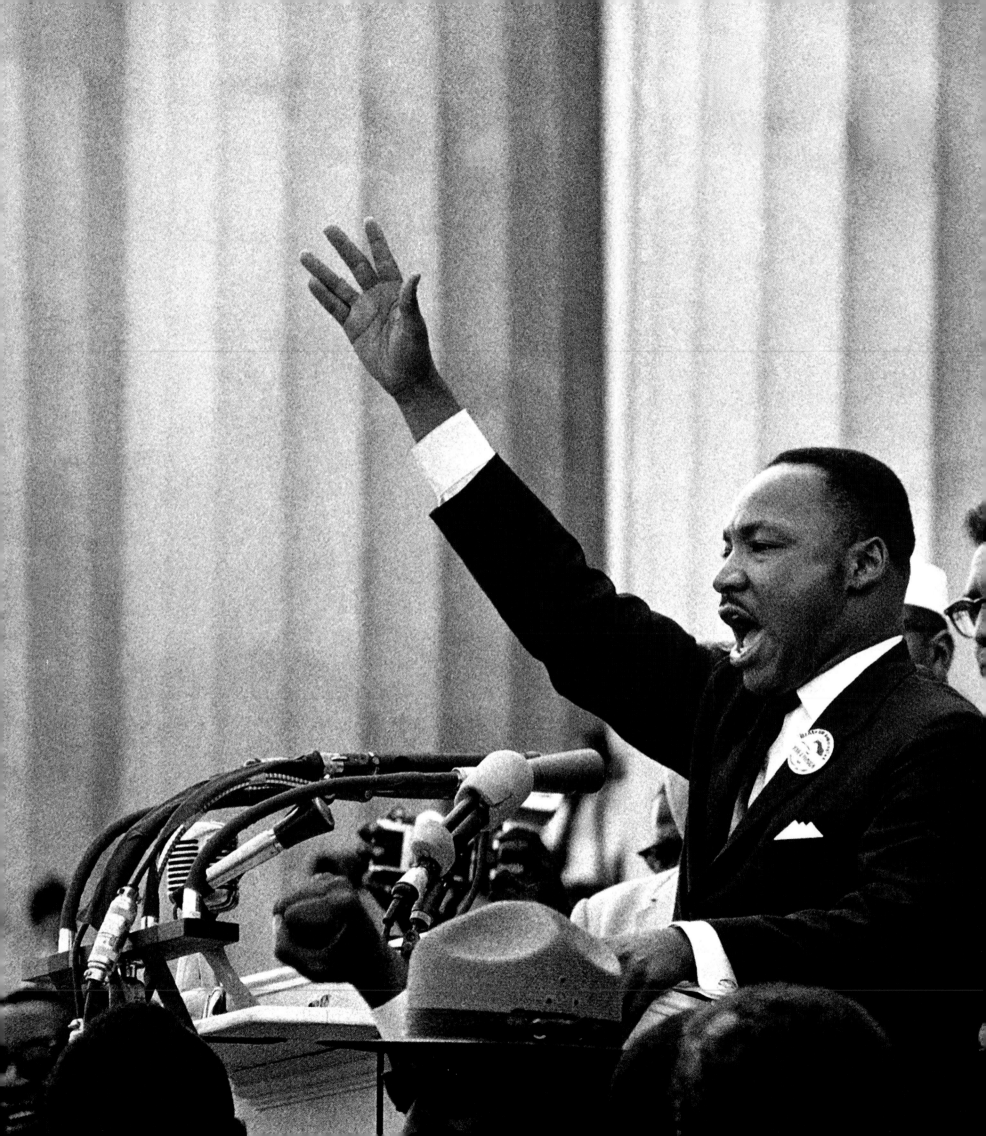

54

"Free at Last!"

Martin Luther King Jr. Speaks at the March on Washington
Bob Adelman • Aug. 28, 1963

Growing up on Long Island in the 1930s, "I didn't know any black people to speak of," Bob Adelman recalled in an interview with the Palm Beach *Post* in 2010. But moved by the battle for civil rights—"What they were doing was so courageous"—Adelman moonlighted from his job under legendary design director Alexey Brodovitch at *Harper's Bazaar* to become a volunteer photographer for the Congress of Racial Equality and recorded many highlights of the struggle for racial justice.

The photograph at left was taken as the Rev. Martin Luther King Jr. reached his peroration in the "I Have a Dream" speech at the March on Washington, invoking the words of an old spiritual: *"Free at last! Free at last! Thank God almighty, we are free at last!"* Adelman was highly aware of the heritage of photography as an instrument to achieve social justice. He told Britain's *Guardian* newspaper in 2008, "My great hero was Lewis Hine, a wonderful photographer, very idealistic."

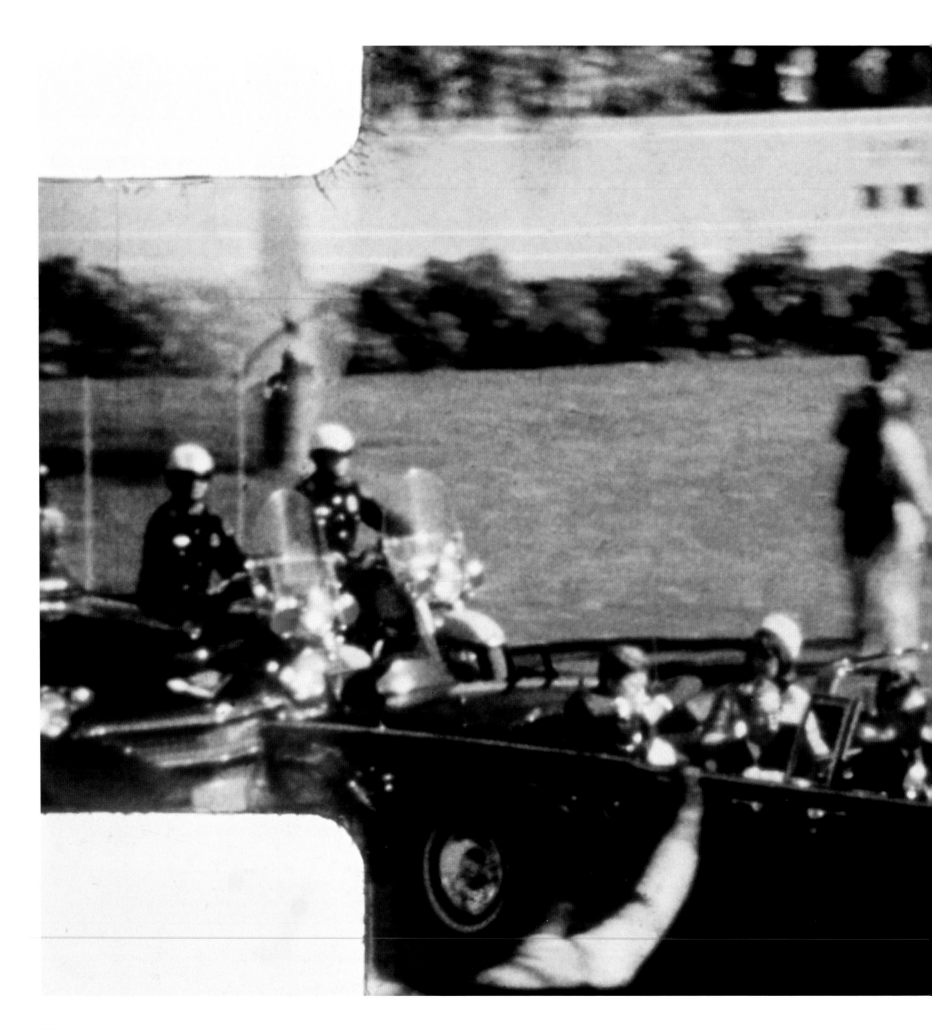

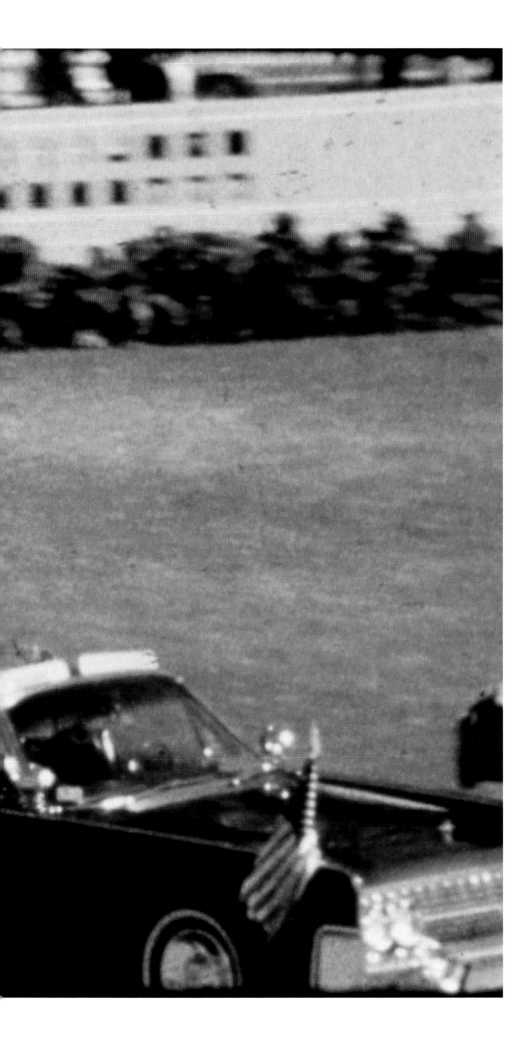

55

Tragedy at 18 Frames a Second
President Kennedy Struck by Bullet
Abraham Zapruder • Nov. 22, 1963

Perhaps the most closely scrutinized images of the 20th century are the 486 frames that make up the 26.6-sec.-long film shot by Dallas dress manufacturer Abraham Zapruder that records the assassination of President John F. Kennedy. Although other footage of the president's motorcade exists, none of it shows in detail the exact moment in Dealey Plaza when the President was hit by rifle fire. Zapruder, who immigrated to the U.S. from Ukraine at 15, was a Kennedy admirer who brought his 8-mm camera along with him when he set out on his lunch hour to watch the motorcade.

Landing in Dallas hours after the event, LIFE magazine Pacific Coast editor Richard Stolley learned of the film's existence; the next morning he met with Zapruder and bought the rights to it. Time Inc. paid Zapruder $150,000 for the film; he donated $25,000 of the money to the widow of Dallas police officer J.D. Tippit, murdered by Lee Harvey Oswald shortly after the assassination. In 1975, five years after Zapruder's death, Time Inc. resold the rights to the film to his family for $1; the original footage is now preserved in the National Archives.

56

Emergency Inauguration
Lyndon B. Johnson Is Sworn In
Cecil Stoughton • Nov. 22, 1963

Only two hours after President Kennedy's assassination, Vice President Lyndon B. Johnson was sworn in as President by federal judge Sarah T. Hughes aboard *Air Force One*. Jacqueline Kennedy, still wearing the pink ensemble from the motorcade that bore her husband's blood, insisted on being present. As TIME's White House correspondent Hugh Sidey recalled, "Aides from both staffs and a handful of reporters [were] leaning and pushing against one another to witness this historic moment." White House photographer Cecil Stoughton, who had taken some 8,000 pictures of the Kennedy family in the previous years, took the only photograph of the most unusual Inauguration in U.S. history.

57

Hail and Farewell
John Kennedy Jr. Salutes His Father's Casket
Stan Stearns • Nov. 25, 1963

Countless histories of the 1960s have recounted how the Kennedy assassination was the first memorable national event to play out in real time on every TV set in the land, binding Americans together in a new sort of electronic community. Yet it is the images from still photographs of that bleak weekend in November 1963 that remain in the mind's eye, including this poignant photograph of 3-year-old John Kennedy Jr. saluting his father's flag-draped casket after the funeral, as it was placed on a caisson that would take it to Arlington National Cemetery. The First Lady had reminded her son that his father, a decorated World War II veteran, had taught him to salute the flag when it passed.

58

The Horror Continues

Jack Ruby Shoots Lee Harvey Oswald • Robert H. Jackson • Nov. 24, 1963

Presidential assassination suspect Lee Harvey Oswald grimaces as he is shot at point-black range by nightclub owner Jack Ruby only 47 hours after President Kennedy was killed in Dallas. The murder occurred in the basement of the Dallas police headquarters, as Oswald was being transferred to the nearby county jail. It also took place in a far more important arena: the activities were being broadcast across the nation, and the shooting was seen by millions of Americans, already grieving over Kennedy's death, live in their homes. Yet it is newspaper cameraman Robert H. Jackson's Pulitzer-prizewinning image that remains our primary visual impression of Oswald's murder.

Earlier, Jackson missed a chance for a potentially more historic photo: he reported that he was riding in the presidential motorcade on Nov. 22 when he saw a rifle barrel protruding from a sixth-floor window of the Texas Schoolbook Depository after shots rang out, but Jackson's camera was out of film, and he could not record what he saw.

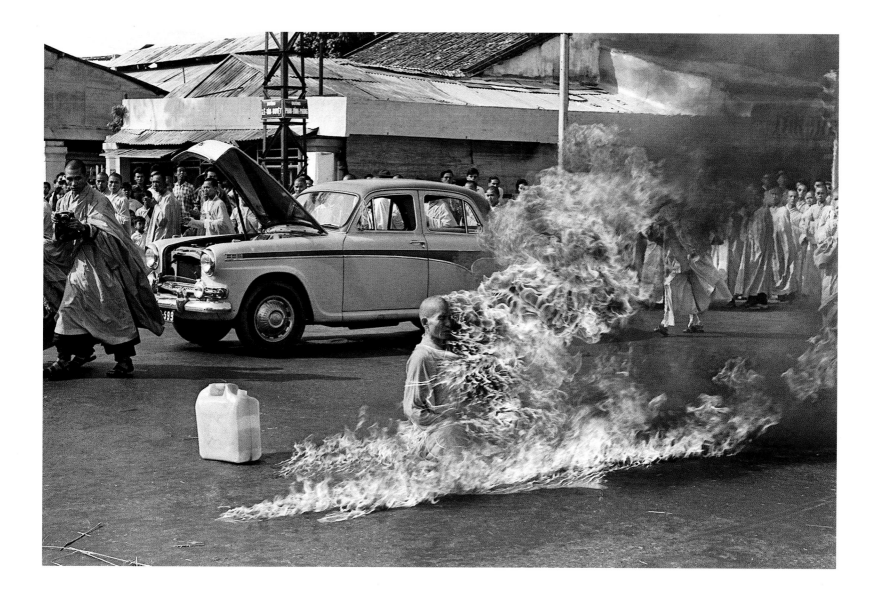

59

"He Never Moved a Muscle"

Buddhist Monk Self-Immolates • Malcolm Browne • June 11, 1963

This horrifying image shows South Vietnamese Mahayana Buddhist monk Thich Quang Duc in the act of self-immolation. In 1963 relations between the regime of Roman Catholic President Ngo Dinh Diem and the nation's many Buddhists grew strained, as Diem outlawed practices central to their religion. On June 11, reporters Malcolm Browne of the Associated Press and David Halberstam of the New York *Times* watched as several hundred monks and nuns paraded to a major intersection in Saigon and assisted Duc in his suicide, which Browne photographed. Halberstam reported, "As he burned, he never moved a muscle, never uttered a sound."

The deceased monk's heart remained intact, his Buddhist supporters claimed, a sign they declared a blessing. In one of history's ironic echoes, the Arab Spring movement that rocked the Middle East in 2011 was begun by the self-immolation of Tunisian street vendor Mohamed Bouazizi, 26, who set himself afire on Dec. 17, 2010, to protest governmental injustice.

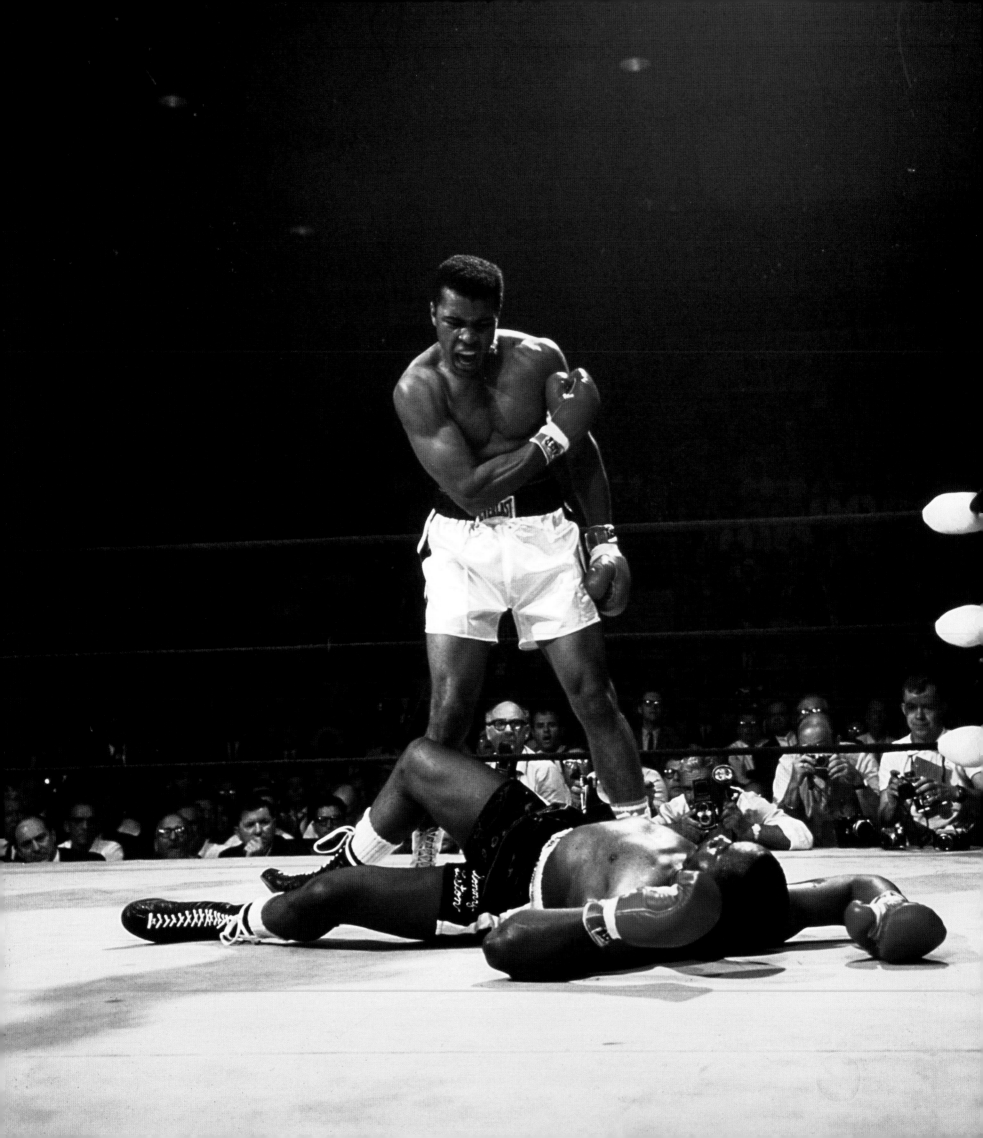

60

A Championship Image
Muhammad Ali Taunts Sonny Liston
Neil Leifer • May 25, 1965

This picture of triumphant young heavyweight Muhammad Ali jeering at Sonny Liston in the first (and last) round of their brief second title match in Lewiston, Maine, is widely considered one of the greatest sports photographs ever taken. When SPORTS ILLUSTRATED published a book titled *The Century's Greatest Sports Photos,* Neil Leifer's image was on the cover. Years later, speaking of taking the famous picture, Leifer said, "There's no sport I enjoy photographing as much as boxing. The atmosphere of a big-time fight—the crowd, the fashion show, all the celebrities—is electric … This image represents the way people want to remember Ali: strength, confidence and braggadocio."

The photo is also historic because it marks the dawn of a new era, as athletes became more involved in social issues in the 1960s, and U.S. blacks divided over their relationship to the majority white culture. Ali, who at 23 was 10 years younger than Liston, had beaten the older boxer in a match in Miami Beach on Feb. 25, 1964, to win the heavyweight title. At that time the young fighter was still known by his birth name, Cassius Clay. Soon after that match, Clay, to wide derision, declared he was a Black Muslim and adopted the name Muhammad Ali. Before the second match, the outspoken, brash Ali successfully—and unfairly—portrayed Liston as a representative of the old order, both as a boxer and as a black man all too eager to get along in an America dominated by whites. For many Americans, Ali's victory over Liston became a symbol of a social revolution that was roiling every aspect of the landscape. Sports, and the times, were changing—fast.

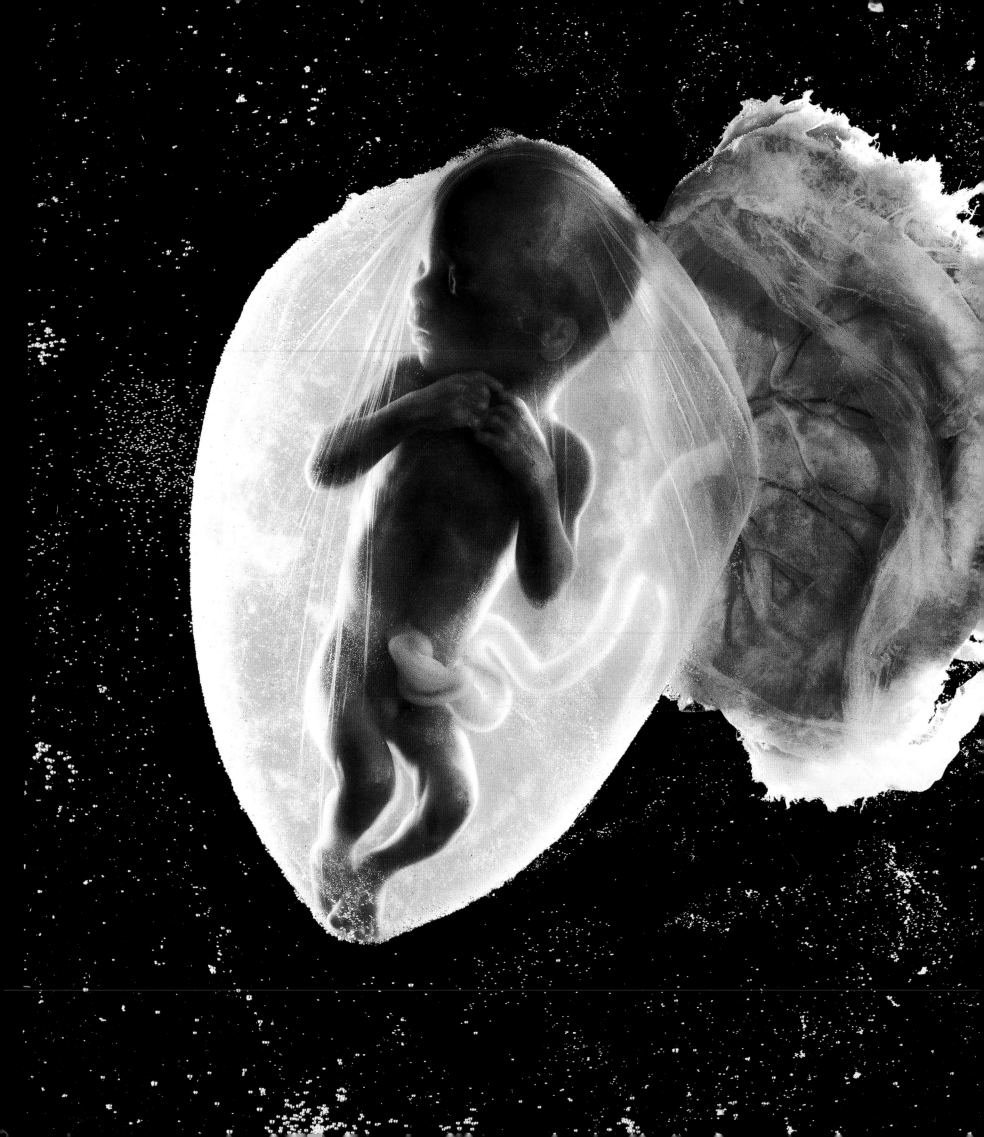

61

A World Unveiled
Eighteen-Week-Old Human Fetus
Lennart Nilsson • Circa 1965

The original prospectus for LIFE magazine described the goal of the publication as follows: "To see life; to see the world; to eyewitness great events … to see things thousands of miles away, things hidden behind walls and within rooms … to see and be amazed; to see and be instructed." Perhaps no LIFE photo essay achieved that outsized ambition more powerfully than the revelatory images of the human embryo taken by Swedish photographer Lennart Nilsson and featured in a 16-page portfolio in the magazine's April 30, 1965, issue. Here were photos that showed us something we had never seen before: an embryonic human before birth.

Nilsson took some of the photos with a tiny camera fitted on an endoscope, a thin, pliable tube just coming into medical usage in the mid-1960s; he worked closely with the creators of the device to make the photos. Other images, controversially, were taken of embryos that had miscarried or had been aborted for medical reasons.

Though he will turn 90 in 2012, Nilsson continues to create remarkable images of our world, often working with advanced imaging devices. Based at the Karolinska Institute, a medical university in Stockholm, he pursues the work he described in a 2001 interview on PBS's *Nova* show: "We try to create or see something which has not been known before—just to discover something together. This is always my dream."

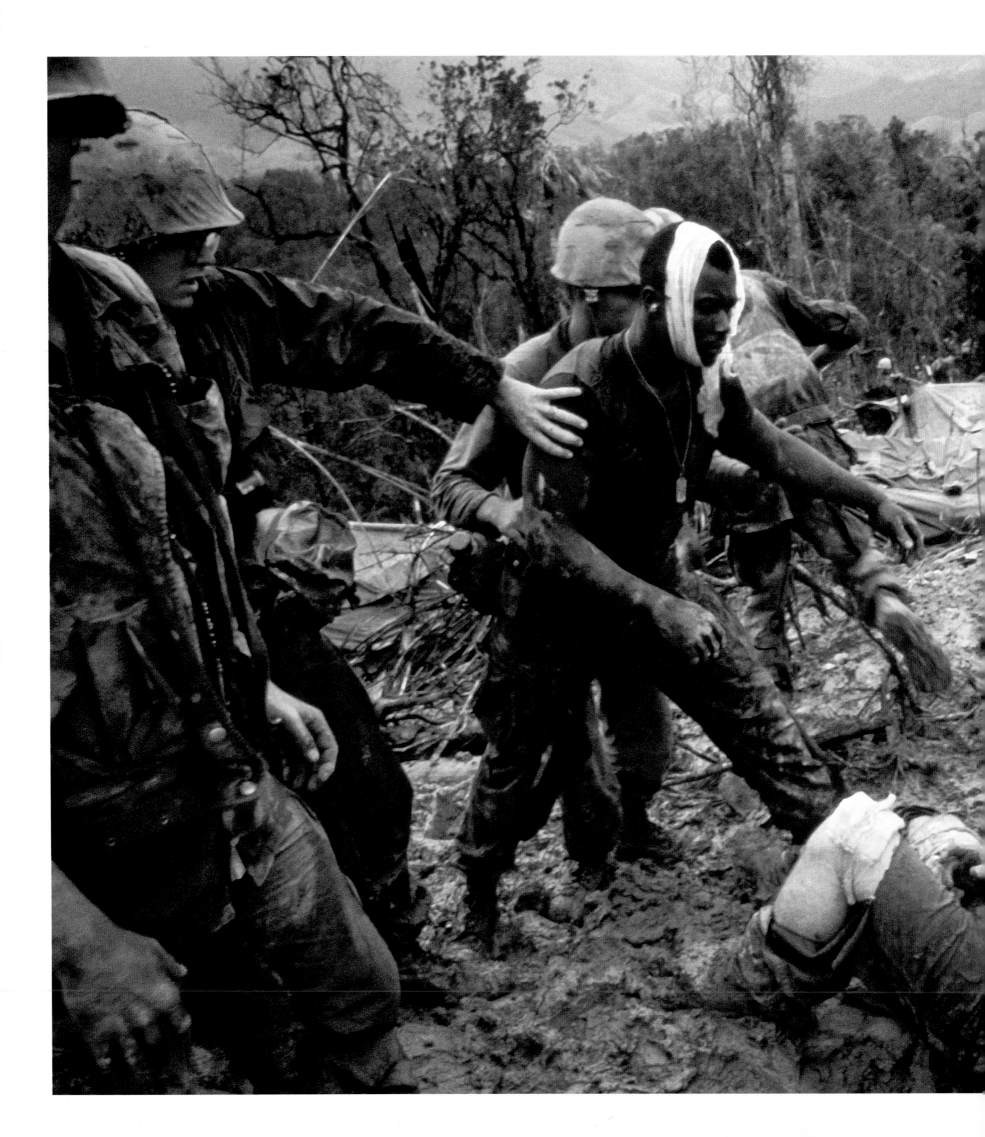

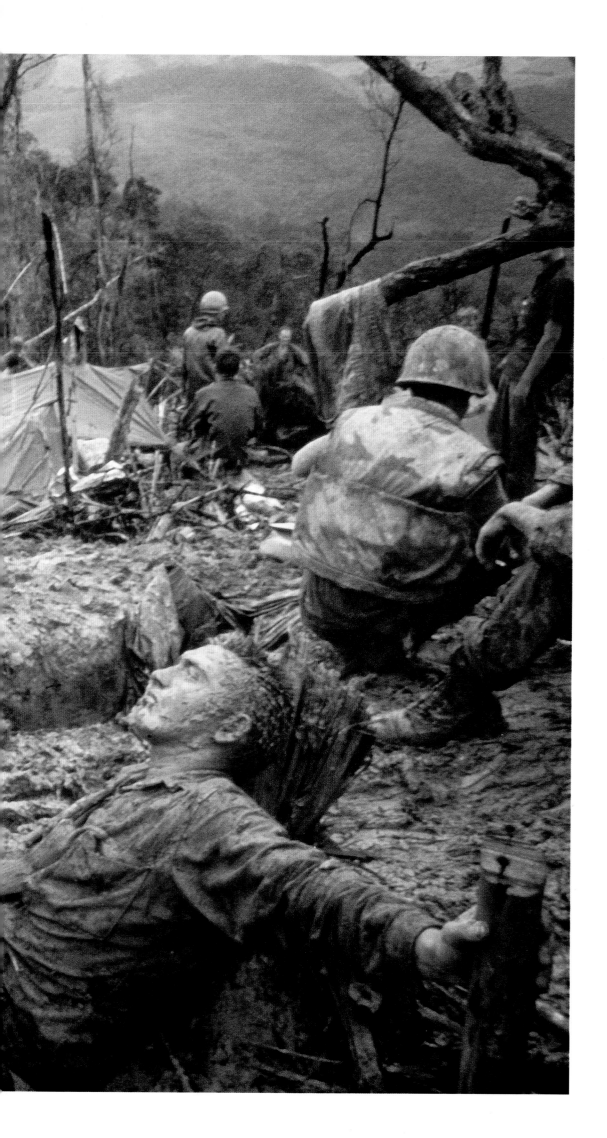

62

Semper Fi
Reaching Out
Larry Burrows • Oct. 5, 1966

Briton Larry Burrows joined the London office
of LIFE magazine in 1944 at age 18, working
first as an errand boy and rising to become a
lab technician who developed the photos taken
by such combat photographers as Robert Capa.
Inspired by their work, Burrows began shooting
conflicts in Africa and the Middle East. In 1962
he arrived in Vietnam to cover the divided land,
and over the next nine years, he chronicled the
struggle as it became a major war.

Burrows spent a great deal of time in the
field and became close with the troops, most
often Marines, that he photographed. In
Reaching Out, the wounded Marine with the
makeshift bandage is Gunnery Sergeant
Jeremiah Purdie, who survived and was sent
home; it was his third wound, qualifying him
for discharge. Years later, Purdie's wife told
Paris Match magazine that a print of the photo
hung in their living room, helping Purdie feel
connected to those Marines who never made it
home from the war. Purdie died in 2005.

Burrows was killed in 1971 when antiaircraft
fire struck the helicopter in which he was riding
with three other photographers in Laos. The
wreckage of the craft, its location unknown for
decades, was found in 1998; near it were strips of
corroded film and bits of shattered lenses, along
with remnants of a Leica camera that was later
traced to Burrows. Scant remains of the four
photographers were found and identified; they
were placed in a memorial at the Newseum, a
museum of journalism in Washington, in 2008.

63

A Revolution Begins, Swimmingly

Chairman Mao Swims in the Yangtze • Photographer unknown • July 16, 1966

China's leader Mao Zedong was 72 in 1966, as he prepared to launch the Great Proletarian Cultural Revolution, an all-out attack on his own party's entrenched leadership. After months of plotting to "bombard the headquarters," as he phrased his intentions, Mao staged one of his greatest acts of political theater, joining aides to take a vigorous swim in the Yangtze River, as thousands watched from the shore.

Photos of the swim were widely circulated in China and abroad, a signal that Mao, at bottom, was in robust health—and that he was ready to do battle with his critics in the Communist regime. Propagandists declared that the Chairman had swum nearly 9 miles (15 km) in 65 min. that day—a world-record pace, if true. The contention alarmed foreign observers, who took the nonsensical claim as a sign that China was descending into political madness. Sadly, they were correct.

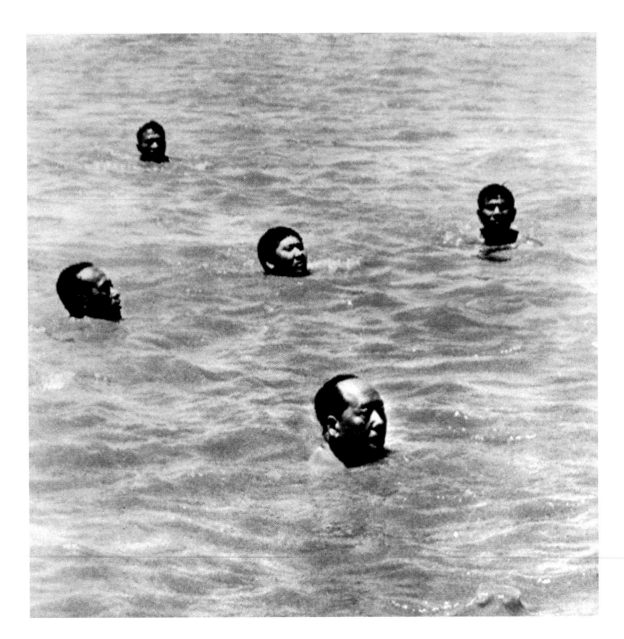

64

Make Love, Not War

Flower Power • Bernie Boston • Oct. 21, 1967

As the battle over the future of the divided nation of Vietnam escalated in the mid-1960s, China and the Soviet Union supported North Vietnam's longtime anticolonialist Ho Chi Minh, while President Lyndon Johnson committed more and more U.S. troops to aid the pro-Western South Vietnamese government. By late 1967, more than 450,000 young Americans were fighting in Southeast Asia, and the Department of Defense had begun drafting young men to serve in a war that many Americans neither fully understood nor supported. As antiwar protests heated up, primarily on college campuses, the faraway war drove a cleft through U.S. society, already splitting along fault lines of young and old, black and white, liberal and conservative. "America: Love it or leave it," declared the hawks; "Make love, not war," replied the doves.

In a major rally late in 1967, some 100,000 antiwar marchers gathered at the Lincoln Memorial in Washington, and many of them walked to the Pentagon to protest the war. Some protesters carried flowers as signs of peace, creating a memorable image of the nation's divisions for Washington *Star* photographer Bernie Boston.

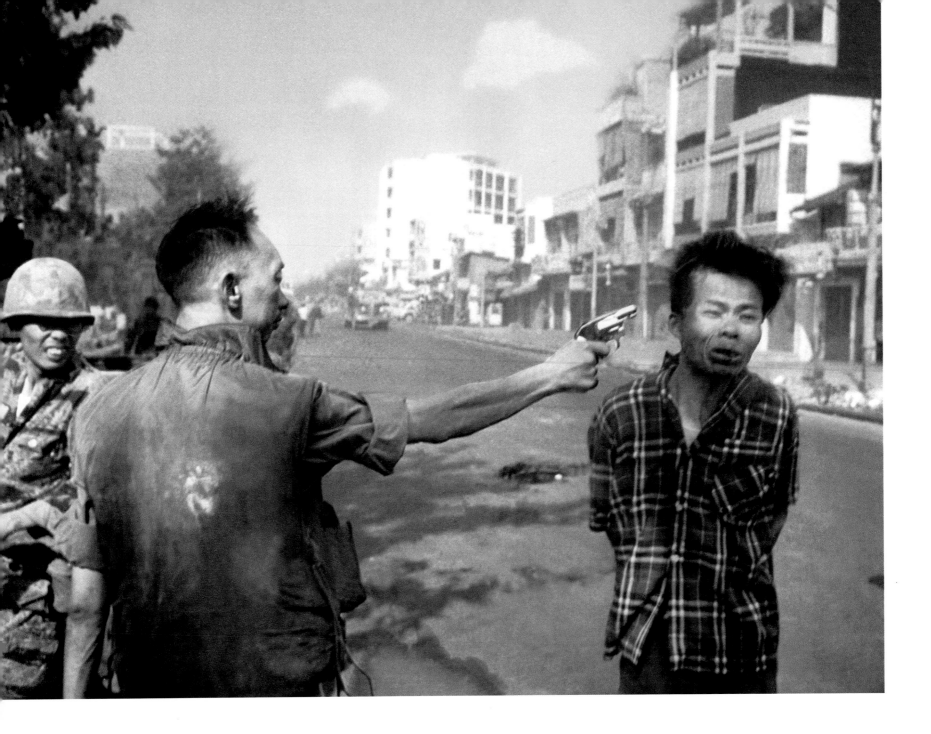

65

Judge, Jury and Executioner

Saigon Execution • Eddie Adams • Feb. 1, 1968

In one of the most infamous photos of the Vietnam era, General Nyugen Ngoc Loan, chief of South Vietnam's National Police, executes a Viet Cong soldier at point-blank range on a Saigon street during the Tet Offensive. The image helped turn U.S. public opinion away from the nation's ally in the war, and it was awarded the Pulitzer Prize for spot news photography. After Saigon fell to the North Vietnamese in 1975, Loan immigrated to the U.S., where he operated a pizza parlor outside Washington, D.C., for some years. He died in 1998.

Photographer Eddie Adams came to regret his photo. Writing in TIME after Loan's death, he said, "The general killed the Viet Cong; I killed the general with my camera. Still photographs are the most powerful weapon in the world. People believe them; but photographs do lie, even without manipulation. They are only half-truths. What the photograph didn't say was, 'What would you do if you were the general in that time and place on that hot day … and you caught the so-called bad guy after he blew away one, two or three American soldiers?' "

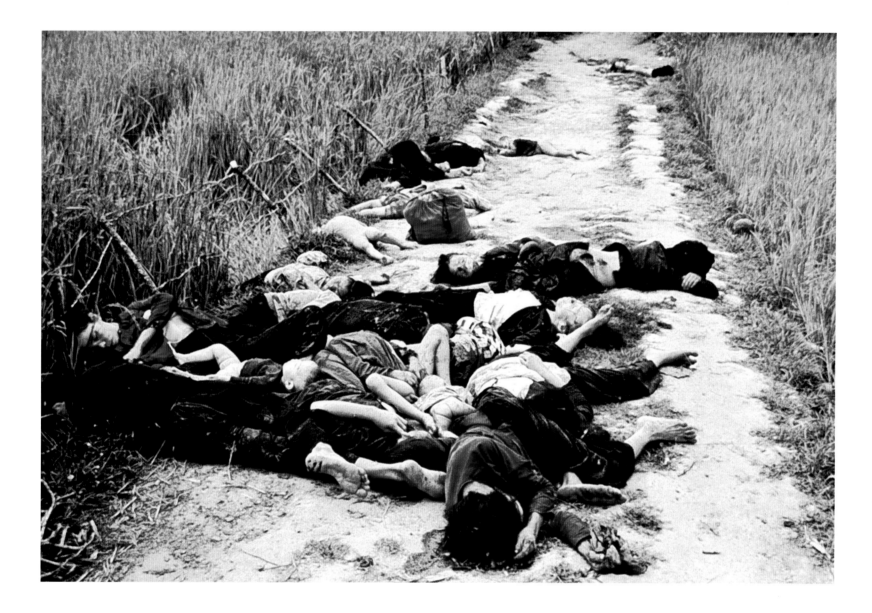

66

War Crimes

My Lai Massacre • Ronald Haeberle • March 16, 1968

"Murder will out," the saying goes, and the grisly story of the My Lai massacre, initially suppressed by U.S. Army officers, eventually came to light 20 months after U.S. troops conducted a savage assault on South Vietnamese civilians in the hamlet of My Lai. The Americans believed the civilians, primarily women and children, were harboring North Vietnamese sympathizers. The massacre claimed hundreds of lives; it took place in March 1968, but it was not until November 1969 that the deeds made news, with the publication of photographs taken by Army Public Information Detachment officer Ronald Haeberle providing shocking evidence of the crimes.

Haeberle took black-and-white photos of U.S. soldiers performing interrogations and other routine actions at My Lai on an Army camera. But, shocked by the crimes he had witnessed, he photographed the atrocities on his personal color camera and eventually provided the pictures to U.S. newspapers and magazines.

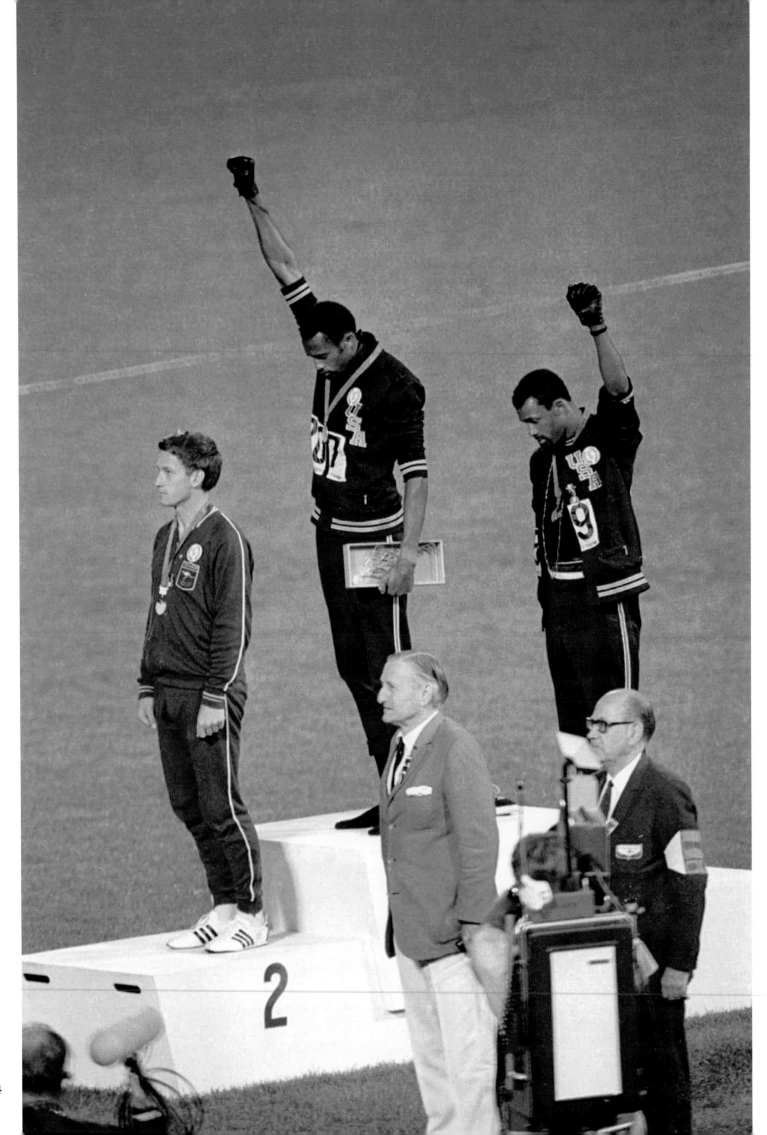

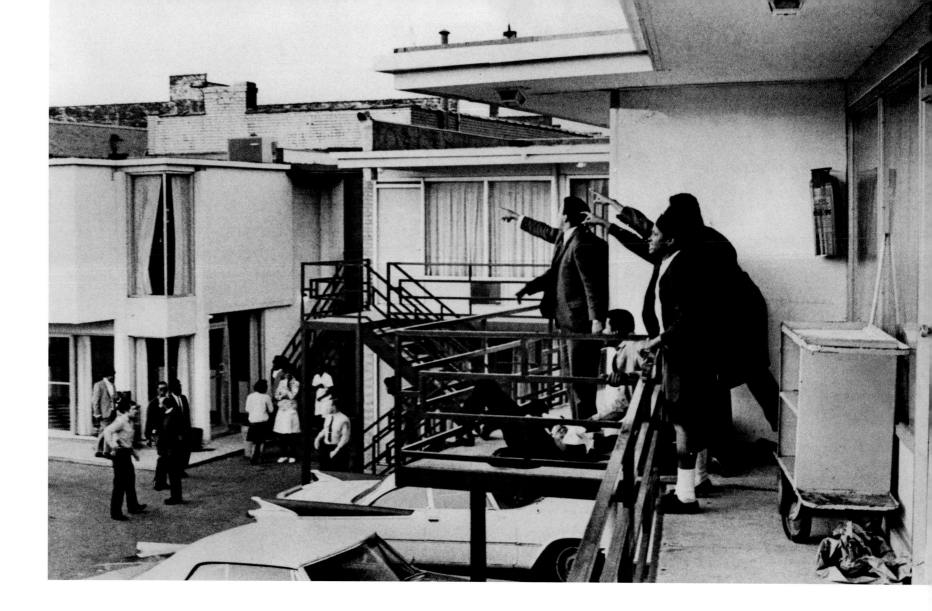

67

Protest on the Podium
Black Power Salute at the Olympics
AP Photographer • Oct. 16, 1968

U.S. sprinters Tommie Smith, center, and John Carlos, right, raise their fists in a Black Power salute after placing first and third in the 200-m race at the 1968 Olympic Games in Mexico City. The gesture was criticized by many Americans, including a TIME writer who called it a "public display of petulance." Hurdling champion Willie Davenport, also African American, declared, "I came here to win a gold medal—not to talk about Black Power." Amid the firestorm, Smith and Carlos were expelled from the Games by the head of the International Olympic Committee, the crusty Avery Brundage, an American.

As time passed, the men's protest has come to be looked upon more benignly by many, as a silent, respectful political statement. A statue of the two athletes, fists raised, was placed at their alma mater, San José State University, in 2005. Silver medalist Peter Norman of Australia, left, joined the two Americans in wearing a human rights emblem on his chest; Smith and Carlos served as pallbearers at his 2006 funeral.

68

Death of an Icon
Martin Luther King Is Assassinated
Joseph Louw • April 4, 1968

From the second-floor balcony of the Lorraine Motel in Memphis, Tenn., associates of Rev. Martin Luther King Jr. point in the direction of the shots that have just hit the civil rights leader, who lies at their feet. King, 39, had come to Memphis to support the city's striking African-American sanitation workers. He first resided at an upscale hotel, which charged $29 for a suite. Criticized as extravagant, King then checked into the Lorraine, a nondescript, black-owned structure, where he and his entourage, which included Andrew Young and Jesse Jackson, paid $13 a night for their rooms.

This famous photo was taken by Joseph Louw, a South African photographer and reporter who was covering King for an upcoming TV profile in Louw's racially fraught nation. The night before he was murdered, King had addressed the sanitation workers, prophetically declaring, "I've seen the Promised Land. I may not get there with you. But I want you to know tonight that we, as a people, will get to the Promised Land."

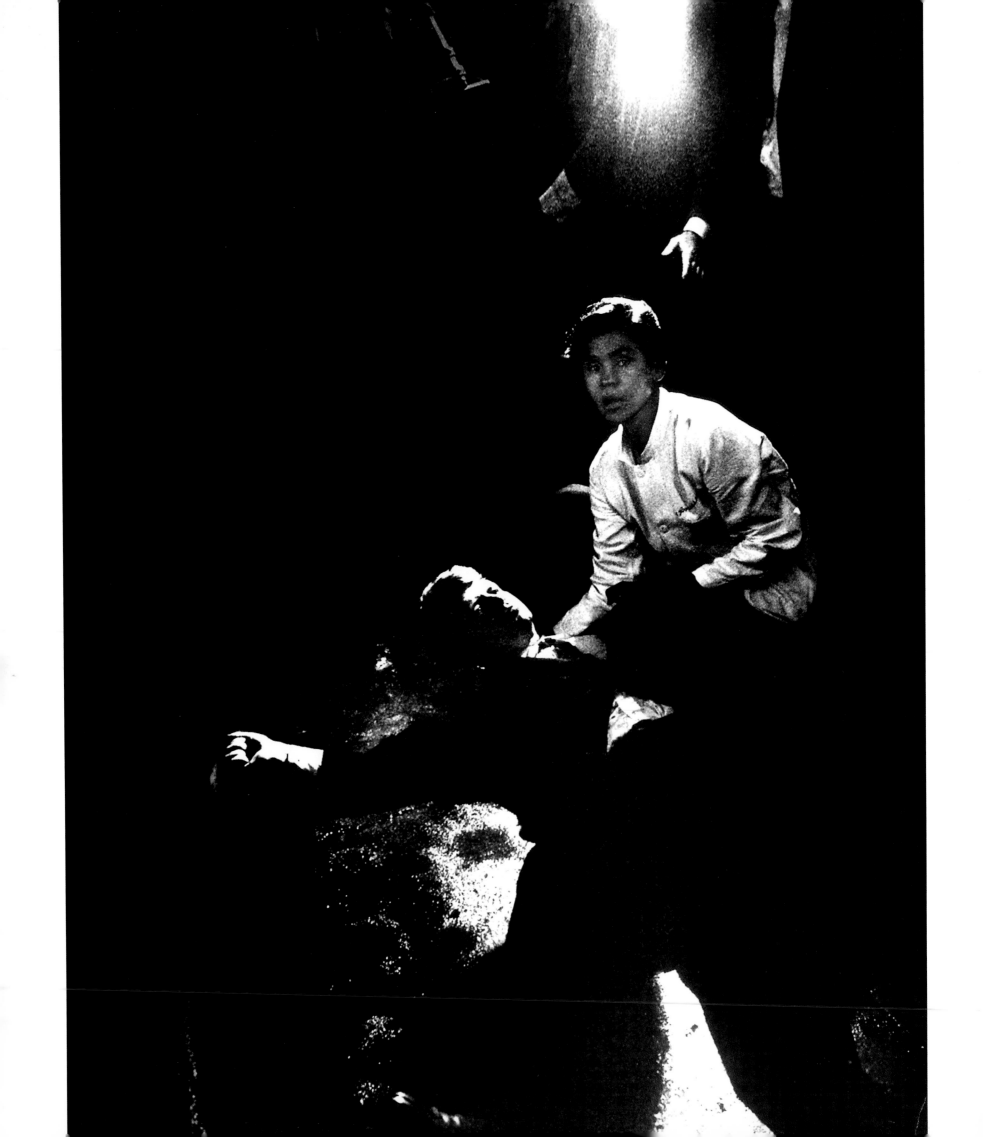

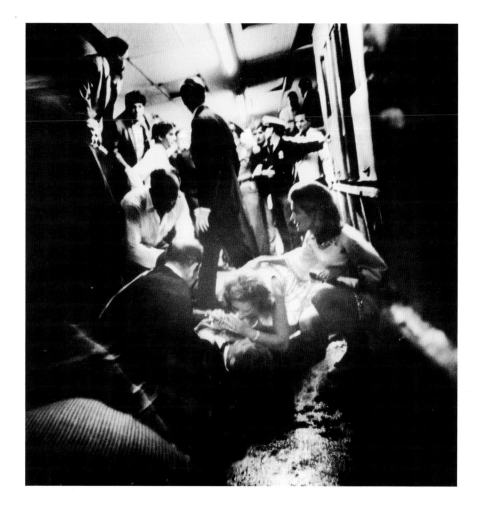

69

A Second Kennedy Is Gunned Down
Robert F. Kennedy Is Assassinated
Bill Eppridge • June 5, 1968

At left, busboy Juan Romero, 17, kneels by Senator Robert F. Kennedy after the politician, 42, was shot by Palestinian immigrant Sirhan Sirhan in the kitchen of the Ambassador Hotel in Los Angeles. Only moments before, Kennedy had addressed a cheering throng of supporters at the hotel after he was declared the winner of the California Democratic primary election. Kennedy had been late in joining the race to win the Democratic Party's nomination to succeed retiring President Lyndon B. Johnson, but his charisma and opposition to the war in Vietnam were quickly making him the front runner in the contest.

LIFE magazine photographer Bill Eppridge took this memorable image, and he continued taking pictures as events unfolded. Above, Kennedy's wife Ethel kneels over her husband. She was very calm in the moments after the shooting, reported TIME correspondent Hays Gorey, who was present in the kitchen. She quietly asked spectators to move back from her husband's body to provide breathing room.

Describing the scene, Gorey wrote, "[Kennedy's] lips were slightly parted, the lower one curled downwards, as it often was. Bobby seemed aware. There was no questioning in his expression. He didn't ask, 'What happened?' [His eyes] almost seemed to say, 'So this is it.' " The Senator was long aware that he was a potential target for an assassin, but he refused police protection, and his unofficial bodyguards carried no weapons. Kennedy survived for some 26 hours, dying early in the morning of June 6.

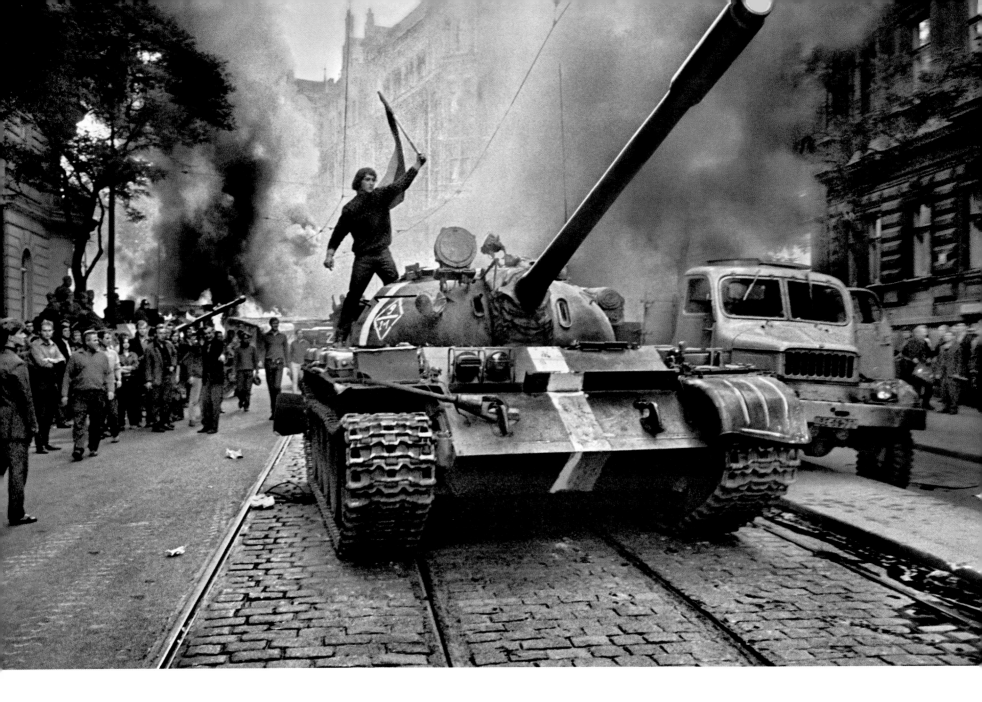

70

A Battle for Freedom
Czech Citizens Take Over Soviet Tank • Josef Koudelka • August 1968

Locked into a perpetual winter of Soviet domination as one of the Warsaw Pact nations of Eastern Europe following World War II, Czechs nurtured their dreams of freedom until they blossomed in the Prague Spring of 1968, when, under leader Alexander Dubcek, citizens rose up and began to defy their oppressors. But on Aug. 20, Soviet leader Leonid Brezhnev sent some 200,000 Soviet and Warsaw Pact troops and hundreds of tanks into Prague to restore the Kremlin's hegemony.

Czech photographer Josef Koudelka, then 30, took timeless pictures of the events that ensued, as Czechs battled the young Soviet troops. In the photo above, Czechs celebrate after taking control of a tank. Many of Koudelka's images were smuggled into the West, where they appeared in TIME and other publications, credited to PP (Prague Photographer). After the Soviet clampdown succeeded, Koudelka managed to immigrate to Britain, but it would be 16 more years before he felt he could take credit for his memorable images of the Czech uprising. In 2008, Koudelka's photos of the Soviet invasion were shown for the first time in New York City, in the exhibit "Invasion 68: Prague." In 2011 the exhibit opened in Moscow. Koudelka, 74 in 2012, continues to travel widely, documenting the lives of Europe's citizens.

GALLERY

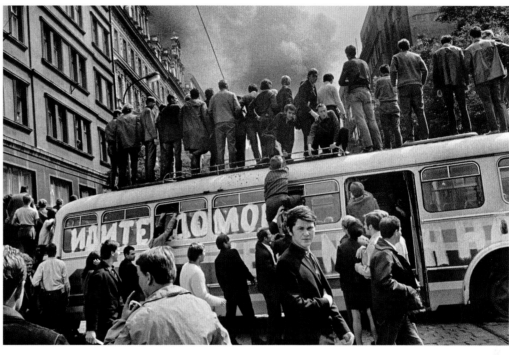

Josef Koudelka

Born in what is now the eastern Czech Republic in 1938, Josef Koudelka originally made a living as an aeronautical engineer but began to gain recognition as a photographer through his pictures of theatrical pieces. The 1968 Russian invasion of Prague immersed him in the topics of upheaval and alienation that were to characterize his later work. He took to the streets, capturing events as they unfolded, and when his shots were smuggled out and published anonymously, they received international acclaim.

Koudelka, shown above in 1985, has lived in exile from his native country since 1970, and in 1987 he became a French citizen. In recent decades he has often trained his lens on modern Europe's complex landscapes, especially those ravaged by industry. He is known for his stark, desolate style. But his work isn't all gloom, as TIME's Lara Day noted in her review of his career-spanning 2007 book, *Koudelka*. "Whatever Koudelka's subject matter," Day wrote, "his photographs are marked by his indelible persona. It is this that enables them to transcend mere form: with the eye of a poet, he sees into the soul of his subjects, giving viewers a privileged glimpse into the ineffable."

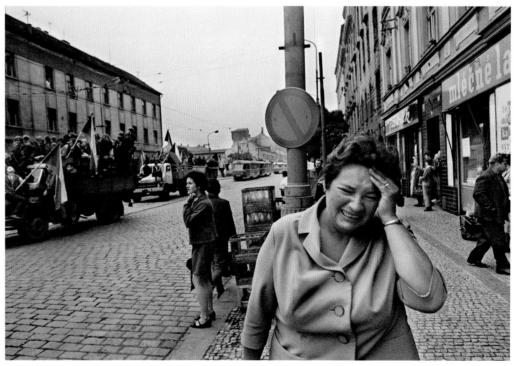

Prague 1968 *Koudelka's photos of the invasion of Czechoslovakia by Warsaw Pact troops captured both the fighting in the streets as Soviet tanks rolled into the city and the personal anguish of the Czech people. At top, rebels use a bus as a barricade against the tanks. At bottom, a woman weeps in the street*

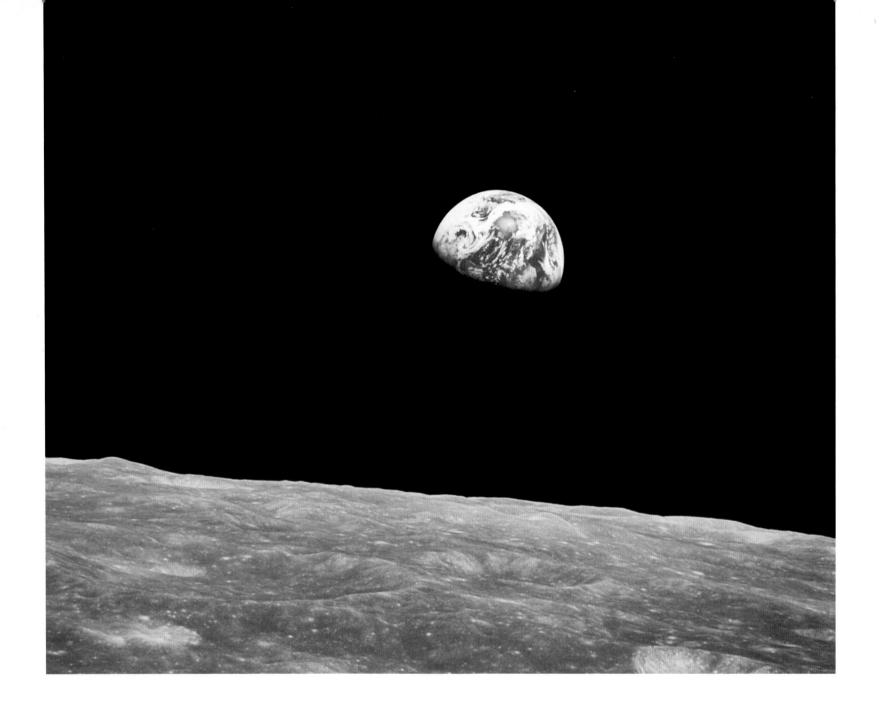

71

The Pale Blue Dot
Earthrise from the Moon
William Anders • Dec. 24, 1968

Buckminster Fuller, architect, gadfly and all-around progressive spirit, did not coin the term Spaceship Earth, but he made it popular in his 1969 book, *Operating Manual for Spaceship Earth*. The term highlights the fragility—and interdependence—of all life-forms on the planet. But vivid as the term is, the sense of common destiny it implies was never captured so memorably as in the magnificent images of humanity's home planet taken by Apollo 8 astronaut William Anders, who was orbiting the moon when this photograph was taken on Christmas Eve 1968. A little more than wo years after this picture was first published, on April 22, 1970, the first Earth Day was observed.

72

Mission Accomplished
Buzz Aldrin Walks on the Moon
Neil Armstrong • July 20, 1969

If Lennart Nilsson's revelatory images of the human embryo took us inside the body to view things never seen before, the photographs off the Apollo 11 astronauts Neil Armstrong and Buzz Aldrin took us outside our world to a place where many believed humans would never stand: the lunar surface. Mission commander Armstrong had been chosen for the honor of being the first human on the moon in part because of his taciturn disposition, but as TIME reported of the historic landing: "Armstrong could not contain his excitement ... he began to snap pictures with all the enthusiasm of the archetypal tourist. Houston [site of mission control] had to remind him four times to quit clicking."

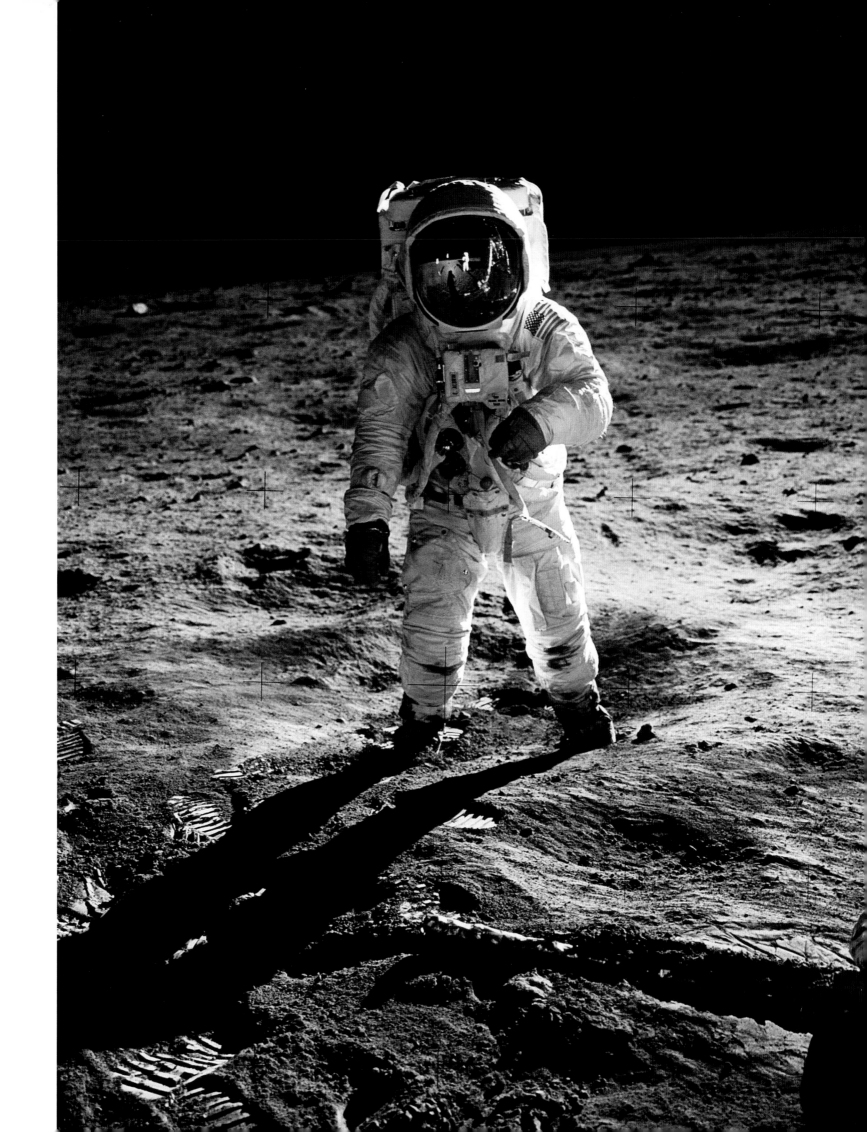

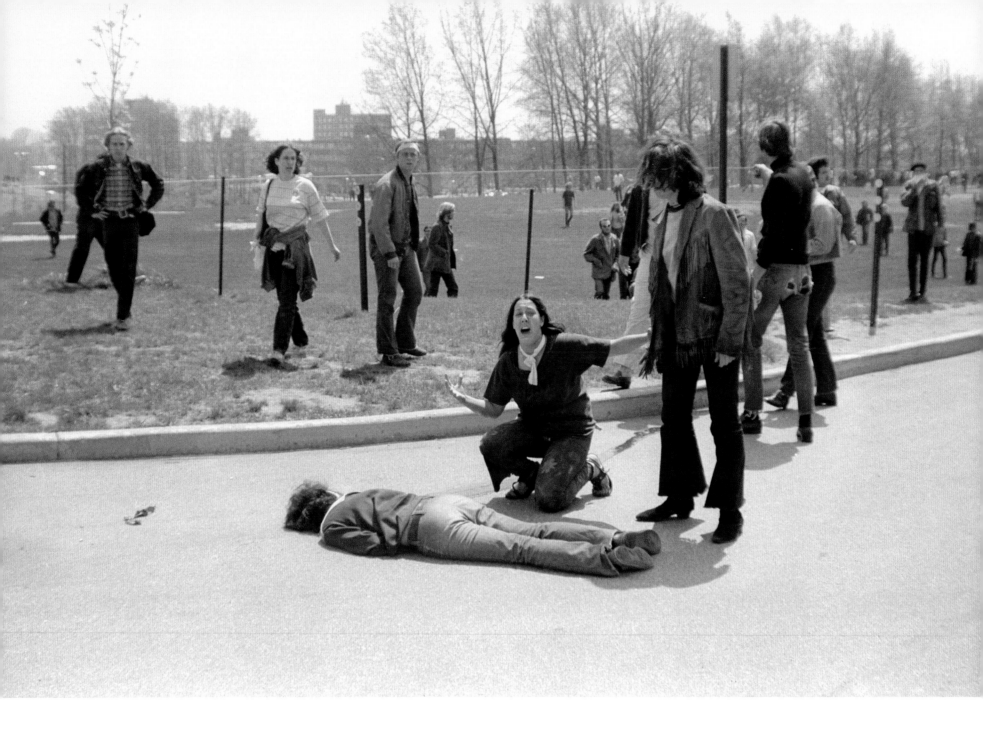

73

The War Comes Home

Shootings at Kent State University • John Paul Filo • May 4, 1970

After President Richard Nixon announced on April 30, 1970, that he was expanding the U.S. military engagement in Southeast Asia by sending troops into Cambodia, American campuses erupted in large demonstrations. At Ohio's Kent State University, the protests turned deadly when a contingent of Ohio National Guard troops opened fire indiscriminately, killing three protesters and a non-protesting student.

Above, Mary Ann Vecchio, only 14 and a runaway from her home in Florida, screams in dismay over the body of student Jeffrey Miller, 20. John Paul Filo, a photojournalism student at Kent State, was awarded a Pulitzer Prize for the image. He told CNN in 2000, "I don't know what gave me the combination of innocence and stupidity … but I never took cover … And the picture I made then was of Jeffrey Miller's body lying in the street … and then a picture where Mary Vecchio was just entering the frame. I knew I was running out of film. I could see the emotion welling up inside of her. She began to sob. And it culminated in her saying an exclamation … something like, 'Oh, my God!'"

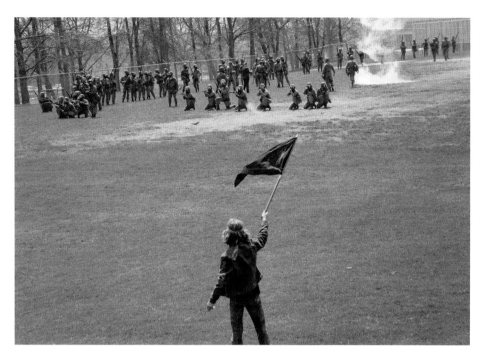

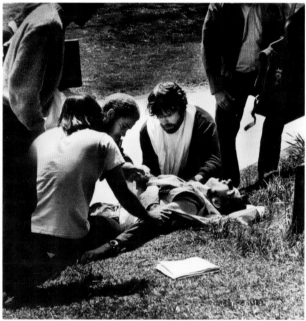

OTHER VIEWS

The events at Kent State University highlighted the extent of the divisions the Vietnam War had created within U.S. society. The deaths of four young people shocked Americans, especially because the young men who made up the Ohio National Guard detachment and shot the students were the same age as the youngsters they killed—one of whom was not a protester but an honors student walking to class. In the top photo above, taken by John Paul Filo, the photographer behind the iconic photo at left, long-haired student Alan Canfora waves a black flag, a symbol of anarchy and government opposition, at the Guardsmen. Shortly after the photo was taken, the soldiers began to fire on the unarmed protesters. A government commission later determined that the shootings were "unnecessary, unwarranted, and inexcusable."

A student majoring in broacast communications, Howard Ruffner, took the photo just above, which shows bystanders kneeling beside wounded student John Cleary, who was shot in the chest but survived. Nine other students were also wounded by National Guard fire but recovered. Following the shootings, protests erupted at campuses across the nation, with more than 900 schools shutting down classes as a result. Kent State University was closed for six weeks.

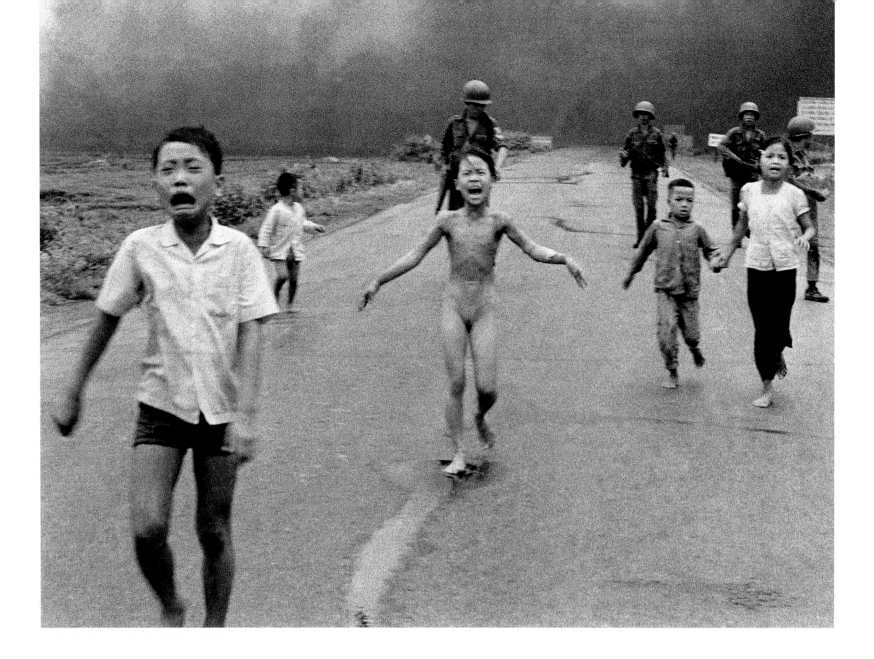

74

Collateral Damage
The Terror of War • Nick Ut • June 8, 1972

Nine-year-old Phan Thi Kim Phuc, screaming in agony from napalm burns on her body, runs toward the camera of Nick Ut, after stripping off her burning clothes. Other members of her family are at her side; two of them died from the burns they received when South Vietnamese aircraft dropped napalm incendiary bombs on their home village of Trang Bang in hopes of killing North Vietnamese troops in the area. The photo won a Pulitzer Prize for Huynh Cong ("Nick") Ut, a Vietnamese photographer working for the AP.

Ut later recalled that Kim Phuc screamed "too hot, too hot" as she ran past him. He and another photographer poured water from their canteens over the girl, then drove her to a hospital and insisted doctors treat her. Kim Phuc survived, after 17 operations. She recalled in 2000, "I suddenly realized that my feet had not been burned. At least I could run away. If my feet would have been burned I would have died in the fire." At right, Kim Phuc is shown cradling her son in 1995 in a picture taken by U.S. photographer Joe McNally. She declared in 2008: "Forgiveness made me free from hatred. I still have many scars on my body and severe pain most days, but my heart is cleansed. Napalm is very powerful, but faith, forgiveness, and love are much more powerful."

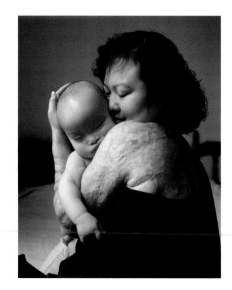

75

Welcome Home

Burst of Joy • Sal Veder • March 17, 1973

Our visual impressions of the Vietnam era are dominated by horror: U.S. soldiers struggling to survive; the bodies of innocent women and children in ditches; American streets and campuses up in arms; a young napalm victim running down a road. The photograph below, in welcome contrast, shows a moment of such utter exhilaration that the image was christened "Burst of Joy." The occasion was the reunion of U.S. Air Force POW Lieut. Colonel Robert L. Stirm with his family at Travis Air Force Base in Fairfield, Calif., after his release from North Vietnam. The photo won a Pulitzer Prize for AP photographer Sal Veder.

Stirm spent five years in a North Vietnamese prison after being shot down over Hanoi on Oct. 27, 1967. Daughter Lorrie, 15, with arms extended, leads the family in welcoming her father. Yet even this image filled with joy is tinged with sadness: three days before he landed at Travis, Stirm was handed a letter from wife Loretta, at rear, saying their relationship was over. They divorced in 1974.

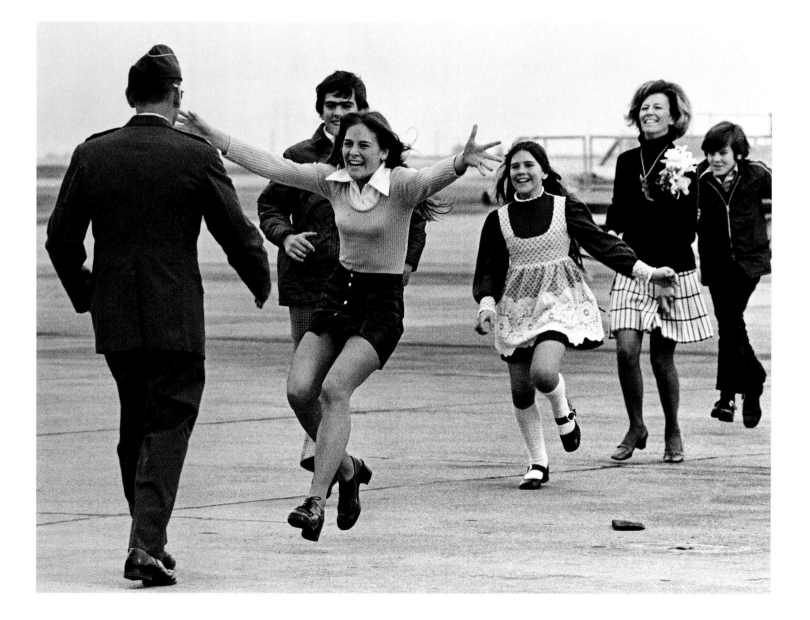

76

A Farewell Gesture

Richard Nixon Departs the White House • Bill Pierce • Aug. 9, 1974

"In victory, magnanimity," Winston Churchill counseled. "In defeat, defiance." Resigning as President after the long, self-inflicted wound of the Watergate crisis, Richard M. Nixon showed his defiance of his critics by flashing the two-fingered V-for-victory salute with which Churchill had rallied Britons during World War II. On the right, below Nixon, Vice President Gerald Ford, who would become President within hours, looks up at his predecessor. Nixon had adopted the gesture as his own during his 1968 campaign for the presidency, even though the antiwar protesters who opposed the U.S. engagement in Vietnam used the same salute to express their desire for peace.

Photographer Bill Pierce was covering the White House for TIME when he caught the gesture, which came to define Nixon's exit. He recalled the moment in 2003 for online site the *Digital Journalist:* "Unexpectedly, and only for a second, President Nixon flashed his trademark 'V' as he got on the chopper. There were a fair number of photographers, but less than should have got the shot … I think it may have been because many photographers had gotten used to staged events. News photography doesn't take a big brain. But it does require amazing concentration and really good reflexes. You can get a little relaxed on a pleasant diet of staged opportunities."

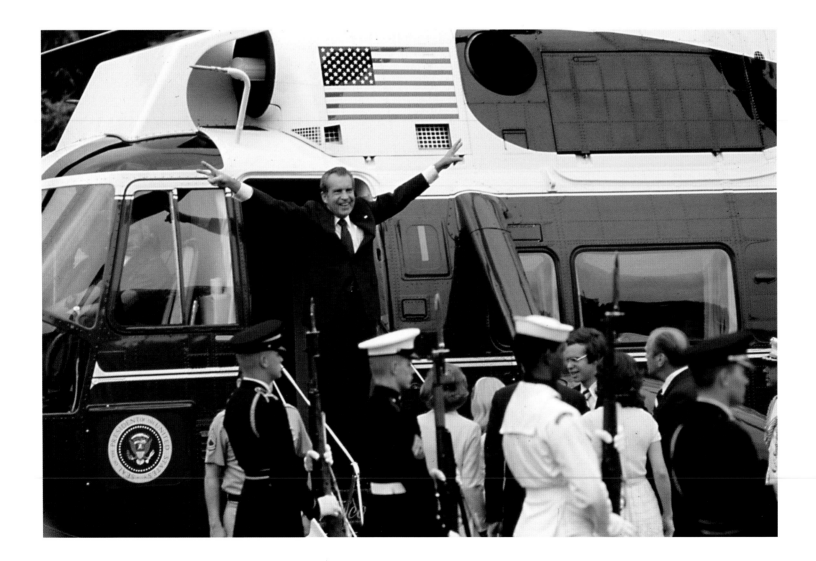

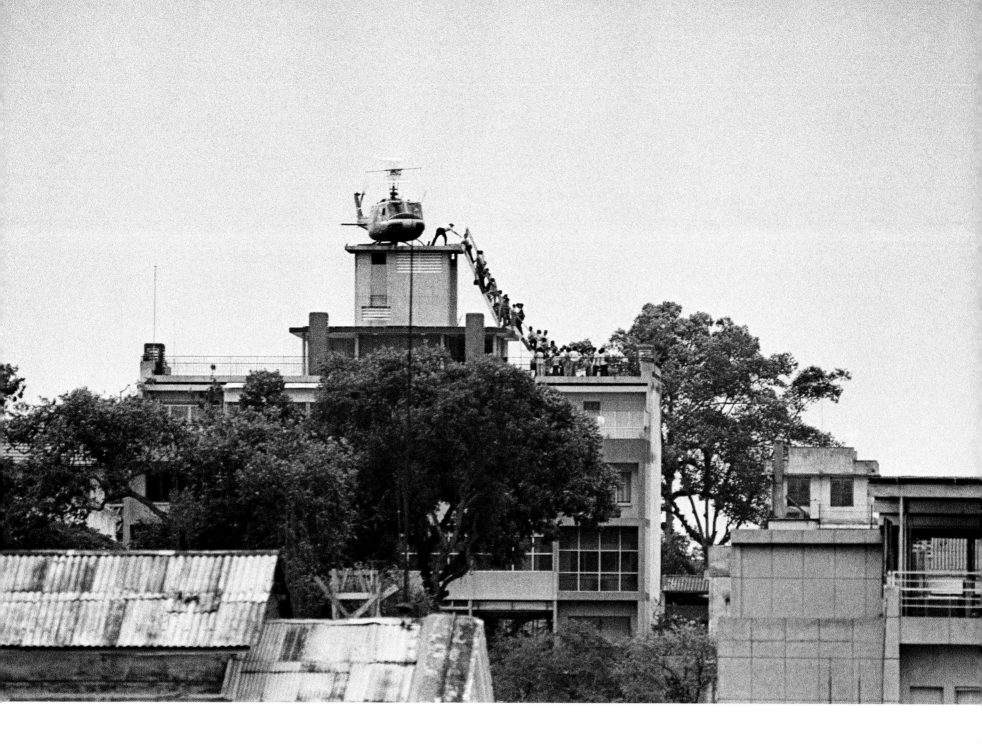

77

Exit, Ingloriously

Americans Evacuate Saigon • Hubert van Es • April 29, 1975

If Joe Rosenthal's famous photo of Americans raising the flag at Iwo Jima in 1945 shows the U.S. at a peak of global achievement, the photo above, taken 30 years later, captures a frustrating, anguishing low point in U.S. military and diplomatic history. Fourteen years after President Kennedy sent the first U.S. military advisers to aid the government of South Vietnam in its battle to retain its independence from the North, the North Vietnamese Army was poised to enter Saigon, and the last Americans in the South's capital queued up on a rooftop to make their escape, along with local civilians who had worked in the losing cause.

Dutch cameraman Hubert van Es's photo is often described as showing the roof of the U.S. embassy; in fact, this evacuation location was atop an apartment building used for CIA operations in Saigon, and the helicopter was part of the Air America fleet run by the CIA.

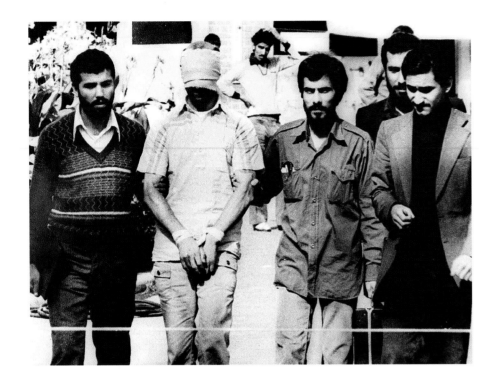

78
A Nation Held Hostage
U.S. Captive in Tehran • AP photographer • Nov. 8, 1979

Four years after South Vietnam fell to the North, Americans were faced with an unexpected crisis in a different area of the world, one that proved every bit as frustrating as the failed war in Southeast Asia. The problems arose in Iran, long a U.S. ally under Shah Reza Pahlavi, whose place on the Peacock Throne had been secured by the U.S. in a 1953 coup. When the Shah traveled to the U.S. in early 1979 for medical treatment, the door was opened for the longtime leader of the Islamic opposition, cleric Ayatullah Ruhollah Khomeini, to return to Iran after 15 years in exile. Khomeini then led a revolution that toppled the Shah and imposed Islamic law in Iran. A few months later a band of anti-American activists, described as "students" by the new regime, overran the U.S. embassy, in violation of international diplomatic law, and took more than 50 Americans hostage.

The picture above, which shows a blindfolded U.S. hostage, his hands bound, being paraded before a jeering crowd in Tehran, became one of the iconic images of the crisis, which lasted for 444 days. President Jimmy Carter dispatched a rescue mission to free the hostages, but it was a spectacular failure, further underlining U.S. futility in the situation. The Americans were not released until the day Carter left office; they were freed by Iran's leader as Ronald Reagan was being sworn in as President.

79
Victory on Ice
U.S. Beats U.S.S.R. in Olympic Hockey
Heinz Kluetmeier • Feb. 22, 1980

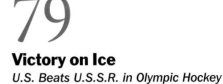

The hoisting of the five-ringed Olympic flag supposedly internationalizes a site, enfolding it in the pristine and timeless kingdom of sport, above nationalistic concerns. But in the days when the U.S. and U.S.S.R. were locked in a bitter rivalry, the 1980 Winter Olympics at Lake Placid in upstate New York seemed like another outpost in the cold war. The quarterfinal hockey match between the two teams was the scene of one of sport's greatest upsets, as a pond-hockey pickup crew of American amateur collegians knocked off, 4-3, an athletic machine assembled from the best that the Soviet army and the Dynamo Moscow professional team could produce. Only days before the Games began, the U.S. team had lost to the Soviets, 10-3, in an exhibition game in Madison Square Garden. But after "the miracle on ice," Coach Herb Brooks' U.S. team went on to defeat Finland in the final round to win the gold medal.

The memorable picture at right was taken by Heinz Kluetmeier, a German-born photographer whose family immigrated to the U.S. when he was 9. Kluetmeier was working for SPORTS ILLUS-TRATED at the time, and he later became photo editor of the magazine. The veteran camerman was known for his elaborate pregame preparations to capture memorable moments, but the most uplifting element of this image, the U.S. flag being waved at its center, was pure good luck.

"There are some pictures that you're remembered for," Kluetmeier told the Dartmouth College alumni magazine in 2007. "I think that's one of the pictures that people remember that I've taken. It's the moment that is compelling. It was the first time that SPORTS ILLUSTRATED ever ran a cover without a billing to identify what was happening—because everybody knew. I'm a cynic by nature, but that week I believed in miracles."

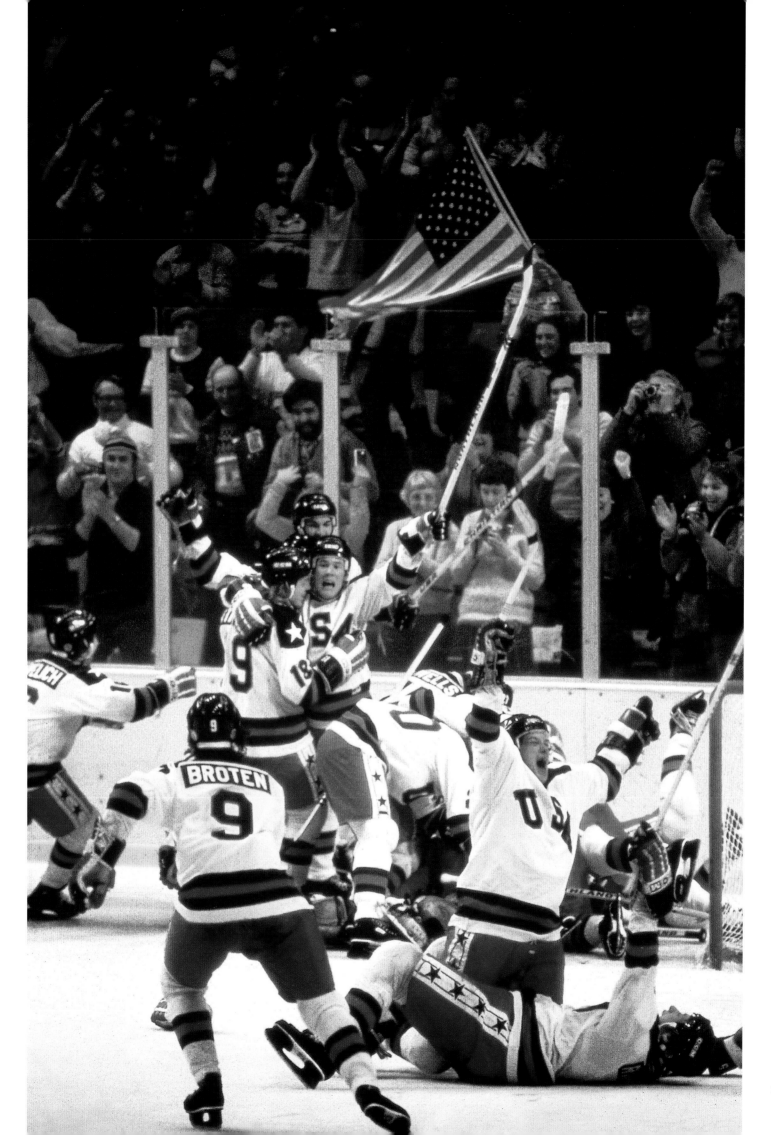

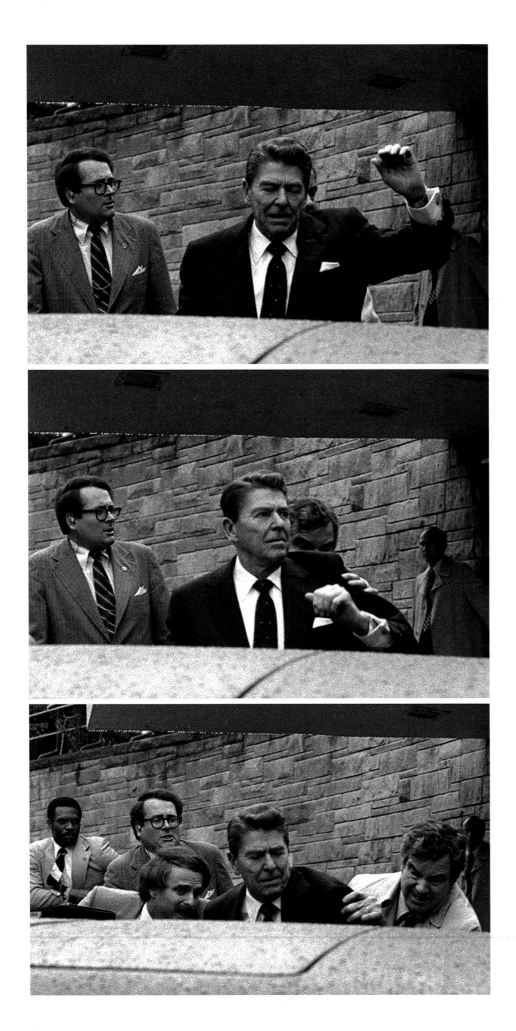

80

A Presidential Target
Attempted Assassination of President Reagan
Ron Edmonds • March 30, 1981

Ronald Reagan had been President for only 69 days when he was shot by a disturbed young man, John Hinckley, Jr., as Reagan left a luncheon banquet at the Washington Hilton hotel. A later inquiry revealed that Hinckley fired six .22-cal. rounds but never hit Reagan directly; the bullet that struck him ricocheted off his limousine. Age 69 at his Inauguration, Reagan was the oldest President ever to be sworn in, but thanks to quick treatment, he returned to work in 12 days.

Photographer Ron Edmonds received a Pulitzer Prize for his photos of the attack. In 2011, on the 30th anniversary of the incident, he spoke with the editors of TIME's online photography gallery, LightBox, and described the day's events. "We almost didn't get up there," Edmonds remembered. "I just barely got up to the car when he came out the [hotel] door. Another probably 10 seconds later and I would have missed the whole sequence."

In the top image at left, the bullet strikes Reagan's chest, beneath his arm. Of this first frame he made of the shooting, Edmonds recalled, "Just as I got ready to press the shutter down and take the picture [of Reagan acknowledging a small crowd of spectators outside the hotel], he waved, [and] the first shot rang out. I didn't know they were shots initially—they sounded like firecrackers. I saw him grimace, and that's when I pushed the shutter down, and I held it down."

In the second photo, Reagan looks in the direction of the shooter. Within seconds, Secret Service agents had pushed Reagan into his limousine. Of his ability to capture this sequence, Edmonds is straightforward: "If you didn't have your camera to your face you were going to miss [it]. It was so quick you couldn't have gotten your camera up to your eye quick enough to shoot it."

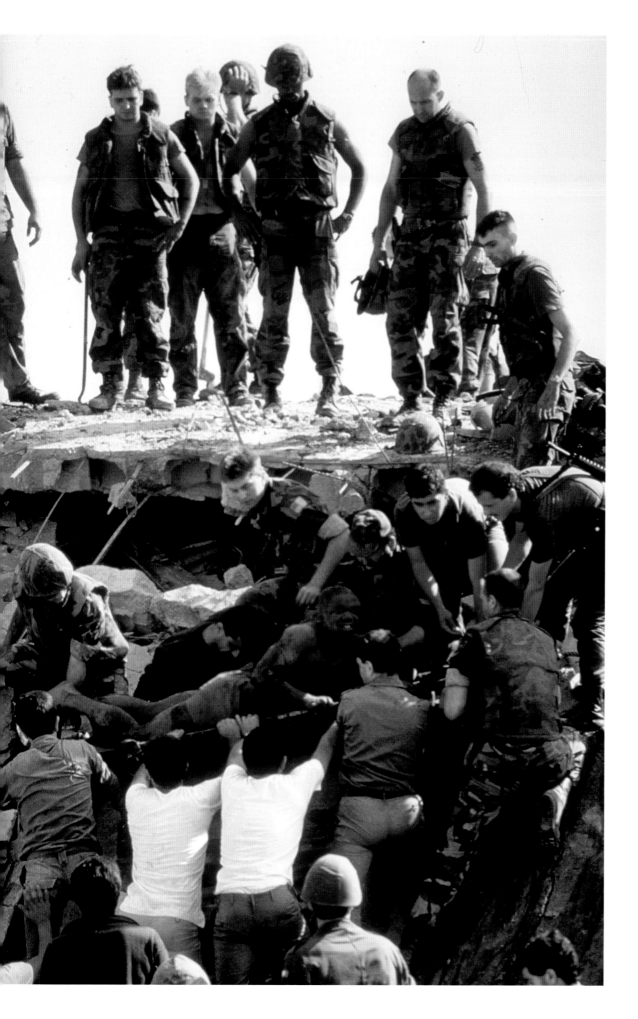

81

A Surprise Attack In Lebanon
Marine Barracks Bombing
Peter Jordan • Oct. 23, 1983

Throughout the 1980s, the battle to control the future of the Middle East was joined on a number of fronts. Lebanon, for decades a nation in which many different ethnic and religious communities managed to live together in peace, became a battleground where neighboring Syria, Maronite Christians, radical pro-Palestinian forces, the Druze and pro-Western capitalists vied to shape the nation's destiny.

In 1982, with Lebanon in chaos, President Ronald Reagan sent 800 U.S. Marines to serve in a multinational peacekeeping force; eventually, some 1,800 Marines were deployed there. On Oct. 23, 1983, suicide bombers penetrated security at two barracks, one housing U.S. troops and the other French troops, and detonated bombs that killed 241 U.S. servicemen, primarily Marines, and 58 French troops.

In Peter Jordan's photo for TIME, Lance Corporal Morris Dorsey is evacuated from the ruins. He survived, but as TIME observed, "All across the nation on Sunday night, Marine Corps officers walked up to homes and apartments to inform Americans that their sons or brothers or fathers or husbands had died under the twisted, smoking debris in Beirut."

82

Tragedy in the Sky

Challenger *Explodes* • Bruce Weaver • Jan. 28, 1986

"Where in hell is the bird? Where is the bird?" shouted an engineer at Cape Canaveral. "Oh, my God!" cried a teacher from the viewing stands nearby. "Don't let happen what I think just happened." But it had: in one fiery instant, the shuttle *Challenger*—and the nation's complacent attitude toward NASA's manned space program—evaporated in the skies over Florida only 73 sec. after lift-off. Below, a news photographer at the launch captured spectators in the bleachers reacting to the explosion, which was clearly visible in the sky above them. Six astronauts died, as well as Christa McAuliffe, 37, a New Hampshire schoolteacher chosen by NASA, amid much publicity, to represent the educational value of space exploration.

A committee of inquiry assigned blame for the explosion to NASA managers who overruled engineers' concerns about launching the shuttle in subfreezing weather. Many Americans alive at the time recall where they were when they heard the news of the disaster, but it is the scrawl of smoke in the sky captured by AP photographer Bruce Weaver that is embedded in our memories: the familiar starburst of a summer fireworks display transformed into an image of pure horror.

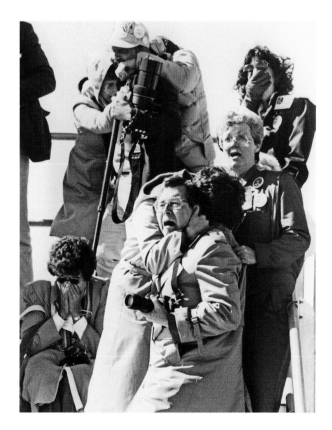

83

Death in the Jungle
Mortally Wounded Contra *Fighter*
James Nachtwey • April 1, 1984

James Nachtwey's pictures of wars, famine and strife have often appeared in the pages of Time; he is widely considered the foremost international news photojournalist of recent decades, often described as the heir to the tradition of Robert Capa, Larry Burrows and other legendary combat photographers. Nachtwey has traveled to most of the world's hot spots since the early 1980s, from South Africa and Northern Ireland to Central America, the Balkans, the Middle East and beyond.

Nachtwey's specialty is the quick-reaction photo of what French photographer Henri Cartier-Bresson called "the decisive moment." Yet, as Time director of photography Kira Pollack notes, Nachtwey manages to combine the quick reflexes of a combat photographer with a brilliant eye for the overall framing and composition of a shot—one secret of his mastery. Both qualities are present in the memorable image at left of a mortally wounded *contra* fighter, his posture resembling a crucifixion, being carried out of the jungle near the town of San Juan del Norte in Nicaragua during the battles in the 1980s over that nation's future.

In 2003 Nachtwey was covering the early days of the U.S. intervention in Iraq for Time, traveling with the magazine's correspondent Michael Weisskopf, when a grenade landed in their Humvee. Weisskopf picked up the grenade to throw it away, but it exploded in his hand. Both men were badly wounded, but Nachtwey, now part of the story he was covering, continued taking pictures of a medic treating Weisskopf until the photographer passed out. Nachtwey and Weisskopf were air-lifted to a U.S. base in Germany. Both men recovered, although Weisskopf lost his hand.

GALLERY

James Nachtwey

"I've been called a war photographer, but I feel that my work has been as an antiwar photographer," the veteran TIME contributor Nachtwey has said, noting that as a college student in the 1960s, he was strongly moved by pictures of the civil rights movement and the Vietnam War. In 2012, Nachtwey was awarded the Dresden International Peace Prize; previous winners include former Soviet President Mikhail Gorbachev and conductor Daniel Barenboim. At the award ceremony, German film director Wim Wenders declared in an appreciation, "The heart is the real light-sensitive medium here, not the film or the digital sensor. It is the heart that sees an image and wants to capture it."

Nachtwey spent the day of Sept. 11, 2001, photographing the terrorist strikes at the World Trade Center, only blocks from his Manhattan home. Shortly afterward, he told the online photography site *The Digital Journalist*, "Many years ago, I felt that I'd seen too much and that I didn't want to see any more tragedies in this world. But unfortunately, the world continues, history continues to produce tragedies. And it is very important that they be documented in a humane way, in a compelling way."

More than ten years after that interview, Nachtwey continues to travel to the most dangerous locations on the globe, pursuing his humane, compelling mission. Agreeing with Nachtwey, Wenders declared in Dresden, "We should stop calling him a 'war photographer.' Instead, look upon him as a man of peace, a man whose longing for peace makes him go to war and expose himself [to danger] in order to make peace. He hates war with a passion, and loves mankind with even more of a passion."

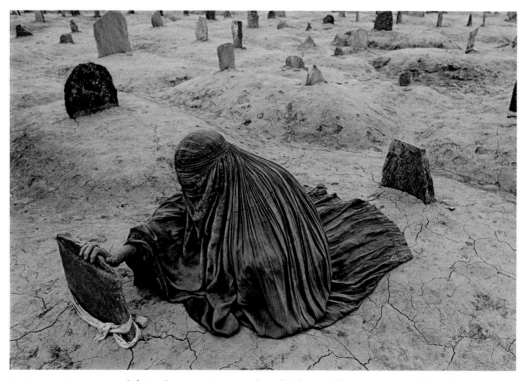

On the front lines *At top left, Nachtwey carries an orphaned girl to a shelter during Rwanda's civil war in 1994. Atop this column, Nachtwey photographed a Hutu man in Rwanda whose face bore the scars of a machete attack inflicted by members of his own clan when he did not join in persecuting members of the rival Tutsi tribe.*

At bottom , a burqa-clad woman in a Kabul cemetery mourns the loss of her brother, killed in a rocket attack during Afghanistan's civil war in 1996

84

Gold Rush Days
Gold Miners in Serra Pelada
Sebastião Salgado • 1986

Like the American photographer Lewis W. Hine, Brazil's
Sebastião Salgado took up the camera as an instrument to
document social injustice. He earned a master's degree in
economics before abandoning the dismal science to record
the inequities of society and share his belief that "the
human race is one." His work has succeeded so power-
fully that the photojournalist now serves as a UNICEF
Goodwill Ambassador, traveling the world to create and
exhibit his photos. "I hope that the person who visits my
exhibitions and the person who comes out are not quite
the same," the photographer wrote of the force with which
the still image can transform hearts and minds.

In 1986 Salgado visited Serra Pelada in Brazil's Pará
state to record the lives of some 100,000 fortune-seekers
who had flocked to the frontier region after gold nuggets
were unearthed there in 1979. His photographs of the
swarming anthill of miners opened the eyes of the world
to this previously little-known location, where backbreak-
ing toil was lightened by dreams of riches.

Often working in black and white, Salgado achieves a
magnificent chiaroscuro in his photos, and he has been
called both an artist and an activist. But he prefers the
latter designation, saying, "I don't want anyone to appreci-
ate the light or the palette of tones. I want my pictures to
inform, to provoke discussion—and to raise money." The
funds the photographer seeks are donations that will
address the conditions he has exposed with his camera.

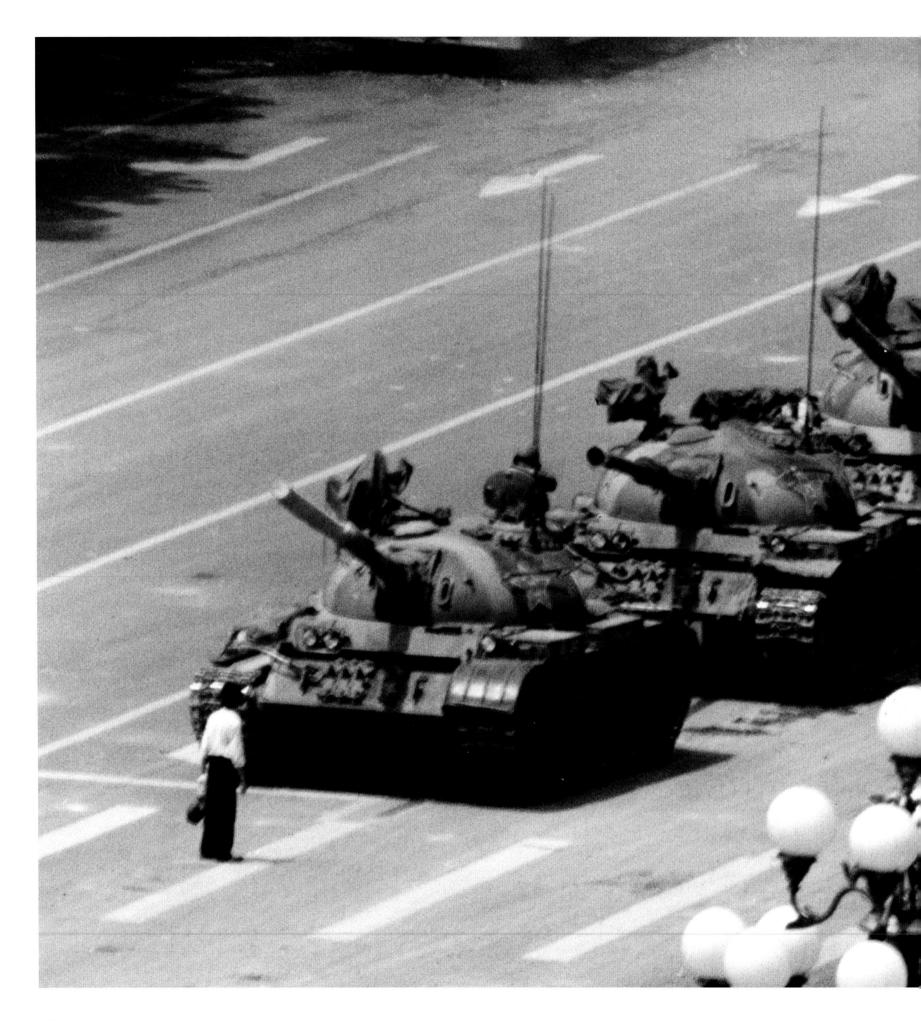

85

The Power of One
Protester Halts Tanks in Beijing
Jeff Widener • June 5, 1989

This picture moved the world by showing a man who refused to move. The scene took place in China in 1989, as citizens rose up to demand a more democratic society. Chinese officials initially tolerated the movement, which began on April 15, but on the night of June 4, they sent tanks into Tiananmen Square and other hot spots in Beijing, killing an unknown number of protesters, arresting many more and quelling the uprising.

On June 5, AP photographer Jeff Widener took this photo of a lone man halting the advance of a line of government tanks: it is an indelible image of an individual standing up to the power of the state. As eyewitnesses testified, the man clambered up on the lead tank and spoke to the soldiers inside, then resumed his position, blocking them until bystanders pulled him out of the way. Canadian historian Timothy Brook called this image "the most extraordinary picture of the last half of the 20th century." But when the producer of a 2006 PBS *Frontline* documentary about the incident showed the photo to contemporary Chinese students, they told him they had never seen it before. The name of the protester, dubbed "Tank Man," remains unknown. But we do know what he stood for.

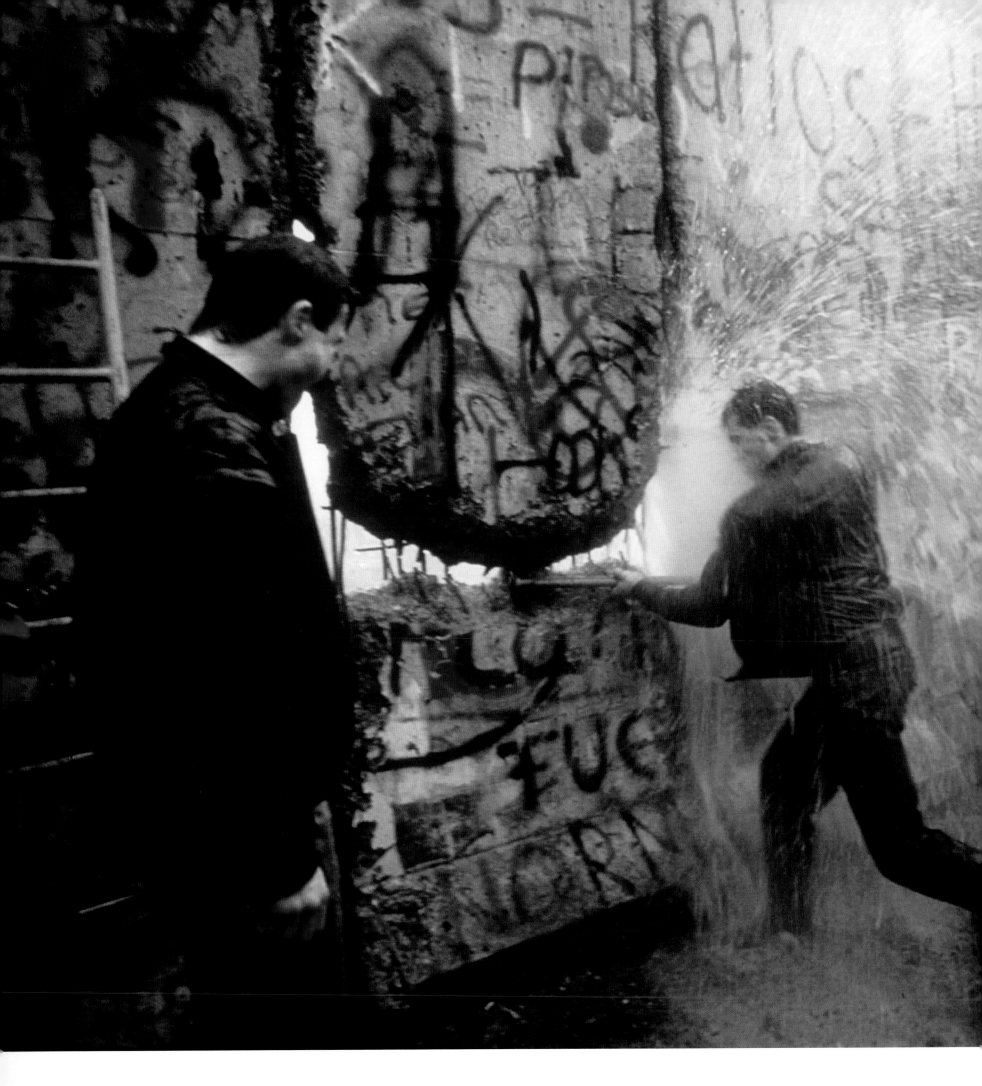

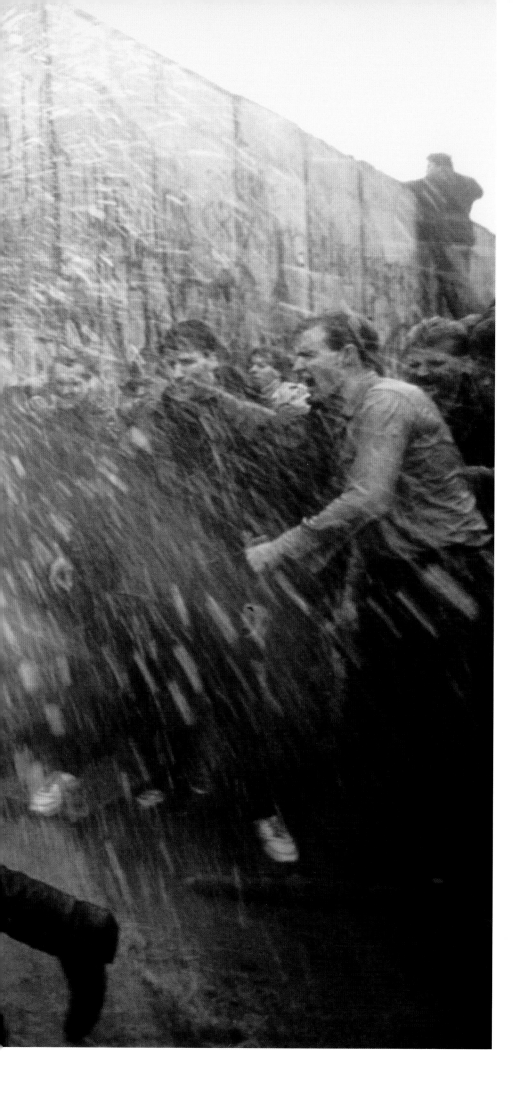

86

Come Together, Right Now
West Germans Demolish the Berlin Wall
Anthony Suau • Nov. 11, 1989

Twenty-eight years after Soviet leader Nikita Khrushchev ordered East German officials to build a barrier to divide Germany's occupied capital into two districts, the Berlin Wall came down in memorable fashion—hurriedly, amid exhilarating chaos and, symbolically, as much by the hands of celebrating Berliners as by government machines. TIME photographer Anthony Suau captured the indelible image at left, as West German civilians took sledgehammers and fire hoses to the structure, which TIME once described as "that hideous, 28-mile-long scar through the heart of a once-proud European capital … and the soul of a people."

Over the course of his career, Suau has been awarded the Pulitzer Prize, the World Press Photo Award and the Robert Capa Gold Medal, awarded by the Overseas Press Club. In 2000 he published *Beyond the Fall,* a collection of his photos that document the transformation of the Eastern bloc nations in the 10 years since the fall of the Wall, the beginning of the end of Soviet hegemony in the region.

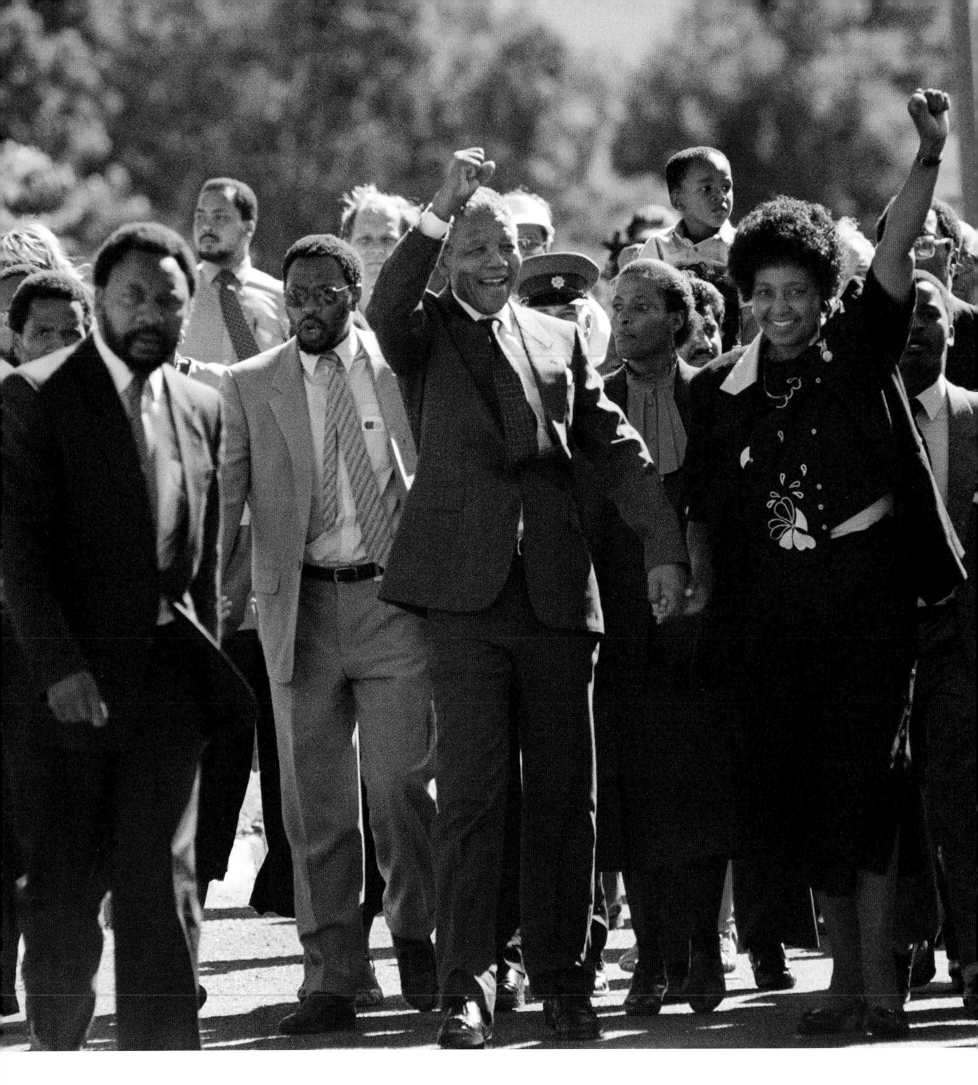

87

Into the Sunlight
Nelson Mandela Is Released from Prison
Alexander Joe • Feb. 11, 1990

Surrounded by aides and admirers and with wife Winnie at his side, Nelson Mandela, 71, walked out of South Africa's Victor Verster Prison a free man after 27 years of incarceration, during which time he became the most celebrated prisoner in the world and the unseen but ever present conscience of his nation. The exhilarating release was the culmination of one of history's greatest about-faces: when Mandela, a leader in the fight against apartheid, entered prison in 1964, he was regarded as a terrorist. But by the end of his long captivity, it was Mandela who appeared to hold all the moral authority in South Africa, while the white minority government, wedded to its racist system of apartheid, seemed squalid, brutal and corrupt.

In this photo, taken by Zimbabwean photographer Alexander Joe, a longtime chronicler of the people and politics of southern Africa, the Mandelas raise their fists in a Black Power salute, but Nelson Mandela made clear that he intended to serve his nation as a unifier, not a divider. In 1994, in the first election in which citizens of all races voted, he was elected the first black President of South Africa.

Incredibly, the moment at left was the first time in decades that Mandela's face had been seen by the world. In an age saturated by photographs and video images, he had become one of the most famous people on the planet despite the fact that the millions of people who embraced his cause had never seen a contemporary picture of him.

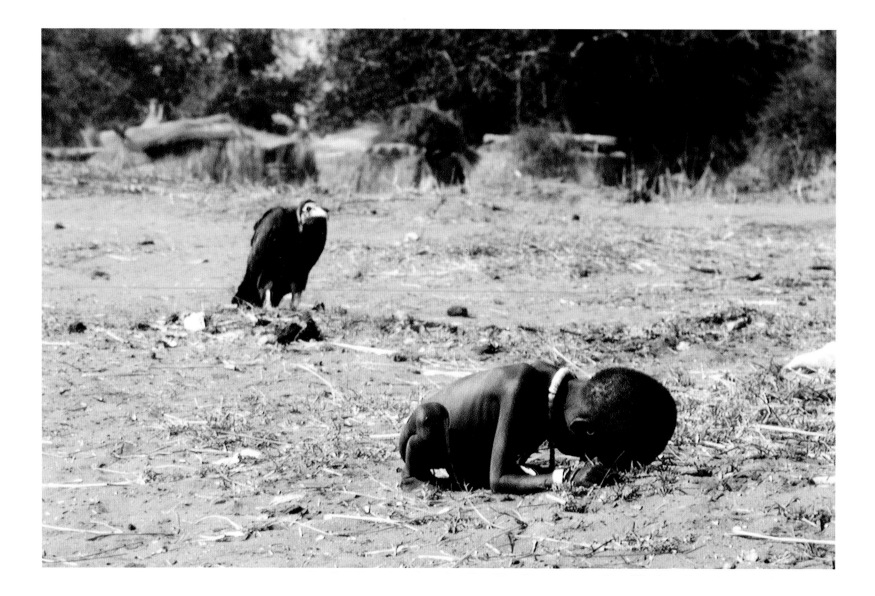

88

The Price of Bearing Witness

A Vulture Stalks a Starving Child • Kevin Carter • March 1, 1993

Kevin Carter grew up in a white suburb of Johannesburg, where he became a rebel who dropped out of college, chased thrills, attempted suicide and went AWOL from South Africa's military to become a radio DJ. Strongly opposed to apartheid, he took up a camera and documented the plight of black South Africans in segregated townships in the 1980s. In 1993 he traveled to Sudan to cover a major famine. Landing at a relief center in the town of Ayod, he wandered into the open bush, heard a soft whimpering and saw a tiny girl trying to make her way to the feeding center. As he crouched to photograph her, a vulture landed in view. Careful not to disturb the bird, he positioned himself for the best possible image. After he took his photographs, he chased the bird away.

 When the photo appeared in the New York *Times,* it was widely discussed and debated. Some voices called Carter as much a predator as the vulture. "I had to think visually," he once said of photographing a shoot-out. "I am zooming in on a tight shot of the dead guy and a splash of red ... a pool of blood in the sand ... You are making a visual here. But inside something is screaming, 'My God!' But it is time to work. Deal with the rest later." But Carter couldn't deal with "the rest"; increasingly depressed and unstable, he took his own life in 1994, only weeks after the picture above was awarded a Pulitzer Prize.

89

Savagery in the Streets
Desecration in Mogadishu
Paul Watson • Oct. 4, 1993

Like Kevin Carter, tormented by his photo of a vulture stalking a child, Canadian photographer Paul Watson remains haunted by the photo at right, which shows a slain U.S. soldier being dragged through the streets of Mogadishu, the capital of Somalia, as citizens jeer and celebrate. Ironically, the U.S. had intervened there in part because of the power of photos: the world was moved by images of starving Somali children and families, suffering after the nation's agriculture collapsed during a warlord-driven civil war.

If those photos helped begin the U.S. humanitarian intervention, this grisly photo helped end it. The U.S. soldier was one of 19 Americans who died in the urban battle that is depicted in the book and film *Black Hawk Down*. "In less time than it took to breathe, I had to decide whether to steal a dead man's last shred of dignity," Watson wrote in his 2007 memoir, *Where War Lives*. "The moment of choice, in the swirl of dust and sweat, hatred and fear, is still trapped in my mind, denying me peace ... I felt like I'd stolen a man's soul to make a point."

Watson's photo won a Pulitzer Prize, but the award felt hollow, he later said. The U.S. withdrew from Somalia; Watson cannot withdraw from his photo.

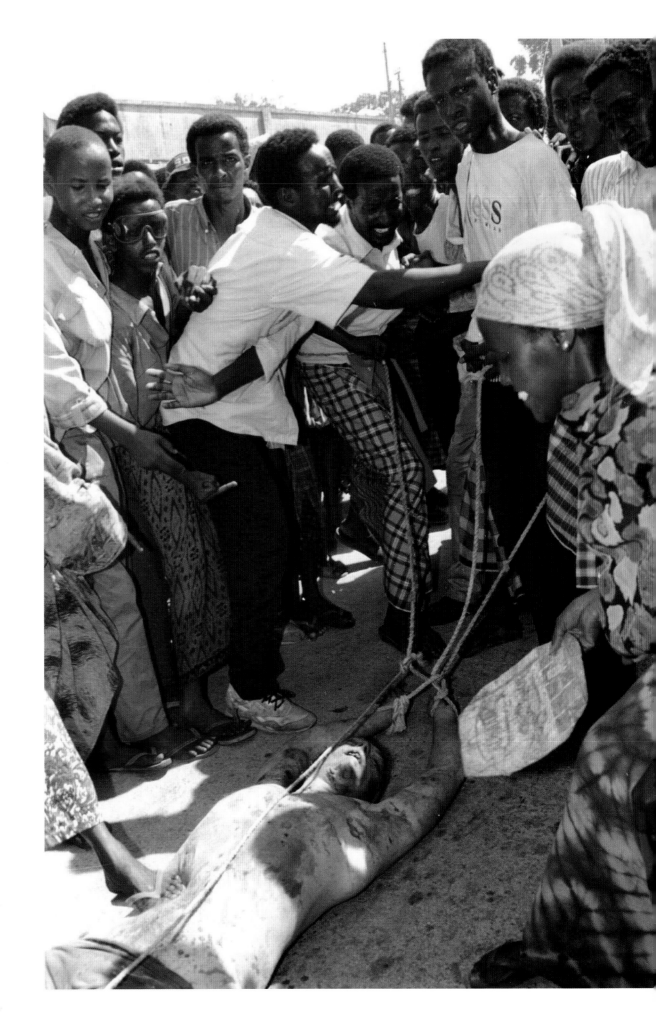

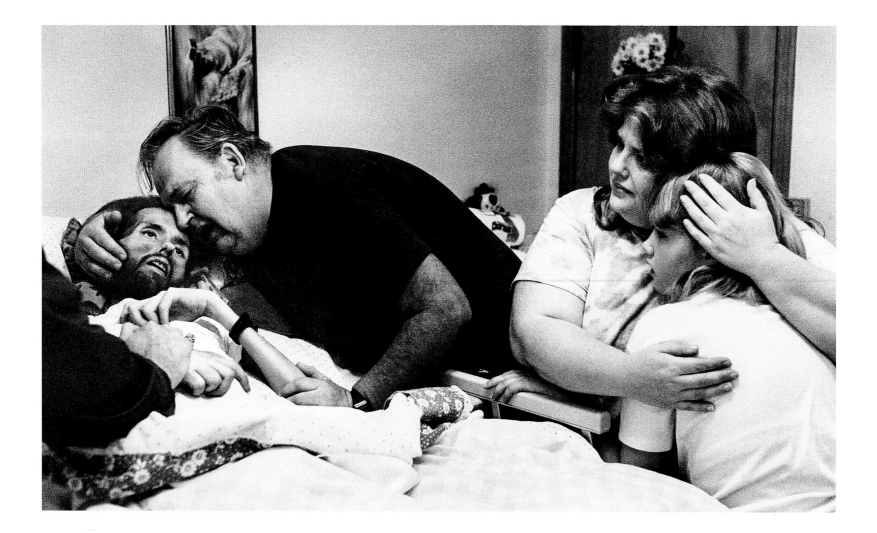

90

Deathbed Anguish

David Kirby, AIDS Victim, and Family
Therese Frare • May 1990

The photograph above, published in LIFE magazine in 1990, shows AIDS activist David Kirby on his deathbed, surrounded by his weeping family. Kirby was only 32 at the time, but his body, wasted from disease, appears to be that of an older man. The photo won a prestigious World Press Photo Award and is said by many observers to have helped remove the stigma and prejudice that surrounded AIDS in the early 1990s.

The picture raises a question often asked of such images: How could the family allow an outsider to capture such a private moment? In this case, photographer Therese Frare was a graduate student at Ohio University and was also a volunteer at Pater Noster House, an AIDS hospice. She began photographing hospice residents for a school project and met the Kirby family, who trusted her and hoped her photo would spread understanding of the disease. Barb Cordle, a former director of Pater Noster, once said that Frare's photo "has done more to soften people's hearts on the AIDS issue than any other I have ever seen. You can't look at that picture and hate a person with AIDS. You just can't."

91

Terrorism's Toll

Firefighter Cradles Bombing Victim
Charles H. Porter IV • April 19, 1995

Oklahoma City firefighter Chris Fields, 30, holds Baylee Almon, who had observed her first birthday the day before, after the child was killed when a bomb exploded at the Alfred P. Murrah Federal Building in Oklahoma City in 1995. The infant was one of 19 children who died in the incident, which claimed 168 lives in all. This compelling image quickly became the symbol of the event. "It was the photo that was felt around the world," said Tommy Almon, the baby's grandfather. The man behind the lens was not a photojournalist; he was a clerk in a nearby bank. Charles H. Porter IV, 25, was awarded the Pulitzer Prize for the picture.

Most U.S. newspapers published the photo. "It touched me very deeply because I [had] a child that same age," Ashley Halsey, then the national editor of the Philadelphia *Inquirer*, recalled. "After we put the paper to bed, I walked out to the parking lot and cried. I have never done that before."

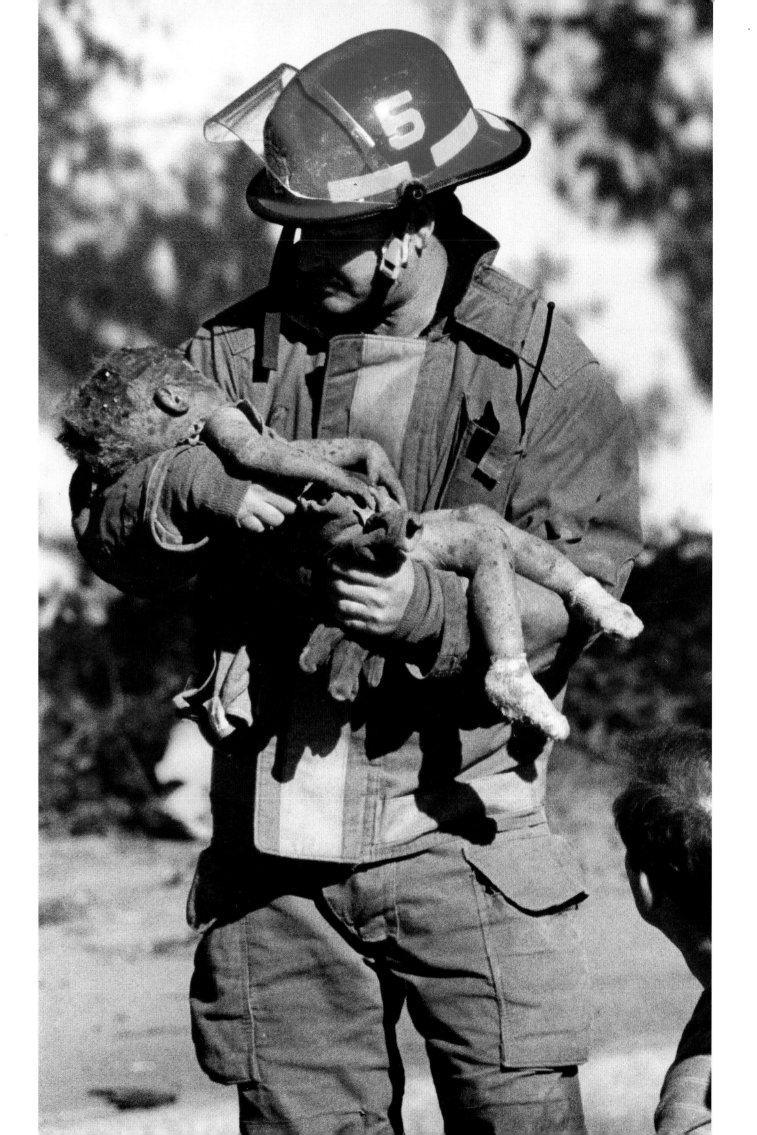

92

A Photograph of the Past
Pillars of Creation
Jeff Hester, Paul Scowen • April 1, 1995

Just as advances in science made possible the first X-ray images and photos of human embryos in the womb, the launch of the NASA Hubble Space Telescope in 1990 gave us new ways to see the universe—once a flaw in the telescope's optics was fixed by a team of astronauts who visited the orbiting scope on a repair mission in 1993.

This photo, composed of 32 images taken by four separate cameras aboard the Hubble, shows "elephant trunks" of interstellar gas (primarily molecular hydrogen) and dust in the Eagle Nebula, a.k.a. Messier Object 16, some 7,000 light-years from Earth. This is the universe's starmaking machinery, and NASA scientists dubbed the great structures of gas the "Pillars of Creation." The gases at the top of each column are so dense that they collapse under their own weight, giving birth to new stars. The entire scene is awash in a flood of ultraviolet light from nearby young, hot stars that have just been formed.

The image takes up only inches in this book, but it covers a vast extent of space. The pillar on the left, the longest of the three, covers about 4 light-years of horizontal area. (A light-year is the distance light travels in a single year; light moves at some 186,282 miles or 299,792 km per second.)

The photograph is remarkable for another reason: it covers not only an enormous area of space but also a great span of time. For the pillars no longer exist, scientists believe: they were destroyed by the shock wave from a supernova some 6,000 years ago, but even at the speed of light, their demise will not be visible from Earth for another millennium.

93

"… You Must Acquit"
O.J. Simpson's Trial for Murder
Sam Mircovich • June 15, 1995

In 1995 Americans were riveted to the televised criminal trial of onetime NLF football hero O.J. Simpson, accused of the brutal knife murders of his wife Nicole Brown Simpson and her friend Ronald Goldman. In the trial's most memorable moment, a Los Angeles prosecutor erred when he asked Simpson to try on a blood-soaked glove that had been found at the murder scene; it matched a set of gloves the star's wife had given him.

Simpson, who had enjoyed a successful career as a commercial pitchman, sports commentator and actor following his NFL days, made a show of struggling to put on the glove, squirming and contorting his body, though his exertions appear not to have convinced the nearby bailiff. Lead defense attorney Johnnie Cochran, who had anticipated that the prosecution might ask Simpson to try the gloves on for size, exploited the courtroom blunder to maximum effect, memorably counseling the jury: "If it doesn't fit, you must acquit." The prosecution offered a host of reasons why Simpson's hand did not fit in the bloody glove, but in the end, the jury found Simpson not guilty.

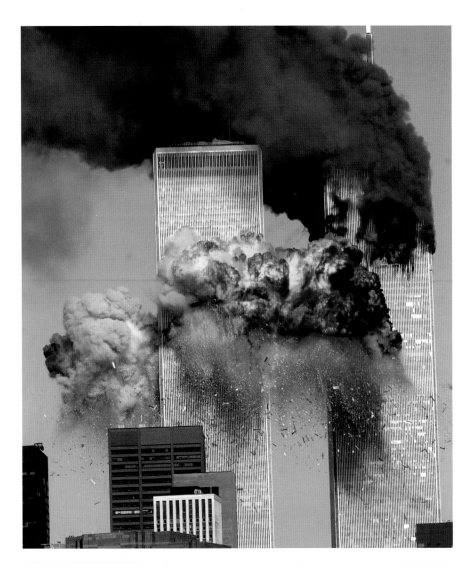

94

Horror in the Sky
Flight 175 Strikes the South Tower
Spencer Platt • Sept. 11, 2001

The photo above captures the precise moment, broadcast live on TV as it occurred at 9:03 EST in New York City, when United Airlines Flight 175 crashed into the South Tower, on the left of the World Trade Center on 9/11. The North Tower is already ablaze, after being struck 17 minutes before by American Airlines Flight 11. The crash of the Boeing 767 killed all 65 people aboard Flight 175, including the four terrorists who had commandeered the craft. It was at this moment that many people became aware that the events in New York City were part of a coordinated attack on the nation; another jetliner soon struck the Pentagon, while a fourth crashed into the ground outside Shanksville, Pa., thanks to a valiant rebellion by passengers against the hijackers.

"On a normal day," Nancy Gibbs wrote in TIME after the attacks, "we value heroism because it is uncommon. On Sept. 11, we valued heroism because it was everywhere. The firefighters kept climbing the stairs of the tallest buildings in [Manhattan], even as the steel moaned and the cracks spread in zippers through the walls, to get to the people trapped in the sky."

95

Home of the Brave
Firefighters Raise the Flag on 9/11
Thomas Franklin • Sept. 11, 2001

This photograph of three New York City firefighters hoisting a U.S. flag onto a tilting flagpole, while outlined against the rubble of the devastated World Trade Center, has become the iconic image of the 9/11 terrorist strike in New York City. The three men, from left, are Daniel McWilliams, George Johnson and Billy Eisengrein.

As photographer Thomas Franklin of the Bergen (N.J.) *Record* tells the tale, he heard about the attack, crossed the Hudson River to lower Manhattan and began taking photos of the collapsed Twin Towers, at times traveling around the site with noted combat photographer James Nachtwey, who lived in the area. Late in the afternoon, Franklin came upon the three men, who had found the flag on a yacht docked at the World Trade Center marina. They soon located a flagpole rising from a pile of rubble and climbed an improvised ramp to reach it. As they hoisted the flag, around 5:01 p.m. E.D.T., Franklin took multiple photos of the scene from 150 yds. (137 m) away, as fellow firefighters hollered support. "As soon as I shot it, I realized the similarity to the famous image of the Marines raising the flag at Iwo Jima," Franklin told a reporter later.

The picture was published in the Bergen *Record* on Sept. 12 and was immediately hailed as a classic image of hope and resolution amid a day filled with darkness and tragedy.

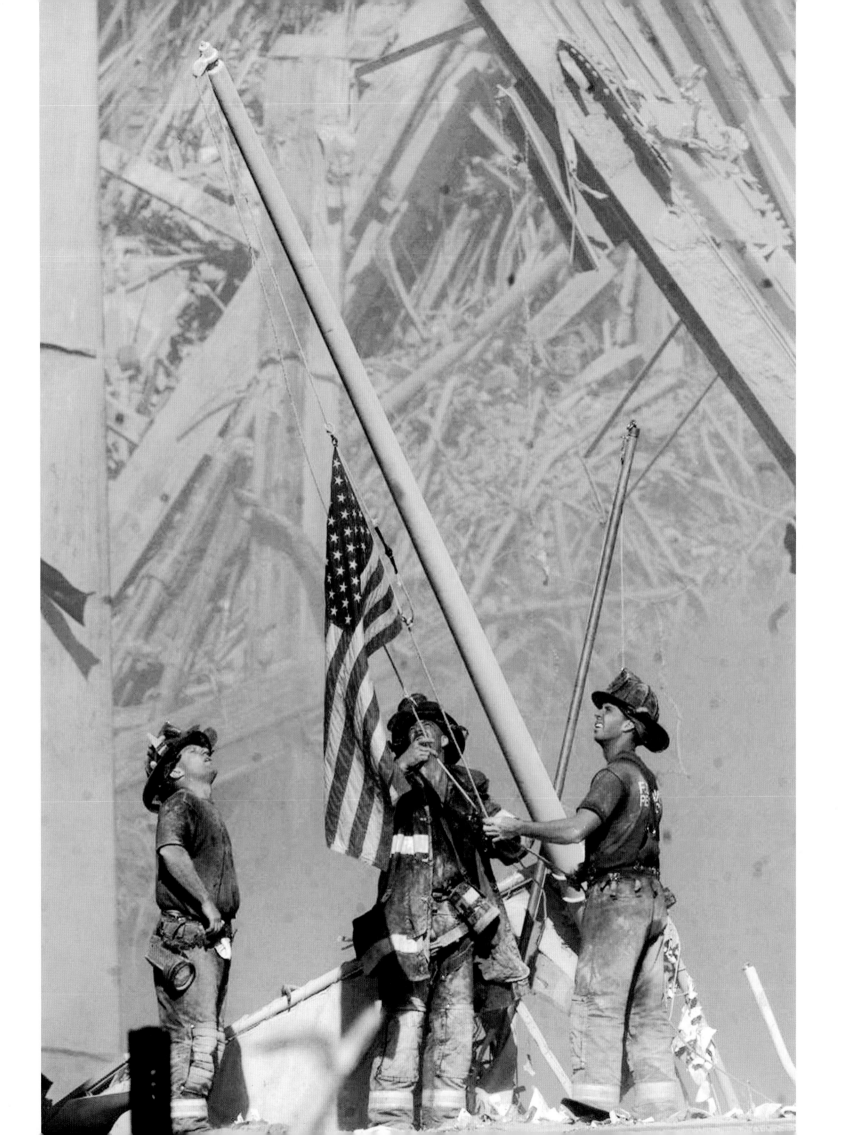

96

House of Horrors
Iraqi Detainee in Abu Ghraib Prison
Photographer unknown • Late 2003

A solitary prisoner balances on a box, head hooded, electric wires hanging from his fingers. The image, a photograph from Iraq's infamous Abu Ghraib prison, shocked the world when it was released in 2004 alongside a trove of other pictures showing U.S. troops subjecting Iraqi prisoners to all manner of violence and sexual humiliation. The images, taken by U.S. service members and contained in a U.S. Army investigative report, were first made public by the *New Yorker* magazine and the CBS News show *60 Minutes II*. They struck at the very heart of President George W. Bush's claim that the U.S. had entered Iraq in March 2003 and toppled dictator Saddam Hussein in order to promote freedom and liberty. "This is our greatest strength," said Connecticut GOP Representative Christopher Shays, "and we've blown it."

Iraq's dictator Saddam Hussein, deposed by the U.S. intervention in Iraq, had used Abu Ghraib as a citadel in which to detain and torture his political opponents without trial. Only a week before the photographs became public, Time's Johanna McGeary noted, the President had told an audience in Michigan, "Because we acted, [Saddam's] torture rooms are closed." In reality, McGeary declared, "it was Saddam's torture chamber, and now it's ours."

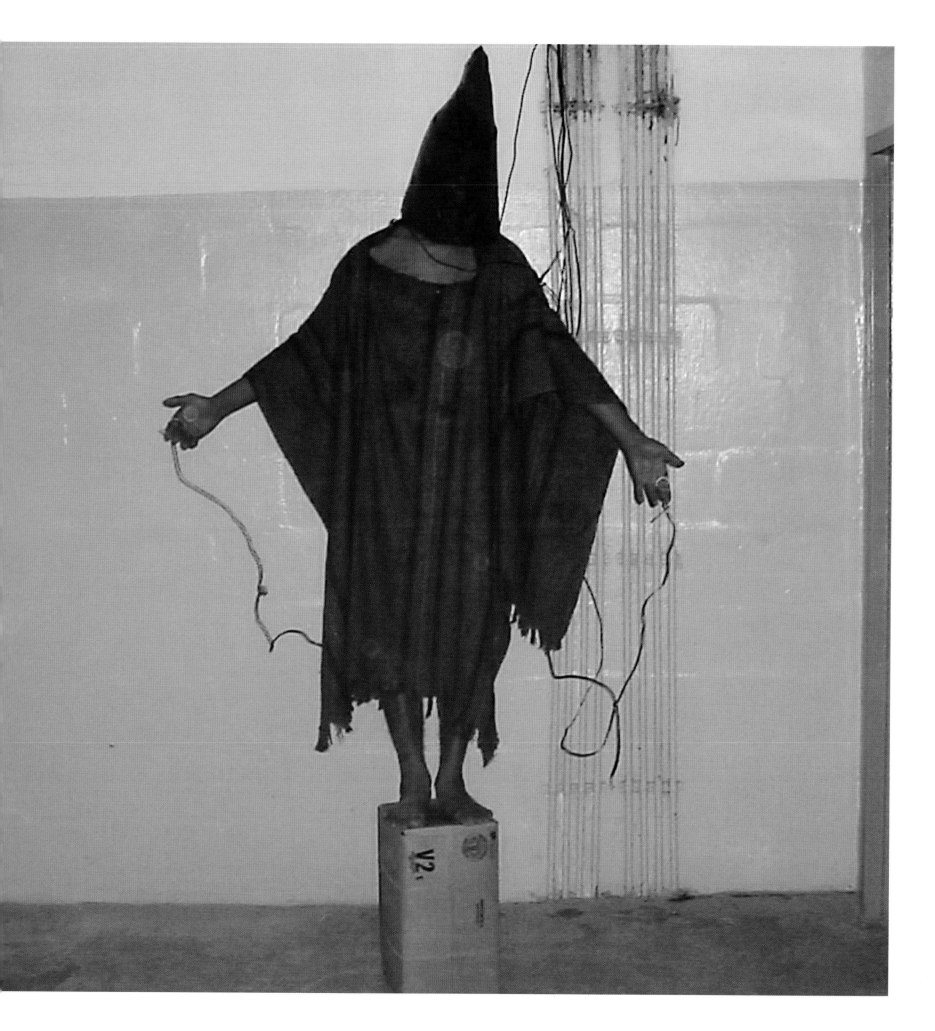

97

Alone in the Dark
Iraqi Survivor of U.S. Fire • Chris Hondros • Jan. 18, 2005

Award-winning U.S. photojournalist Chris Hondros was
covering American troops working a checkpoint in Tal Afar,
northern Iraq, in 2005, when a car rapidly approached their
position. The driver of the vehicle ignored multiple warn-
ings to stop. At the time, suicide car bombings were plaguing
occupying U.S. forces, and, operating under liberal rules of
engagement, the soldiers opened fire on the auto, only to
find it was being driven by Hussein Hassan, a civilian. Both
Hussein and wife Camila were slain, while son Racan, 11, was
paralyzed from the waist down. Daughter Samar, 5, survived,
and Hondros' photo of the child, taken in the moments after
her parents were slain and her brother was injured, were
widely published.

Students of photojournalism say the photo at right may
stand as one of the iconic images of the Iraq war. Hondros
later said, "I think one of the reasons the photo had this
sort of resonance that it does is because it has a sort of
empty feeling, 'The poor girl, all alone in the world now,
just standing there in the dark.'"

Hondros' work frequently appeared in TIME and in other
major magazines. On April 20, 2011, he was killed, at age 41,
along with British photojournalist Tim Hetherington, 40,
while the two were covering battles between Gaddafi-regime
loyalists and rebel forces in Misrata, Libya.

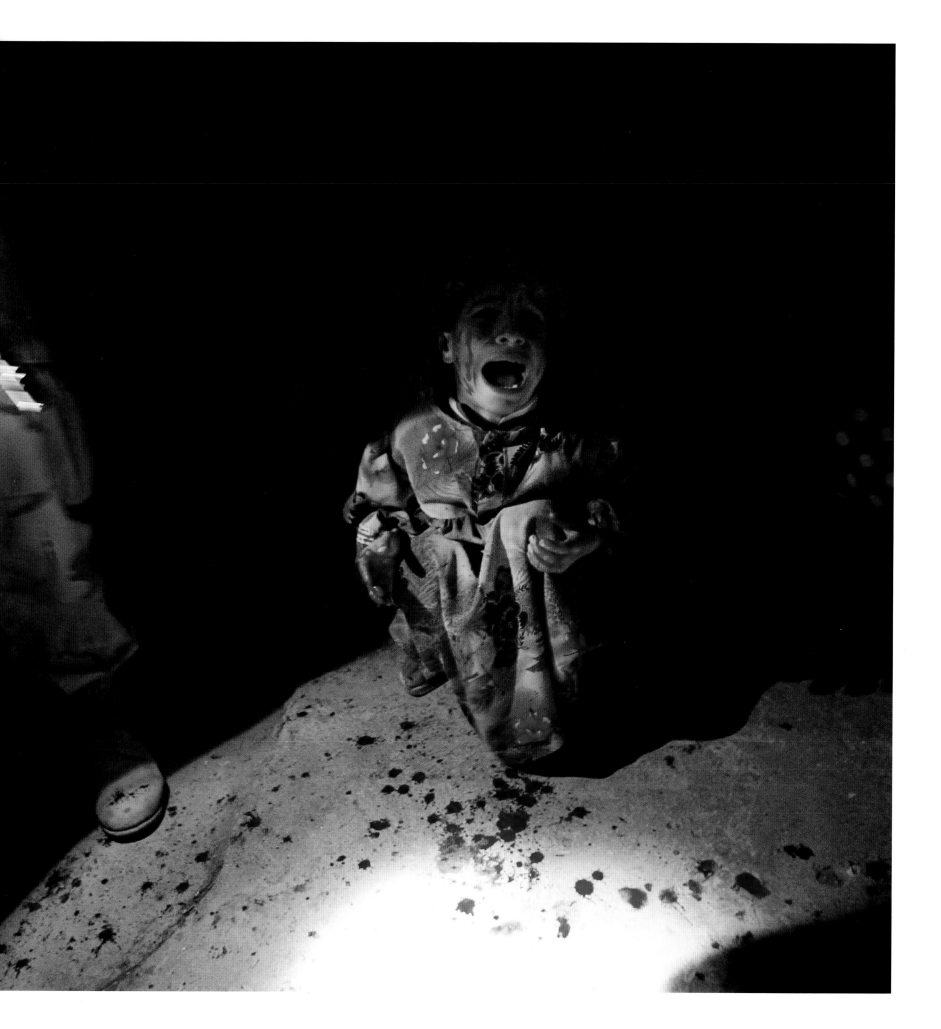

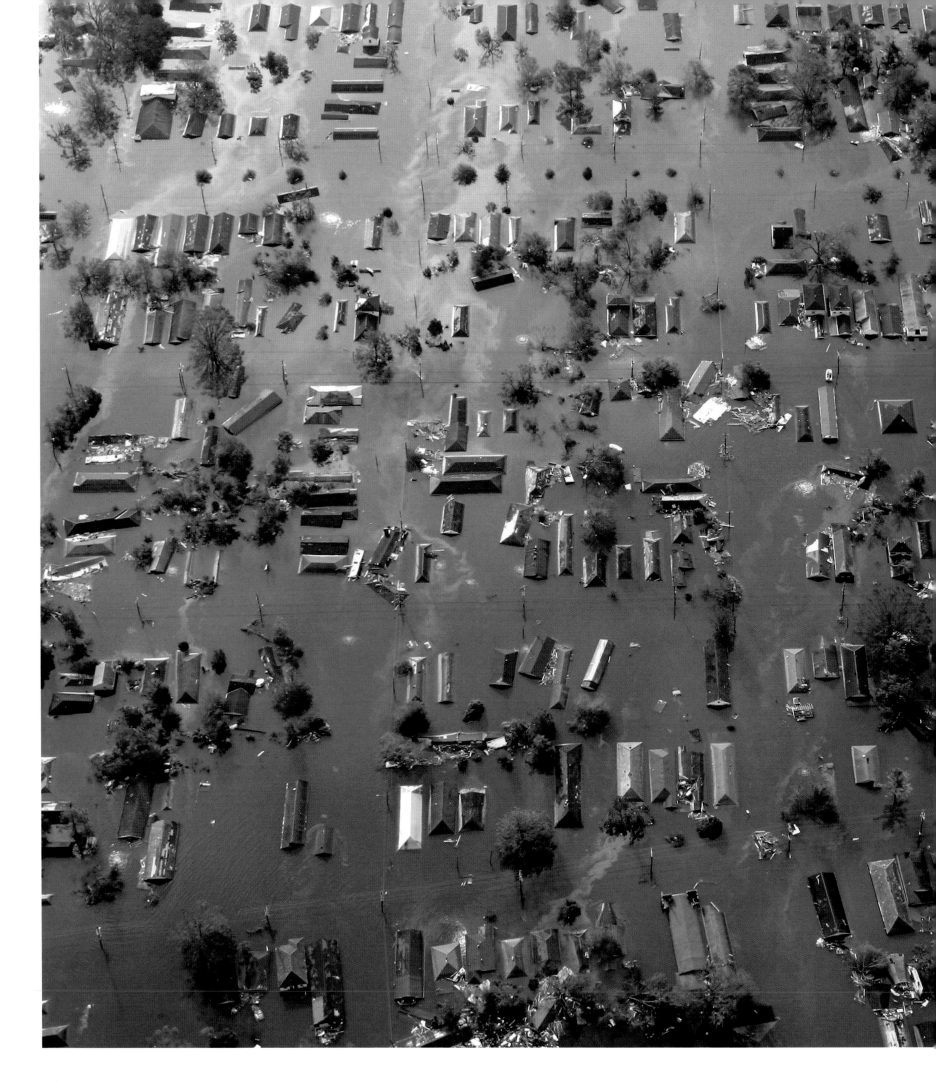

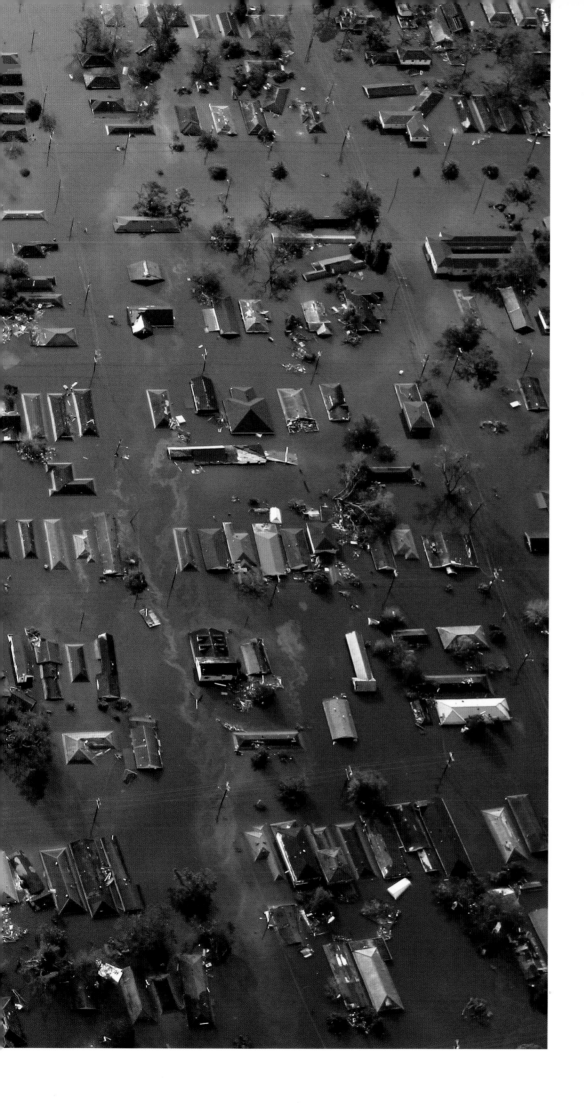

98

Sinking Feeling
Floodwaters Submerge New Orleans
Smiley N. Pool • Aug. 30, 2005

With its winds howling at 125 m.p.h., Hurricane Katrina made landfall in Louisiana just after 6 a.m. CDT on Monday, Aug. 29, 2005. The big storm system drove before it surging waters that breached the levees of New Orleans, a city whose unique music, cuisine and let-the-good-times-roll spirit make it an especially vibrant patch in America's cultural quilt. In the days and weeks that followed, Americans watched in dismay as government response to the flooding of the Crescent City proved tardy, halfhearted and inept.

The image at left shows brackish waters engulfing residences near the breached Industrial Canal: the rooftops of homes appear to be rafts floating atop the muck. This photo, like many of the best images of the disaster, was taken by Smiley N. Pool of the Dallas *Morning News.* In an article he wrote for online site the *Digital Journalist,* Pool recalled showing the photos he took on his first day of helicopter trips over the city to friends who had evacuated it: "Shooting aerial photographs is by nature a very impersonal endeavor. Filing those photos is impersonal as well. You hit a button and the photo is gone. Rarely do you get a sense of the reaction people will have when they see them. I wasn't prepared for the very personal reaction of having my friends see what had become of their city. As the images flashed by ... gasps of, 'Oh, my God,' were followed by tense silence as one by one images of the flooded city came up on the screen."

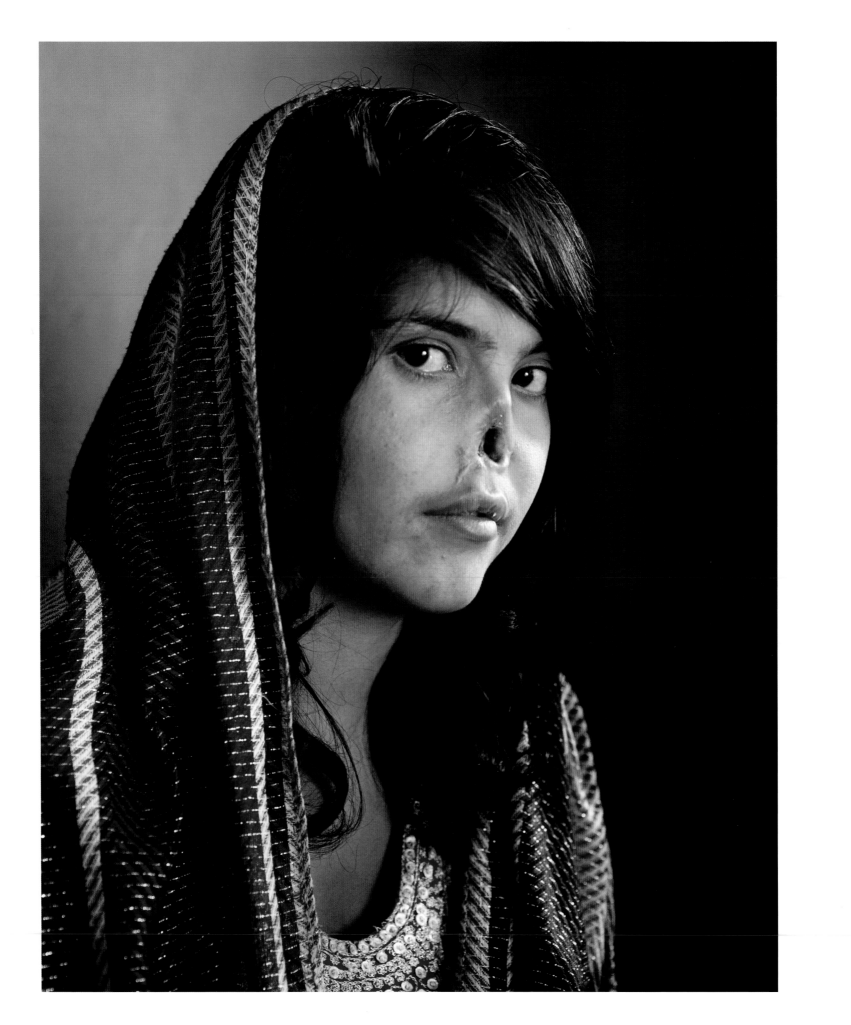

99

Who Bears the Disgrace?
Bibi Aisha, Disfigured Afghan Woman
Jodi Bieber • July 2010

A wife at age 14 after a marriage arranged by her family, Bibi Aisha fled her abusive husband when she was 18 and returned to her home village in Afghanistan. But in the view of Islamic fundamentalists, her flight was deeply insulting to the husband's family. Aisha's father returned her to her in-laws, who promised she would be treated well. Instead, they took her to a mountain clearing near their village, where her husband, father-in-law and brother-in-law assaulted her, cutting off her nose and her ears, then left her for dead. The punishment was approved by local Taliban authorities.

Aisha survived and was given medical treatment by U.S. military personnel. She was then taken to a secure women's center, Women for Afghan Women, in Kabul, the capital. There she was photographed by South African photojournalist Jodi Bieber, on assignment for Time. "Photographically I really wanted to capture her inner strength and her beauty," Bieber later said. "Clearly, I couldn't understand what it feels like to be so violently abused, but something happened and we worked together." Bieber's unflinching portrait won the coveted World Press Photo Award for 2010.

Aisha's disfigurement shocked the world when Time featured the portrait of the young woman on its Aug. 9, 2010, cover—with Aisha's full consent. Time managing editor Richard Stengel explained his decision to run the image on the cover in a letter to readers of the magazine: "Bad things do happen to people, and it is part of our job to confront and explain them. In the end, I felt that the image is a window into the reality of what is happening— and what can happen—in a war that affects and involves all of us. I would rather confront readers with the Taliban's treatment of women than ignore it. I would rather people know that reality as they make up their minds about what the U.S. and its allies should do in Afghanistan."

A New World, a New Life

Bibi Aisha was brought to the U.S., where she was fitted with a prosthetic nose in the fall of 2010, only months after she appeared on the cover of Time. She then spent a year in New York City under the sponsorship of the Women for Afghan Women organization, where she began to learn to speak, read and write English. Dr. Peter H. Grossman, the California-based surgeon who fitted the prosthetic nose, said he hoped to give Aisha a more "permanent solution" in the future, perhaps by creating a new nose and ears grafted from bone, cartilage and tissue take from elsewhere in her body.

In December 2011, the Women for Afghan Women organization announced that Aisha, who will be 21 in 2012, had moved in with an Afghan family in the U.S. and will be applying for political asylum in the United States. The agency website declared, "All of us who cared for Aisha (WAW staff and board members, the tutors, roommates, psychiatrists and other medical professionals), all those individuals from within and outside the community who took her on regular outings—to the theater, the movies, the circus, and museums—miss Aisha very much. She was quite a mainstay in our community ... she will always be a part of the WAW family."

100

Watching and Waiting

U.S. Leaders Viewing Pakistan Raid
Pete Souza • May 1, 2011

Most of the photographs in this book are self-explanatory. The scenes they portray are immediately clear and pack an emotional wallop: that's precisely why the photos of American troops raising the flag on Iwo Jima and the shooting of Lee Harvey Oswald by Jack Ruby are iconic. But some photos do not speak so plainly; they are only compelling in context and are mute without their backstory.

This scene is such an image. Captured by an insider, White House photographer Pete Souza, it fascinated the world after it was released and was endlessly analyzed and scrutinized. At first glance, it shows only a group of people gathered around a table, attending—tense with anticipation—to something to the photographer's left that we cannot see in the frame.

Once we know the secret of the photo, we can understand its power. The group comprises President Barack Obama's national security team. They are watching a live video feed of events taking place half a world away, where a squad of U.S. Navy SEALs has entered Pakistan, secretly, to conduct a daring raid on a compound where the man behind the 9/11 terrorist strikes on the U.S., al-Qaeda leader Osama bin Laden, was believed to be hiding.

By the time the picture was released, the morning after the raid, the world knew that the risky plan had succeeded and that bin Laden had been killed while the raid was in progress. Yet even though viewers know the outcome, we can still feel the power of the image and the nervous, fretful energy it conveys.

FRONT COVER

Top row, left to right: Edmund Hillary—Royal Geographical Society; Anthony Suau; Sam Shere—Bettmann Corbis; Thomas Franklin—*The Record,* Bergen County, N.J.—AP Images; Nat Fein—Courtesy the estate of Nat Fein

Second row, left to right: Harold E. Edgerton—©Harold & Esther Edgerton Foundation, 2012, Courtesy of Palm Press, Inc.; Mathew Brady—Library of Congress Prints and Photographs Division; Bob Adelman—Magnum Photos; William Anders—NASA; Abraham Zapruder—Zapruder Film ©1967, (Renewed 1995), The Sixth Floor Museum at Dealey Plaza. All rights reserved.

Third row, left to right: Norman Potter—Central Press/Getty Images; Jeff Widener—AP Images; Neil Leifer—Sports Illustrated; Charles C. Ebbets—Bettmann Corbis; Charles Porter IV—Zuma Press

Bottom row, left to right: NASA, ESA, STScI, J. Hester and P. Scowen (Arizona State University); John T. Daniels—National Archives; Alexander Joe—AFP/Getty Images; Dorothea Lange—Library of Congress Prints and Photographs Division; Bruce Weaver—AP Images

BACK COVER

Joe Rosenthal—AP Images

FRONT MATTER

i SSPL—Getty Images
iii John Loengard—Time Life Pictures—Getty Images
v (Burrows) Express Newspapers—Getty Images; (Curtis) American Stock—Getty Images; (Eisenstaedt) Leonard Mc-Combe—Life Magazine—Time and Life Pictures; (Ut) AP Images; (Muybridge) Rischgitz—Hulton Archive—Getty Images; (Bieber) Mikaela Zyss—Courtesy of Institute; (Lange) Larry Colwell—Anthony Barboza—Getty Images; (Hondros) Getty Images; (Rosenthal) U.S. Marine Corps—AP Images
1 Time Magazine ©Time Inc.
2 Louis-Jacques-Mandé Daguerre
4 William Henry Fox Talbot & Nicholaas Henneman—Getty Images
4 Mansell Collection—Time Life Pictures
5 Mathew Brady—Getty Images

HISTORY'S GREATEST IMAGES

7 Joseph Nicéphore Niépce
8 Roger Fenton—Library of Congress Prints and Photographs Division (2)
9 Mathew Brady—Library of Congress Prints and Photographs Division
10 Alexander Gardner—Library of Congress Prints and Photographs Division
12 Eadweard Muybridge
13 Wilhelm Conrad Röntgen—U.S. National Library of Medicine
14 Jacob Riis—Museum of the City of New York, Jacob A. Riis Collection
15 (left) *Puch Brothers*—Hulton Archive—Getty Images; (top, right) *In the Home of an Italian Ragpicker,* ca. 1890, Museum of the City of New York, Jacob A. Riis Collection; (bottom, right) *Street Arabs in Sleeping Quarters,* ca. 1890, Museum of the City of New York, Jacob A. Riis Collection
16 John T. Daniels—National Archives
18 Edward S. Curtis—Library of Congress Prints and Photographs Division
20 Arnold Genthe—Library of Congress Prints and Photographs Division
22 Lewis W. Hine—Miriam and Ira D. Wallach Division of Arts, Prints and Photographs, New York Public Library Image Collection
23 (left) Miriam and Ira D. Wallach Division of Arts, Prints and Photographs, New York Public Library Image Collection; (right, top and bottom) Lewis W. Hine—Miriam and Ira D. Wallach Division of Arts, Prints and Photographs, New York Public Library Image Collection
24 Brown Brothers
25 Courtesy of Kheel Center, Cornell University
26 T.L. Aitken—Getty Images
27 Mansell Collection/Time Life Pictures
28 Harry Burton—Mansell Collection/Time Life Pictures
29 Lawrence Beitler—Bettmann Corbis
30 Charles C. Ebbets—Bettmann Corbis
32 Christian Spurling and Ian Wetherell—Keystone/Getty Images
33 (top) Roger Patterson—Bettmann Corbis; (bottom, left) Time Life Picture Collection; (bottom right) Frances Griffiths—Copy photo by Glenn Hill—SSPL—Getty Images
34 Harold E. Edgerton—©Harold & Esther Edgerton Foundation, 2012, Courtesy of Palm Press, Inc.
35 (left) Alfred Eisenstaedt—Time Life Pictures; Harold E. Edgerton—©Harold & Esther Edgerton Foundation, 2012, Courtesy of Palm Press, Inc. (2)
36 Arthur Rothstein—Library of Congress Prints and Photographs Division
37 (top) ©Walker Evans Archive, The Metropolitan Museum of Art, Digital Image ©The Museum of Modern Art/Licensed by SCALA/Art Resource, NY; (bottom) ©Walker Evans Archive, The Metropolitan Museum of Art, Digital Image ©The Metropolitan Museum of Art/Art Resource, NY
38 Dorothea Lange—Library of Congress Prints and Photographs Division
39 Ted Benson—Modesto *Bee*—MCT via Getty Images
40 Robert Capa ©International Center of Photography/Magnum Photos
41 H.S. Wong—National Archives
42 Sam Shere—Bettmann Corbis
44 Heinrich Hoffmann—Time Life Pictures
46 AP Images
47 Pictures Inc./Time Life Pictures
48 U.S. Navy Photographer—National Archives
50 Robert Capa ©International Center of Photography/Magnum Photos
51 Robert Capa ©International Center of Photography/Magnum Photos (3)
52 U.S. Army Signal Corps
53 (top) Carl Mydans—Time Life Pictures; Jerome Zerbe—Time Life Pictures—Getty Images
54 Joe Rosenthal—AP Images
55 PFC Bob Campbell—U.S. Marine Corps
56 United Israel Appeal/Time Life Picture Collection
57 Private H. Miller—U.S. Army/National Archives
58 Anne Frank Fonds/Anne Frank House via Getty Images
59 Anne Frank Fonds/Anne Frank House via Getty Images (2)
60 Ed Clark—Time Life Pictures
61 Yevgeny Khaldei—Corbis
62 Yoshito Matsushige—Chugoku Shimbun
63 U.S. Army Air Force Photographer—Office of War Information/National Archives
64 Alfred Eisenstaedt—Time Life Pictures
65 Robert Capa ©International Center of Photography/Magnum Photos
66 Nat Fein—Courtesy the Estate of Nat Fein
68 W. Eugene Smith—Time Life Pictures
69 (top, left) Bettmann Corbis; W. Eugene Smith—Time Life Pictures (3)
70 Walter Sanders—Time Life Pictures
71 John Sadovy—Time Life Pictures—Getty Images (3)
72 Max Desfor—AP Images
73 David Douglas Duncan, Courtesy of Harry Ransom Center, The University of Texas at Austin (3)
74 Edmund Hillary—Royal Geographical Society
75 Norman Potter—Central Press/Getty Images
76 Will Counts—Will Counts Collection: Indiana University Archives
77 Alberto Korda; (bottom) Courtesy of Jim Fitzpatrick
78 Paul Schutzer—Time Life Pictures
79 (left) Paul Schutzer—Time Life Pictures; Hank Walker—Time Life Pictures
80 Ian Berry—Magnum Photos
82 Peter Leibing, Hamburg, Germany—Courtesy Estate of Peter Leibing
83 Getty Images
84 Bill Hudson—AP Images
85 Charles Moore—Black Star (2)
86 Bob Adelman—Magnum Photos
88 Abraham Zapruder—Zapruder Film ©1967 (Renewed 1995), The Sixth Floor Museum at Dealey Plaza. All rights reserved.
90 Cecil Stoughton—The White House
91 Stan Stearns—UPI—Corbis Bettmann
92 Bob Jackson—Dallas *Times Herald*
93 Malcolm Browne—AP Images
94 Neil Leifer—Sports Illustrated
96 Lennart Nilsson—Scanpix
98 Larry Burrows—Life Magazine
100 Xinhua
101 Bernie Boston—Rochester Institute of Technology Archive Collections
102 Eddie Adams—AP Images
103 Ronald S. Haeberle—Time Life Pictures—Getty Images
104 AP Images
105 Joseph Louw—Time Life Pictures/Getty Images
106 Bill Eppridge—Time Life Pictures
107 Bill Eppridge—Time Life Pictures
108 Josef Koudelka—Magnum Photos
109 (left) Abbas—Magnum Photos; Josef Koudelka—Magnum Photos (2)
110 William Anders—NASA
111 Neil Armstrong—NASA
112 John Paul Filo—Getty Images
113 (top) John Paul Filo—Getty Images; (bottom) Howard Ruffner—Time Life Pictures—Getty Images
114 Nick Ut—AP Images; (bottom) Joe McNally
115 Sal Veder—AP Images
116 Bill Pierce
117 Hubert van Es—Bettmann Corbis
118 AP Images
119 Heinz Kluetmeier—Sports Illustrated
120 Ron Edmonds—AP Images
121 Peter Jordan—Getty Images
122 Bruce Weaver—AP Images
123 Bettmann Corbis
124 James Nachtwey
125 (left) Gilles Peress—Magnum Photos; James Nachtwey (2)
126 Sebastião Salgado—Amazonas Images—Contact Press Images
128 Jeff Widener—AP Images
130 Anthony Suau
132 Alexander Joe—AFP/Getty Images
134 Kevin Carter—Sygma/Corbis
135 Paul Watson—The Toronto *Star*
136 Therese Frare
137 Charles Porter IV—Zuma Press
138 NASA, ESA, STScI, J. Hester and P. Scowen (Arizona State University)
139 Sam Mircovich—AFP/Getty Images
140 Spencer Platt—Getty Images
141 Thomas Franklin—*The Record,* Bergen County, N.J./AP Images
142 AP Images
144 Chris Hondros—Getty Images
146 Smiley N. Pool—Dallas *Morning News*/Corbis
148 Jodi Bieber—Institute for Time Magazine
149 Michael Kovac—Film Magic—Getty Images
150 Pete Souza—The White House